BOSCH

in Perspective

THE ARTISTS IN PERSPECTIVE SERIES
H. W. Janson, general editor

The ARTISTS IN PERSPECTIVE series presents individual illustrated volumes of interpretive essays on the most significant painters, sculptors, architects, and genres of world art.

Each volume provides an understanding of art and artists through both esthetic and cultural evaluations.

JAMES SNYDER is a professor in the Department of the History of Art at Bryn Mawr College. He has written widely on Netherlandish art of the late Middle Ages.

BOSCH
in Perspective

Edited by
JAMES SNYDER

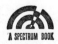

A SPECTRUM BOOK

Prentice-Hall, Inc., Englewood Cliffs, New Jersey

Library of Congress Cataloging in Publication Data

SNYDER, JAMES, comp.
 Bosch in perspective.

 (Artists in perspective) (A Spectrum Book)
 Bibliography: p.
 1. Bosch, Hieronymus van Aken, Known as,
d. 1516. I. Title.
ND653.B65S58 1973 759.9492 73–16063
ISBN 0–13–080416–9
ISBN 0–13–080408–8 (pbk.)

A SPECTRUM BOOK

1 2 3 4 5 6 7 8 9 10

Printed in the United States of America

PRENTICE-HALL INTERNATIONAL, INC. (LONDON)
PRENTICE-HALL OF AUSTRALIA, PTY. LTD. (SYDNEY)
PRENTICE-HALL OF CANADA, LTD. (TORONTO)
PRENTICE-HALL OF INDIA PRIVATE LIMITED (NEW DELHI)
PRENTICE-HALL OF JAPAN, INC. (TOKYO)

CONTENTS

PREFACE

The North-Netherlandish painter Hieronymus Bosch (ca. 1450–1516) was unquestionably the most enigmatic artist of his epoch. His art was much appreciated and widely imitated in the sixteenth century, the period of the Renaissance and Reformation in the North, but during the eighteenth and nineteenth centuries his status as an artist rapidly waned and he was soon forgotten or, at best, ridiculed as a weird painter of bizarre and heretical imagery. Only in this century has there been an enthusiastic and positive reevaluation of his art, and it is very likely the climate of our times that has brought about this renewed interest in his art. The first major monograph on Bosch, that of Charles de Tolnay, was published the year after the first exhibition of his works, in Rotterdam in 1936. The literature on Bosch gradually increased, and since the second major exhibition of his paintings, in his hometown 's-Hertogenbosch in 1967, the body of scholarship has swelled immensely.

It would be impossible to treat all of the "perspectives" on Bosch adequately in a single volume. Not only is the scholarship vast, but it is, for the most part, very controversial. In the introductory essay I have attempted to summarize the basic schools of interpretation of Bosch's paintings and then apply them to some of his major works. This has been done at the expense of many of his smaller pieces, especially those half-length figures of the Passion of Christ, and while I regret this, I must admit that many of these works are of questionable attribution.

The articles and studies on Bosch include excerpts that range

from the earliest commentators on the artist, mostly Spanish, through the memorable essay by Carl Justi, in 1889 (the first modern art-historical assessment of his paintings), and down to recent critics of Bosch's art. A number of the essays selected were of such length that only brief excerpts from them could be reprinted, and I apologize to those authors whose interpretations were abbreviated for that reason. In other cases, because of copyright laws or difficulty in obtaining permission from authors, I have had to omit essays that I would otherwise have included. It is hoped that the introductory essay will state the interpretations of these authors clearly and accurately.

The numbering of the plates or illustrations in the essays reprinted has had to be changed to avoid repetition; in some cases, illustrations of only secondary importance for the articles were not included. Otherwise the texts and footnotes are as originally published. For their permission to reprint articles and excerpts in this book I would like to thank Dr. Charles de Tolnay, Director of the Museo della Casa Buonarotti, and Professors Charles D. Cuttler, Lotte Brand Philip, Helmut Heidenreich, A. Pigler, Jakob Rosenberg, and Irving L. Zupnick. To the editors of the following journals and books I also extend my thanks and appreciation: *The Art Bulletin, The Art Quarterly, The Burlington Magazine,* Harry N. Abrams, Holle Verlag of Baden-Baden, The Institute for Advanced Study in Princeton, the *Nederlands Kunsthistorisch Jaarboek,* Anton Schroll and Company, and *The Journal of the Warburg and Courtauld Institutes.*

I wish to thank Dr. Diego Angulo, Director of the Instituto Diego Velazquez in Madrid, for his kind help in acquiring photographs of Bosch's paintings in Madrid. Among the many friends and colleagues who have helped me in selecting essays and points of criticism, I would like to extend my gratitude to the graduate students of Bryn Mawr College who have worked with me on problems of Bosch scholarship over the past two years. I am much indebted to Mrs. Heide Bideau for her help in translating the article by Carl Justi and to Mrs. Jetske Ironside, who has been a valuable source of information on problems concerning the style of Bosch. Finally, very special thanks go to Miss Claudia Fedarko, who helped me through the Spanish translations and a number of other problems in the final preparation of this book.

BOSCH
in Perspective

INTRODUCTION

James Snyder

What is the meaning, Hieronymus Bosch,
 of that frightened eye of yours?
Why that pallor of your face?
 It seems as if you were seeing
Spectres and apparitions of Hell flying
 face to face.

D. LAMPSONIUS, *effigies* (1572)

Erwin Panofsky concluded his history of Early Netherlandish paint-
ing with a single page devoted to the art of Bosch, and quoting an
early sixteenth-century German scholar and translator who lamented
his inability to render the final book of Marsilio Ficino's *De vita
triplici,* Panofsky ended with the words, "This too high for my wit,
I prefer to omit." According to Panofsky, the secret to interpreting
Bosch's unusual pictures has yet to be found: "We have bored a few
holes in the door of the locked room; but somehow we do not seem
to have discovered the key." For students of Netherlandish art
familiar with the literature on Bosch, Panofsky's brief confession
should come as a welcome and refreshing appraisal. Nothing can
be more discouraging when first studying Bosch's paintings than to
face the countless number of articles and books written in search of
the ghost key that will open the inner door to the meaning of his
pictures. And whether these clues are sought in the realm of scrip-
tural exegeses, folklore, or magical, alchemistic, or astrological trea-
tises, the end results are nearly always the same, presenting us with

1

an incoherent and unwieldy mass of data that often make his personality more remote and inaccessible than before. To be sure, the unique surrealistic quality of his art invites such interpretations because of its weird beauty and libidinal symbolism. Strange twisting towers, resembling the constructions of Antonio Gaudí, are very likely meant to be overt phallic symbols; succulent, seedy strawberries and ripe pomegranates bursting their pods suggest natural acts of procreation; and the stagnant ponds and pools that fill his pulsating landscapes are no doubt meant to be spawning grounds. But all is not sex in Bosch. With a curious and disturbing modernity he fashioned plastic tubes and metal casings as aspects of architecture and costume that have been related to specific heresies or deadly sins, and the soaring, half-finished structures of brick and stone are very likely derived from contemporary descriptions of Hell. All of these observations may be true and obvious in part, but one cannot approach Bosch's paintings wearing blinders that mask out the vast and complex panorama of his unusual landscapes. One must view them with telescopes as well as microscopes, stopping now and then for a more natural focus on things.

A good example of the problems encountered in interpreting Bosch's works is the bewildering scholarship on the so-called *Landloper* (tramp) (Fig. 1). The striding figure in the tondo (round painting), tattered and torn as he limps along a dirt road leading from a ramshackle brothel, has been identified as the biblical prodigal son (Glück, De Tolnay), a peddler (Seligman), a vagabond thief (Conway), an errant drunkard (Bax), a wayward shepherd (Calas), a personification of Sloth (Zupnick), a child of Saturn (Pigler), a personification of the melancholic humor of Saturn (Philip), and, finally, an image of *Elck* (Everyman) of Netherlandish proverbs. It could well be argued that one of these identifications was primary in Bosch's mind when he painted the tondo while the others might simply be associations implicit in any general reading of a picture that presents us with a weary tradesman or tramp passing through a desolate countryside. The broader concept, that he represents Everyman and his sins passing through life, would seem in my mind to be the most comprehensive.

Iconographic analyses that depend on strict application of literary sources to visual motifs simply do not provide us with the "key." With the paintings of Bosch before us, Panofsky's exacting method

for finding disguised symbolism in painted objects must be considered somewhat obsolete and in need of modification or extension. For one thing, Bosch is much more than a clever illustrator of texts, and in many respects his works are, in and by themselves, masterpieces of social polemic that far surpass the ravings of theologians or the theories of the literati of his day who were attempting to account for the ills of their Christian world. In some respects Bosch is like some fiery, eloquent *rederijker* (rhetorician) who spells out great and threatening extemporaneous sermons in paint, fashioning the images themselves with a high degree of originality.

• • •

Some of the earliest commentators on Bosch's paintings clearly noted the uniqueness of his subject matter and admitted that they could not understand all of the details before their eyes. In his description of the paintings in the Escorial collected by Philip II, the historian Fra José de Sigüenza, writing about 1604, spent considerable time in discussing the many works of Bosch because of their great inventiveness and profundity of Christian meaning. The fact that the King, a zealous Roman Catholic, collected these pictures for his apartments and chapels was evidence in itself of their pious and orthodox content—contrary to some statements that they were the absurd inventions of a heretic. An earlier Spanish writer, Don Felipe de Guevara, writing about 1560, reports that Bosch painted strange and wondrous figures because his themes were so often set in Hell but that he executed even these creatures with decorum and good judgment. With some later Spanish critics, to be discussed fully in the essays, this positive interpretation seems to have been challenged, as it so often was in nineteenth-century allusions to Bosch.

Two important aspects of the early criticism of Bosch clearly emerge in the commentaries of Guevara and Sigüenza: first, Bosch's works presented them with an astonishingly new version of religious subject matter that explored the haunting obsessions of the inner man; second, the numerous imitations—and travesties—of his pious works (whose existence attested to his widespread popularity) that were considered authentic or reliable copies of his paintings had, in fact, only obscured and perverted the true meaning of his art and misled critics in interpreting his religious sentiment.

From a modern point of view the art of Bosch seems very different from the tradition of fifteenth-century Netherlandish painting. In the masterpieces of Jan van Eyck, Rogier van der Weyden, and Hans Memling we look in on hushed Gothic chambers where demure Madonnas sit quietly and a bit shyly. We see comforting landscapes framed with trees and spangled with delicate flowers and ferns. We have intimate glimpses down clean Flemish streets neatly bordered by tidy houses and shops. Everywhere in Flemish painting we meet modest, pious folk: young Madonnas, passive martyrs, humble burghers and peasants—some of the finest and most approachable people one meets in art history. Their world is one of peaceful resignation tinged at times with a certain self-consciousness or melancholy, but it is a place of serenity, peace, and hope, assuring them of salvation through the good Christian life. However, as Sigüenza has already noted, Bosch differs from these painters in that he painted the inner man, or, to put it another way, he conjured up frightening dream imagery that haunts one's subjective experiences.

As Baldass and others have pointed out, this inner world of Bosch is fraught with bizarre and alarming images of the pessimistic age of the Reformation to which Bosch belonged, presenting us with a world of extreme psychic instability on man's part in a landscape of violence and corruption. In fact, it can be said more precisely that the society that Bosch depicts is threefold in character: frenzied, violent, and hybrid. His people seem to be caught up in some frantic Brownian motion, racing in no particular direction toward no goal. But from infancy to old age man charges on, inevitably, toward a seething Hell, and, though his movements seem uncontrollable, he blindly races to his fate of his own free will. Or so it seems at first. In truth, Bosch is telling us in some of his more ambitious pieces that man really has no choice about it all. Man was and is and will be a sinful creature, and it has been so since the beginnings of Creation. There is no salvation. There is no heaven in his concept of the Last Judgment, which in a Joachimite manner was very imminent. Bosch's masterpiece, *The Garden of Earthly Delights*, once in the collection of Philip II, is a manifesto of this pessimistic theology of Bosch, as we shall see. Furthermore, all of nature partakes of this evil. Often there are no distinctions between flora and fauna among the nightmarish creatures and hybrids that

tease and torment man, but if the lower forms of nature had the jump on him in time in the great chain of corrupted being, she found in him, *Homo sapiens,* the supreme corruptor of all of God's creations—a complete inversion of humanistic thinking. Whom are we to blame for this incredible degradation of man who was created in the image of God? And why and how did it all come into being in the first place? It is to these questions that most authorities have directed their inquiries into the art of this mysterious painter-prophet of 's-Hertogenbosch in North Brabant.

• • •

Since the publication of Dollmayr's memorable essay, "Hieronymus Bosch and the Representations of the Four Last Things in Netherlandish Art," in 1898, much attention has been focused on the traditional moralizing content of Bosch's imagery. Sigüenza, it should be noted, already made that point in his commentaries on the Prado Table Top (a tabletop painting of *The Seven Deadly Sins*) and *The Haywain.* The world is a violent one where murder, rape, theft, and, in general, gross overindulgence are commonplace activities to be expected of "Everyman" and are the inevitable results of human behavior. Bosch's people, except for the ascetic hermit-saints, are totally given over to the seven major vices of the medieval world. But no longer are the condemnations spelled out with attributes or stereotyped narratives. Rather Bosch clothes them in the "here and now" to such an extent that in many instances it is difficult to decipher the seemingly naturalistic genre scenes.

People are cheated by the tricky magician or the quack doctor. A rudderless vessel without a pilot, *The Ship of Fools,* floats at random, filled with rowdy nitwits of every class eating, drinking, singing. Sluggishness as well as lust and violence characterize his people, as evident in the mangy *landloper* who stumbles along the dusty road. The sources for much of this imagery are to be found in the marginalia of late Gothic art and literature (or at least what seems marginal to us today) that survive in the colorful drolleries on the borders of manuscripts or in the bawdy and sometimes humorous activities carved on the misericord seats in the churches. Many literary equivalents of such marginalia in the form of *exempla,* popular stories and everyday lessons illustrating the Scriptures, are lost to us today, but others survive in the form of popular treatises

such as Sebastian Brant's *Narrenschiff* (*Ship of Fools*), the *Ars moriendi* (*Art of Dying*), and the more traditional manuals of instruction such as *The Calendar of the Shepherds* and *The Children of the Planets*. As for religious texts, it is clear that Bosch drew heavily from many devotional and mystic writings, and, as Lotte Brand Philip has shown, early Jewish legends were very likely another source of inspiration.

Bosch relied not only on the folk wisdom of the Bible but on popular Netherlandish literature as well. Some scholars, in particular Bax, find the keys for decoding many of Bosch's themes in folk sayings that at times verge on simple punning. *The Cure of Folly* (Fig. 2) is a good example of the use of the double-entendre: *Meester snijt die Keye ras / Mijne name is Lubbert Das* (Master, cut out the stone, my name is Lubbert Das). Bax sees in the reference to Lubbert Das a popular Netherlandish image of the fool (*lubber*) who is deceived by the charlatan doctor. This, in turn, could well be related to the Netherlandish saying, *iemand van de kei snijden* (to cut the stone from someone), that refers to the removal of the seat of folly from the brain of a fool or a madman. For Bax the word *keye* (stone) is, furthermore, a pun on the name *Keye*—the boastful and malicious knight of King Arthur's Round Table, Sir Kay. Nicolas Calas, in an article on the *landloper* (1967), extends the theory of Bosch's use of puns, double meanings, and similar cryptic riddles even further. According to Calas, Bosch puns in Latin and Greek as well as in Dutch.

● ● ●

Man's insatiable appetite for earthly pleasures and his uncontrollable animal passions generate a frightening and malformed population. Bosch seems obsessed with the idea that evil breeds evil at an astonishing rate. Once the infectious mating begins everything and everyone become corrupted, altered, or hybrid in body. Malformed beggars and grotesque cripples could well have been observed firsthand in the streets. Other, more surrealistic, hybrid creatures, offspring of mismating in the world, emerged from his own imagination as horrid, unnatural things with distended or dwarfed torsos, insect-like appendages, or human faces with bird beaks, and all are arrayed in uncanny costumes that only add more confusion about the character of their being. Animal, mineral, vege-

table forms grow from one body sheathed in metallic casings or rotting vestments. There is a long tradition for such grotesques, of course, and Guevara (*ca.* 1560) already described these hybrids of Bosch as *grilli*, a type of ancient grotesque that was, according to Pliny, invented by the Egyptian painter Antiphilos, a contemporary of Apelles.

Bosch's obsession with such rapid-breeding hybrid creatures would furthermore suggest his familiarity with the theories and practices of pseudo-scientists such as the alchemists, and since pharmacy, the art of chemistry so basic to the alchemists, was a profession of Bosch's in-laws, it is likely that his knowledge of their arts was thoroughly founded. While alchemists were considered dangerous in Bosch's day—Sebastian Brant classed them with witches and sorcerers as deceitful tricksters who contaminated the world with their falsehoods and filth—their mysterious quest for the philosopher's stone must have fascinated the artist. Their secrets of creation and mutation were symbolic of the sexual union of male and female forces in nature. Hermetic mercury, the goal of their experiments, was the key to producing the philosopher's stone, the elixir of life, that could turn dust into gold or assure its user of immortality. Mercury wedded to sulphur, under exact conditions, could produce the wonder-child, and aside from the symbolism of the chemicals themselves, the very objects employed by the alchemist took on sexual meaning. According to Jacques Combe, such imagery is to be found in many of Bosch's works. The egg is perhaps the most recurrent motif, being the crucible or retort for the mixture and as such symbolizing the bridal chamber for sexual union. For Bosch the egg assumes a variety of forms, many of which are clearly suggestive of the reproductive process in their corpulent, seedy, juicy, or fertile nature: strawberries, cherries, grapes, pomegranates, and seed pods of various plants. Other objects suggestive of the bridal chamber in their operative and secretive nature are mussels, clams, and oysters. The pools and swamps found in many of Bosch's landscapes represent the watery matrix for conception, and the birds that crowd in them, usually inflated in size, are fowls usually associated with lust, fertility, and the like: kingfishers, mallards, etc. According to Combe, Bosch makes much use of this weird alchemistic symbolism, and he shows us how the process degenerates. The flowering and juicy fruits rot; the luscious eggs be-

come parched and empty shells; the warm waters of the spawning ponds turn to ice. In the end all are symbols of sterility and death.

• • •

In recent years a number of studies on the astrological symbolism in Bosch's paintings have appeared. While this aspect of his iconography can be easily exaggerated and misconstrued, there can be little doubt that Bosch was learned in such matters and that he made much use of manuals such as *The Children of the Planets,* in which the influences of the planets and stars on man's temperaments and humors were explored. Pigler, for example, has demonstrated that the *landloper* is actually a child of the planet Saturn because of the secondary details of the painting. Lotte Brand Philip, in an elaborate article published in 1958, further related the Rotterdam tondo to three other Boschian themes (including *The Conjuror* and *The Cure of Folly*) that, according to her intricate analysis, would form an unusual ensemble bringing together representations of the four planets (Saturn, Luna, Ares, Sol) and at the same time incorporating attributes of the four humors (melancholic, phlegmatic, sanguine, and choleric) and the four elements (earth, water, air, and fire). One scholar, Anna Spychalska-Boczkowska, in a study of the astral symbolism of *The Garden of Earthly Delights,* even detects zodiacal configurations in Bosch's forms and compositions (for example, the Cancer formed by the elaborate fountain in the panel of the Garden of Eden).

Bosch was familiar with a more cancerous revolution breeding within society and the church body that took the form of secretive heretic and erotic cults that turned to black magic and witchcraft to draw in vast numbers of lower-class members of the Christian community. By the end of the fifteenth century these groups were apparently so evident and influential in northern Europe that a Papal Bull (1484) condemned them, stating that "many persons of both sexes, heedless of their own salvation and departing from the Catholic faith, have intercourse with demons . . . and by spells, incantations and other unspeakable crimes of excesses in superstition and sorcery corrupt and sterilize the foetuses of women and animals, fruits and trees. . . ." [1]

[1] E. Castelli, *Le Démoniaque dans l'art* (Paris, 1959).

For the most part these sects were anticlerical, inverting traditional patterns of religious ethics and behavior. Fraenger has written at length on the nature of the erotic cults, which he believes were viewed as positive forces in society by Bosch. Erotic rituals were commonplace, according to Fraenger, with secret rites fashioned to reinforce their belief in mystical union. Their leaders announced new methods for attaining true bliss and natural salvation. Often they gave themselves suggestive names such as the Brothers and Sisters of the Free Spirit, and their members saw themselves as Adamites, the true descendants of natural man, Adam and Eve, before the Fall. True paradise could only be experienced by indulging freely in the creative impulses originally endowed by nature. One whole school of scholarship, initiated by Fraenger, claims that the painter himself was a member of such a group and that his paintings were mysterious cult images created for their chambers whose iconography was devised by some ingenious Grand Master. However, all of the known facts of Bosch's life as well as the iconography of many of his more traditional works discredit this interpretation of his art, although there is no reason to doubt that Bosch alluded to such cult practices in his pictures of man's degradation and corruption as *exempla* par excellence.

● ● ●

It is obvious that none of the above explanations provides us with the complete answer to the inner meaning of Bosch's art. De Tolnay, Fraenger, and Praz, among others, have probed deeper into the psychology of his art and regard him as a unique genius in art history, whose paintings anticipate in many ways the illusive visions of modern Surrealists. Praz writes that Bosch was "the first spark of that bonfire, Salvador Dali," and he lists other Surrealist writers and painters who seem to have been indebted to him for models and inspiration. Freudian symbolism can hardly be discounted in his art. It is interesting that the American master of erotica, Henry Miller, in describing a watercolor he had executed with a horse standing before mountains in a cemetery, attributed his inspiration to Dante, Spinoza, and Bosch; and the painter Clovis Trouille made repeated use of the motif of the nude girl sprawled beneath the satanic throne from the Hell panel of *The Garden of Earthly Delights*. In a recent article (1971), G. Moray has linked

Miró's imagery to Bosch, and *The Temptation of Saint Anthony* by Flaubert is very likely linked to the master's triptych as well. Other examples could be cited, and it is not surprising that Bosch, along with Arcimboldo, Fuseli, and Goya, often appears in the general backgrounds to histories of surrealism or in the prefaces to exhibitions of surrealist paintings (cf. the retrospective of 1947, Galérie Maeght, Paris, listing Bosch among *les surréalistes malgré eux*).

In his famous essay, "What is Surrealism?" André Breton discounted any continuity of such a Surrealist tradition, arguing that the visions of contemporary artists "can in no way be put on the same level as the imaginary beings born out of religious terror and escaping from the more or less troubled reason of a Jerome Bosch. . . ." [2] One might question Breton's statement, however, and, in a more general sense, agree with Wallace Fowlie, who writes that "Baudelaire and Bosch would agree with the surrealists that much of man's inner life is composed of caverns, fearful, guiltful nightmares, which must be explored, and whose projection in art is a liberation of the human spirit." [3]

Among the myriad hybrid and fantastic creatures and objects that fill Bosch's paintings, many fuse into surrealistic *trompe d'oeil* images of even larger monsters. They become conglomerate heads, and sex organs that evoke the spectra of nightmarish fears, and hallucinations that suddenly become manifest in concrete, realistic objects. The application of modern methods of Freudian psychoanalysis and Jungian depth psychology could surely be of much value in interpreting Bosch's "macaronic" works, those that reveal the "inner" man as Sigüenza states, but so far these attempts have been arbitrary, and it is questionable whether even one properly versed in the methodologies of both psychology and art history will ever be able to unravel these secrets of his paintings.

Whatever romantic conceptions we may have of his surrealism, Bosch must be studied first of all as a sixteenth-century Netherlandish artist who responded in an incredible fashion to the psychosis of his turbulent times. Unlike Salvador Dali, Max Ernst, or Joan Miró, who often played tongue-in-cheek with dream visions that had been more or less codified by Freud, Bosch worked in a

[2] André Breton, *What is Surrealism?* (London, 1936).
[3] Wallace Fowlie, *Age of Surrealism* (Bloomington, Ind., 1963).

totally different manner, with a totally different intent. He fashioned his surrealism in the context of a definite religious iconography, and his images, although spontaneous and archetypal, have to be seen as parts of the pattern of traditional religious compositions, albeit they may fit like pieces of a jigsaw puzzle that seems impossible to solve. It is in this juxtaposition of the traditional Christian iconography and the personal dream imagery of his mind that we encounter a disconcerting conflict in his art. His obsession with the theme of the Temptation of Saint Anthony is surely no coincidence. The horrifying monsters and grotesque creatures that close in on Anthony from every side were hallucinations of the sort in which Bosch could give full vent to his imagination. But even here one must finally admit that the resources for interpretation are too limited to open that inner door with the key Panofsky hoped we could find.

One final thought along this line. Delevoy suggested that Bosch's dreams might have been induced by drugs: "Dare we assume that the painter resorted to some phantasmogenic drug so as to give free rein in his subconscious self and attain one of those 'abysses of the psyche' to which Henri Michaux had access under the influence of mescaline?" [4] Delevoy then describes a witch's pomatum of the sixteenth century that induced a deep sleep that brought forth weird, satanic creatures and spooks flying in and out of the netherworld of the mind. It is hardly likely that Hieronymus Bosch took recourse to any such stimulants. His compositions are carefully planned and his craftsmanship is much too exacting and detailed to have been created under the spell of such stimuli.

• • •

It is in the interpretations of the early Spanish historian Fra José de Sigüenza, cited above, that one finds some of the most penetrating analyses of Bosch's paintings. After dispelling doubts in the reader's mind about the piety in Bosch's works, Sigüenza goes on to describe three basic categories of subject matter treated by Bosch. The first comprises traditional devotional themes from the life of Christ. The various paintings of the Temptations of Saint Anthony make up the second category. Here innumerable monsters create

[4] R. L. Delevoy, *Bosch* (Cleveland, 1960).

endless fantasies in order to confuse and disturb the soul of the pious saint. The "macaronic" works—which he links to that genre of Italian literature—form the third category of themes. Within this third group, with no apparent or easily recognizable subject matter, Fra José takes particular delight in discussing, as examples, *The Haywain* and *The Garden of Earthly Delights* (which he called *The Strawberry Plant*).

One might question Sigüenza's judgment of the first category, the traditional devotional themes, as being free from any weird or unusual additions, since the very picture he cites, *The Adoration of the Magi* (very likely the one in the Prado, Figs. 3–5), is a most unusual interpretation of that theme. When the wings of the Prado triptych are open we view a vast, panoramic landscape that stretches across all three panels in a manner that anticipates the landscapes of Patinir and his Antwerp followers. A bright light floods the panels, bringing the foreground figures into sharp relief, with the main scene devoted to the Adoration of the Magi. It has been pointed out that certain details of this representation depend on works by Jan van Eyck and the Master of Flêmalle, but on closer inspection a number of curious features can be discerned that are not at all common for this traditional theme.

The hut itself is of strange construction, with Mary and Jesus moved far to the right and curiously isolated in a fragile porch supported by flimsy wooden posts. Joseph is missing. He appears in the far background of the left wing, crouching in the corner of a ruined palace drying diapers. Shepherds, rather menacing in appearance, climb about the roof of the stable, and the ox and ass, usually prominently displayed behind the crib, are nearly lost in the darkness of the hut; only the huge head of the ass is really visible, with his nose just touching the post beside the lap of Mary. But more curious than these details is the group of sinister-looking men standing in the doorway staring intently at the Virgin and Child (Fig. 4). They are led by a diabolic figure, bearded, half-naked, who wears a strange metallic crown of thorns and carries a curious inverted funnel. A plastic-like bandage covers a wound on his right ankle, perhaps indicating that he is a leper. Sinister touches appear in the landscape, too. Still another unusual feature of the triptych is the subject matter of the outside wings: the Mass of Saint Gregory (Fig. 5).

These details cannot be explained away easily although most scholars are in general agreement regarding their meaning. The most striking addition, the man in the hut, although identified as Adam by Fraenger, is usually seen as the Old Testament Messiah (Isaiah 53:3–4), a prefiguration of the new Messiah, Christ. Lotte Brand Philip, however, identified him more precisely as the Antichrist, who represents the forces of evil on earth. The strange hut has been interpreted variously as the humble abode of Christ's Nativity (De Tolnay) and as the Old Testament synagogue (Philip). The shepherds crawling about the stable have generally been identified as the bad shepherds referred to in the parable of John (10:1), and there is also general agreement concerning the baleful overtones of the landscape, with its familiar Boschian elements of dancing peasants, the brothel of the White Swan, and acts of violence in the right panel, where a bear devours a shepherd while a wolf chases a maiden along a distant road. It has been pointed out that the retinues of the three kings in the distance of the central panel appear to be armed bands approaching each other as if for combat (Philip), but that episode is not new with Bosch.

Two different interpretations have been given Bosch's Epiphany Altar. De Tolnay sees a positive message in it, with the essential theme that of a liturgical act involving the offering of the gifts by the magi. The key to this interpretation is found in the unusual representation on the reverse, the Mass of Saint Gregory, the story of the miraculous vision of the Transubstantiation of the bread and wine into the body and blood of Christ that Gregory experienced during a Mass. For De Tolnay the interior also represents the Mass. Mary is the altar; the first king, Balthasar, is the priest officiating; the other magi are his acolytes. It is well known that the Adoration of the Magi did serve as a special theme for the Mass, particularly in the Latin West, where the Epiphany was from earliest times a major feast of the Christmas cycle. In support of De Tolnay's theory are the attributes associated with the three kings. Before the kneeling Balthasar is a gift with a metallic representation of the Sacrifice of Isaac, the Old Testament type for the Sacrifice of Christ, the very event associated with the Eucharist. Melchior, the second magus, wears an elaborate collar with embroidered representations of two other Old Testament scenes. Along the lower border is the rare theme of the Sacrifice of Manoah (Judges 13:15), another type for

the Sacrifice of Christ, and above it is the depiction of the visit of
the Queen of Sheba to Solomon (I Kings 10:10), a well-known type
for the Adoration of the Magi, the very theme of the altarpiece.
Finally, Caspar carries an orb with a relief of the Three Heroes
bringing water to David (II Samuel 23:15), another type, repeated
in such manuals as the *Speculum humanae salvationis,* for the
Epiphany. Thus the two themes, the Crucifixion of Christ and the
Adoration of the Magi, could refer to the liturgical feast of the
Epiphany and the Eucharist of the Mass. For De Tolnay, the picture
presents us with a liturgical act wherein the fulfillment of the Old
Testament promise of a Messiah is realized in the Incarnation of
Christ.

While agreeing with De Tolnay in some details, Lotte Brand
Philip interprets the altarpiece in a totally different fashion, argu-
ing that it presents a threat and warning for mankind. Her proofs
derive from more complex and erudite sources, mostly Jewish leg-
ends, and the reader should consult her essay for these arguments.

• • •

The second category described by Sigüenza includes the rep-
resentations of the Temptations of Saint Anthony. Sigüenza con-
cludes, after a brief but vivid description of them, that they were
meant to demonstrate that one who has faith in God cannot be
diverted from his quest for salvation no matter what fantasies and
temptations may be cast before him.

The triptych in Lisbon (Figs. 9–11) is typical of these pic-
tures. The altarpiece, probably destined originally for an Antonine
Hospital, displays a panoramic vista of the earthly world under the
devastation and torment of the forces of the devil, with a view of
a desolate sea in which ships sink to the left, a fantastic city laid
waste by plunderers and peasants to the right, and, in the central
panel, a holocaust at night with an eery village in flames and a
sulphurous and phosphorescent sky filled with insect-like creatures
in battle. Seen against this uncanny background are episodes in the
life of Saint Anthony. In the left wing the saint, collapsed in ex-
haustion from his ordeals, is carried back to his hut by three com-
panions. The right panel depicts the temptations of gluttony and
lust that harassed the saint while he desperately attended the scrip-
tures. In the central panel Saint Anthony kneels in prayer within

the confines of his ruined abode on the Nile. Here, at night, he is attacked from every side by weird forces of evil and glances back directly toward the spectator. The lesson of his perseverance in this moment of violence is undoubtedly the point Bosch wished to convey.

Many of the textual sources for the altarpiece have been uncovered by Bax. Bosch probably drew heavily from the biographies of the saint in Voragine's *Golden Legend* (Dutch edition, Gouda, 1478) and the *Vaderboek* of Athanasius (Zwolle, 1490), although these texts by no means account for all of the details. Aside from Sigüenza's straightforward account of the Temptations, at least three other interpretations have been given it. De Tolnay and Praz see it as some dream world of Freudian hallucinations that beset the saint during his solitude, and as such Bosch's painting would anticipate the visions of more contemporary Surrealist painters. For De Tolnay these hallucinations are mostly sexual in symbolism and innumerable details support his theory. For Pigler and Cuttler the key, once again, is astrology. Cuttler sees here a *summa* of fears overlaying pessimism engendered by planetary influence, the didactic presentation of the Seven Deadly Sins, and the general tenor of the apocalyptic doomsday. He further points out that Anthony was born under the sign of Saturn and thus predestined to a life of torment but that he nevertheless was able to overcome the evil effects of the planets and the temptations of the devil through his steadfast faith in Christ. Combe writes that the essential feature of the painting is the symbolism of alchemy that appears for the first time in Bosch's representation of Anthony. Only in light of alchemistic symbolism, Combe continues, can the central core of this theme make sense and assume its proper significance in Bosch's *oeuvre*. All authorities seem to be in agreement concerning the general pessimistic tone of the picture: the world of man is filled with evil and violence.

Bosch's message in the *Saint Anthony* triptych clearly goes far beyond any simple narrative of the lives of saints; however, the side wings are easier to interpret in terms of textual sources. As Bax has shown, the iconography of the right panel depends largely on the biography by Athanasius. The nude temptress and the hag behind her pouring wine from a pitcher very likely represent the legend of Anthony's encounter with the Devil Queen. Anthony met

the Devil Queen when she was bathing nude in a river. She be-
friended him and took him to her city, where she performed many
miraculous deeds. The Queen then propositioned Anthony, and
after he refused her she accosted him and tried to disrobe him.
After a long and fierce battle with her legions of demons, Anthony
emerged triumphant. The major temptation in this panel would
thus be one of lust. However, the sin of gluttony is just as obvious,
with the bizarre table of gluttony set to entice him away from his
meditation. All about him are symbols of gluttony, including the
stomach pierced by a knife in the lower right corner and the dwarf-
ish man within a walker above him to the right who carries a jug
and who probably represents the childishness that man is reduced
to by overindulgence in drink. The flying fish, a symbol of the devil
according to Cuttler, is ridden by a fat man carrying a pot on a long
pole, another allusion to the temptations of gluttony harassing the
saint.

The left wing is more complex. It shows Anthony's companions
carrying the weary saint back to his hut after the ordeal. Bax and
others see a self-portrait of the artist in the figure leading the group.
They cross a bridge under which a sinister clerical figure reads from
some unholy scriptures to two bestial companions, perhaps refer-
ences to the corruption of the church. On the icy waters a strange
bird wearing a funnel for a hat skates with a note stuck to its beak.
An inscription, hardly decipherable, is perhaps an allusion to the
sale of indulgences, and other references to the corrupt practices of
the church appear in four hybrid creatures dressed in clerical dress
to the right and in the strange fish-grasshopper-church to the far left.
However one reads these details, the emphasis on the sins of the
church and the clergy, when compared to the more obvious refer-
ences to lust and gluttony in the right panel, indicates that Bosch
was here attacking the perversion of certain factions of the church
that had strayed too far from Anthony's model of asceticism. The
depiction of the saint carried aloft on the back of a monstrous bat
and the combat of the merman and the catfish boat are no doubt
hallucinations of erotic desire as De Tolnay and others have sug-
gested.

Any narrative elements of the central panel are smothered
beneath a wild nightmarish panorama, a veritable Witch's Sabbath,
in which the saint finds himself accosted from every side by gro-

tesque and unholy forces. It is a seething night scene, with a burn-
ing city lighting the sky. One could identify it as that of Anthony
at prayer in his abandoned fort beside the Nile, as the biographers
describe it, but aside from the lonely saint and his hidden chapel,
where Christ appears standing to the side of an altar, the texts
explain little of what we see here. It is as if Bosch wished to spell
out the disintegration of the corrupt earthly world that his own age
inherited, a world beset with every type of depravity and evil known
to mankind from the beginning of time. Cuttler believes that the
Seven Deadly Sins are cloaked in the various groupings of the
composition, but because of Bosch's unpredictable imagery they
cannot all be identified in the traditional manner. De Tolnay de-
scribes the panel as the "world under the spell of the Evil One,"
and while the plethora of fantastic and frightening creatures can be
interpreted as the hallucinations of the dark night of Anthony's soul,
there seems to be a cataloguing of all corrupt strata of society on
earth, from the peasants to the clergy to the nobility.

The most conspicuous of these partake of the so-called Black
Mass just above Anthony on the platform of the ruins. De Tolnay,
and most other scholars following him, see the hatchet-faced man
wearing a headpiece of serpents as the magician or false priest; the
woman in white acts as his attendant, while the negro to the left
enters carrying a paten with a frog holding the false host in the
form of an egg. The idea of a "Black Mass" of false clergy is further
underscored by the disgusting trio standing beside the podium to
the right. The main figure, a priest, reads from a text inscribed on
dark blue parchment and seems to instruct two hybrid companions
in his magic lore. His corrupt and sterile teaching is underscored
by the rip in his vestments that allows us to view his body, a bloody
skeleton with viscera. Finally, to complete the unholy communion,
a female temptress kneeling beside Anthony offers a dish of wine
to two figures, a nun and a man with no torso. Cuttler (1957), ex-
panding some ideas of Pigler, sees this group differently. For him
the figures about the table are derived from those in the deceitful
gaming tables depicted in astrological prints of *The Children of the
Planets,* specifically that of Luna (whom he identifies as the lady
in white), which would surely be appropriate for the nightmarish
setting of the picture. He further attempts to identify the very
source of Bosch's iconography as a set of prints of the *Planeten-*

kinder engraved in Florence in about 1460. According to Cuttler, other prints in this series were used by Bosch for details such as the bridgelike prison and the old woman seated on a rat among the curious band of mounted figures in the lower right. This group has been interpreted by Bax as a clever inversion of two Christological scenes, the Flight into Egypt and the Adoration of the Magi, although he gives no convincing reasons why Bosch should have utilized these motifs in this context. To me this group represents the sterility and corruption of the noble classes, with the mockery of the hunt and the archaic Burgundian costumes. The Queen mother, encased in the dry tree of sterility, cradles a dead heir in her arms.

The curious tower that rises behind this last group is particularly eye-catching. De Tolnay correctly identified the scenes on it, from top to bottom, as: Moses receiving the tablets of the law (a type for the coming of the Holy Ghost), the worship of the golden calf (heresy), worship of the monkey (heresy), and the emissaries of Hebron carrying the grapes (Baptism), and he describes them as shadowy images of the hallucinations within the mind of Anthony. Cuttler, correctly I believe, interprets the tower and its representations as the ruins of the Old Testament, with its incompleteness and errors, contrasting with the modest but sacred chapel of the New Testament where Christ stands so inconspicuously.

For Combe, as mentioned above, the central panel is rife with symbols and images of alchemy, and he particularly emphasizes the motif of the egg, the crucible in which the philosopher's stone is brewed, and the lurid configurations of fire and water, sulphur and mercury that make up the elements of this art. For Delevoy the theme of fire in this panel is important for understanding Bosch's expression since, from a psychoanalytical view, fire is a symbolic subconscious image of sin and destruction. If one wishes to wipe the slate clean or radically change the status quo, he subconsciously resorts to fire.

• • •

Sigüenza's third category includes those paintings that he classified as "macaronic" after the genre of literature invented by the Italian Teofilo Folengo (under the name Merlin Cocajo, 1491–1540), which featured burlesque compositions in which regional vernacular vocabularies were mixed with Latin and hybrid words

for bizarre effects. Sigüenza was living at a time when Spanish literature itself experienced one of the most individual styles to develop in the sixteenth and seventeenth centuries. Gongorism, named after the Cordovan poet Don Luis de Góngora (1561–1627), displayed a predilection for obscure language and symbol, generally Latinized, filled with extravagant and abstruse figures of speech that could be appreciated by only those few participating in the *cultos* of that art. Obscure references and symbols abound, with the use of puns and plays on words evoking images that can only be described as general ideas and not concrete statements. Thus Sigüenza approached Bosch's art from a rather unique aesthetic background; that he should place such works as *The Haywain* and *The Garden of Earthly Delights* in the tradition of such genre is very significant for the history of Bosch scholarship.

The Haywain is interpreted by Sigüenza in a rather straightforward fashion (cf. that of Morales in the essays) that hardly corresponds to the concept of "macaronic" as it is understood today. But the second work discussed at length, *The Garden of Earthly Delights* (Figs. 12, 13, 14, 15, 16), gives us a clearer idea of what Sigüenza meant by the term.

The three panels are unified by a continuous landscape. Except for the right panel, the colors are light and bright, dominated by soft pastel hues that evoke the sensation of some frivolous dream world. The effect is much like that of a tapestry—one copy in tapestry survives in the Escorial—featuring countless episodes of lovers engaged in amorous acts of every sort, picnicking, dancing, swimming, in a panorama of sensuous delights. The central panel, in fact, has the fragrance and lusciousness of an aphrodisiac, and Bosch, in a sense, seems to be singing a hymn of praise in honor of sensuous pleasures. De Tolnay summed it up as "an encyclopedia of love and at the same time a representation of the sweetness and beauty of mankind's collective dream of an earthly paradise that would bring fulfillment of its deepest unconscious wishes, while at the same time it shows their vanity and fragility."

The triptych is in the form of a Last Judgment. The left panel depicts the original garden of desire, the Garden of Eden, with God presenting the newly formed Eve to a bright-eyed and eager Adam. The landscape behind them consists of a pond with an elaborate fountain as the central feature and a variety of animals, birds, and

amphibians scattered in the softly rolling hills that rise into four complex mountain formations that are suggestive of nature's own sex organs. Nature herself seems to pulsate with life at this primeval stage and hybrid forms have already emerged from the ponds. It is perhaps significant that Bosch does not include the episodes of the Fall or the Expulsion (De Tolnay suggests that he intended to do so), but only the marriage of Adam and Eve.

The crisp morning landscape of Eden is transformed into a warm summer afternoon in the central panel. The ponds and lakes are still there, but now they are peopled by the countless descendants of Adam and Eve enjoying the full fruits of early maturity. The four mountain peaks are articulate, hybrid formations that seem to mark out the four corners of the world, each nourished by streams issuing from the broad lake that surrounds the giant metallic fountain. One further transformation should be noted. Scale seems to be inverted, with the plants and birds far larger than man, and in keeping with the fertile character of the setting there appears a superabundance of succulent fruits and ripe pods bursting open from their fullness.

The bright landscapes of the left and central panels abruptly change into a cold wintry wasteland in the right wing. Here, on a freezing night, a distant village burns with hellish sulphurous and phosphorescent flares against the dark purplish background. The ponds are now frozen, and the Fountain of Life of Eden is replaced by a parched Tree-Man, the image of death and despair, with its feet in boats caught fast in the ice. As Fraenger has shown, Bosch catalogues the major sins of society in this panel, with episodic references to the hells of knights, monks, the avaricious, the vain, the wrathful, etc. Below the Tree-Man the hell of musicians is represented by an unholy trio of performers literally crucified on their instruments, and dominating the lower part of the composition is the gruesome form of the bird-beaked Satan the Devourer, the counterpart to Christ the Creator.

Several interpretations have been given Bosch's *Garden of Earthly Delights*. With the exception of a few scholars, most have seen the triptych as an elaborate condemnation of the follies and sins of man totally given over to the delights of the flesh and the fate that awaits him in hell, where he must continue to indulge in these senseless activities forever while being prodded and tortured

by frightening demons who attack him from every side, never letting him rest. All things are inverted in the end. The delights become tortures, the warmth of summer becomes the freezing cold of winter, the afternoon sunlight is replaced by the pitch black of midnight, the fertile Fountain of Life is transformed into the empty, dry Tree-Man, and the creative principle, Christ, is replaced by the destroyer, Satan, who has an unending appetite and in whose bowels those who once rejoiced in earthly love now experience a weird marriage.

Friedländer and Baldass, among others, are content to interpret the triptych as a general apotheosis of sin, with its puzzling contents devoted to the curse of the flesh wherein God's creation seems to be thrown into utter confusion. Others have penetrated its meaning more deeply. De Tolnay's discussion of the central panel relies on psychoanalytic interpretation, "the collective dream of an earthly paradise," and he suggests that Bosch actually turned to ancient theories on the reading of dreams, citing Macrobius on Cicero's *Somnium Scipionis* and Vergil's statements that the substance of dreams is either of ivory (deceptive dreams) or horn (true dreams). De Tolnay describes the mountainous crags as horn-like in texture while the figures themselves resemble ivory figurines. He concludes that Bosch comes closer than any artist of his time to anticipating modern interpretations of sexual dreams by psychoanalysis (Freud) and depth psychology (Jung).

Cuttler has pointed out surrealistic images such as the rock with a man's face in the middle ground of the left wing and the pod that forms, along with human bodies, the image of a devouring head, a hell-mouth, which is located one-third of the way up the central axis in the central panel. For Combe the alchemistic tenet that sexual duality is the key and basis of all earthly evolution offers the proper interpretation of the triptych. He finds alchemistic motifs in the three-headed monster in the left wing and in the motif of the egg as well as the hollow tree in the scene of hell. Far more obvious, however, are the alchemistic devices scattered throughout the central panel. The lower group of revelers are disporting themselves in situations that, according to Combe, can only be related to alchemy, including the pair of lovers encased in the transparent globe, the alchemist's bridal chamber. The birds, for Combe, are the sublimations resulting from the search for the philosopher's

stone, while the background landscape, with its weird excrescences, shows the full participation of the mineral world in these all-embracing sexual activities, according to the tenets of the alchemists.

Along somewhat similar lines, astrology has been held the key to the inner meaning of the triptych. The most ambitious study of the astrological meanings is that of Anna Spychalska-Boczkowska. For her the symbolism is basically lunar, with the Fountain of Life in the left panel representing the zodiacal Cancer, the principal House of Luna, in the form of an inverted crab. Boczkowska concludes that the astral symbolism presented in the triptych actually provides us with a *terminus ante quem* for its execution. On June 6, 1504, the well-publicized *coniunctio aurea*, the conjunction of the Sun and Moon in the House of Cancer (along with Jupiter, Mars, and Saturn) occurred, and that event, for her, is the ideological concept of Bosch's painting. Boczkowska, in a startling inversion of the traditional reading of Bosch's triptych, rejects the pessimistic and sinful interpretation of the Garden, seeing it rather as a vision of Christ's paradise of the blessed, the *paradisus ecclesiae*. The most dramatic reversal in the interpretation of the central panel of the triptych, however, is to be found in the studies of Wilhelm Fraenger. In his analysis of the positive, blissful meaning of Bosch's work, Fraenger follows much different lines than those of astrology, emphasizing the mystical association of a more natural philosophy steeped in Pythagorean number systems and the symbolism of the alchemists. To begin with, the left panel of the triptych does not depict a corrupt and sinful garden of lust, but, to the contrary, an exotic fairyland that represents the earthly paradise wherein man, in his original state of innocence, follows nature in the pure instincts of life. While acknowledging the sexual symbolism of the landscape and the creatures, Fraenger argues that these acts are all part of the natural striving for some higher perfection. The spiraling birds represent man's birth and youthful ascent; the owl within the "Tree of Life" fountain is a symbol of meditation and inner revelation of the meaning and the conquest of death. The narrative in the foreground is not the Fall but the marriage of Adam to Eve, the first union of man and woman.

The central panel, which he calls the Millennium, represents for Fraenger a continuation and rebirth of the same state of innocence after 1,000 years as part of some Pythagorean renewal and

reincarnation. An entire cult ritual then unfolds, divided into sequences by the three divisions of the landscape. The initiation ceremonies take place in the lower zone, with the initiates gradually learning to enjoy the first fruits of their new innocence. This is followed by the triumphant ritual of love exemplified in the elaborate cavalcade of youths mounted on hybrid beasts prancing about the pool of virgins, and it culminates in the final sublimation of lovers in the far distance as they return to the natural elements at the conclusion of the cycle of life. Bosch's panel thus presents a grandiose *ars amandi*, with the alchemistic motifs of the wedding chambers in the form of nature's own crucibles and the act itself as the chemistry of true love.

Fraenger's analysis of the right panel is more traditional. He classifies the various sinners into groups: the hell of the four elements, the knights, the monks, the musicians, etc. For Fraenger this panel illustrates the fate of those who, in asserting their egos, stray from the innocent and natural union of nature, man, and God as it is presented in the Utopia of the central panel.

And how did such a painting come about? Surely, as Fraenger argues, no orthodox painter could have created such imagery. Bosch was, he continues, an active member of one of the secretive, heretical cults in the Netherlands that followed the tenet that true salvation could come only by returning to a natural state of innocence as it was with Adam and Eve in the Garden of Eden before the Fall. The cult to which Bosch belonged, Fraenger suggests, was the "Adamite" sect of the Brothers and Sisters of the Free Spirit, and he cites the details of a heresy trial against this group held in Cambrai in 1411 in which many of their erotic practices and mystical beliefs were uncovered. The Grand Master of the Free Spirits (whom Fraenger later identified as one Jacob van Almangien, a Jewish convert who belonged to the confraternity of Our Lady in 's-Hertogenbosch in which Bosch was enrolled) and his bride appear standing in the enigmatic cave in the lower right corner of the central panel on the morning of their wedding day. The setting is the "Cave of Pythagoras," which is fashioned as the transparent womb of the eternal Mother, with the shadowy form of Eve redeemed lying on its threshold dreaming. According to Fraenger, the Grand Master must have devised the entire program for Bosch since the only person capable of such esoteric imagery would be a "theologian of such

many-sided erudition that he could, in his biblical exegesis, make use of remote subjects like the secret language of alchemy and the numerological mysticism of neo-Pythagorean musicology." [5]

Fraenger and his followers have applied similar methods of analysis to several other works by Bosch, including the *Saint John the Baptist* (Madrid), *Saint John on Patmos* (Berlin), *The Marriage at Cana* (Rotterdam), *The Prodigal Son* (Rotterdam), and the Table of *The Seven Deadly Sins* (Madrid). The inversion of meaning by the learned Grand Master is always evident; the Table of the Vices becomes the Table of Wisdom, etc. It is not surprising that Fraenger's theories have been contested or ignored by a number of scholars. Bax (1956) has written a lengthy critique of Fraenger's studies, pointing out that his interpretations of numerous details in Bosch's paintings are erroneous and not properly related to the traditional literary and artistic vocabulary of Bosch's time. Furthermore, by reducing Bosch's role in the production of these highly imaginative works to that of a mere illustrator who follows the secret instructions of some learned Grand Master, Fraenger thereby greatly diminishes the stature of an artist who has always been considered to be of exceptional genius. Finally, Bax surmises, there is good reason to believe that the famous triptych was commissioned by some secular nobleman and not a religious group, orthodox or heretical.

The most damaging evidence against Fraenger's theory supports Bax's last point, and it is summed up by Steppe (1967) in his reconstruction from a number of documentary sources of the past history of the triptych. It now seems certain that the work hung in the Hotel of the House of Nassau in Brussels by 1517, one year after the death of Bosch. The triptych was briefly described by Antonio de Beatis when he visited the city in July of that year, and, as Steppe argues, it is very likely that the original patron of the triptych was Hendrik III of Nassau, who originally built the palace in Brussels. It was still hanging there when it was copied for tapestries for Antoine Perrenot, Cardinal of Granvilla, in 1566; it was apparently confiscated from the collection of William the Silent, Hendrik's heir, and taken to Spain by one Don Fernando of Toledo in 1568. It passed finally into the collection of Philip II in 1593 after the

[5] W. Fraenger, *The Millennium of Hieronymus Bosch* (London, 1952), p. 148.

death of Don Fernando. Thus, one of the most vexing questions posed by Bosch's enigmatic paintings—for whom were they commissioned?—can be answered at least in part. *The Garden of Earthly Delights* and other pieces like it were commissioned by learned secular patrons or members of the nobility and not for religious organizations, as long thought. Thus it would seem that Fraenger's ingenious theory of Bosch's activity and affiliations with the exotic sect of the Free Spirit, despite all of its romantic appeal, must be put aside for good. However, in the most recent monograph on Bosch (Reuterswärd, 1970) Fraenger's theory has found new support.

One important question remains concerning the triptych: what meaning does the representation of the Third Day of Creation on the reverse of the side wings have in the program? Within a thin transparent globe the earth appears as a flat plain seen as it was on the third day, with light and dark, water, firmament, dry land, and flora. The fish, fowl, beasts, and man have not yet been created, and for most scholars, the exterior represents the logical prelude to the inner left wing of the triptych, where the remainder of God's creations are catalogued. Fraenger sees alchemistic principles at work in the primeval act of generation on the exterior, with the crystalline sphere as the retort and the basic elements of earth, mist, and water as the ingredients of the chemical reaction. De Tolnay rightly points out that in this "pure landscape" the transient state of the world is already suggested in the strange forms of the rocks and vegetation along the edges of the land.

Recently Ernst Gombrich has written that the exterior actually represents the world after the flood, suggesting that the reflection in the sphere is that of the rainbow that served as a token of the covenant that God made with Noah after the ark settled on Mount Ararat (it is painted in grisaille). Turning to the interior, Gombrich interprets the central panel as a representation of the unchaste behavior of the descendants of Adam in the days of Noah before the flood, with the lustful acts and the oversized fruits accounted for in Genesis 6. Thus, for Gombrich, the triptych should be properly entitled *Sicut erat in diebus Noe* and not *The Garden of Earthly Delights*, which is too general.

Gombrich then cites two documents that list paintings on that subject by Bosch in early inventories, and he uses this evidence to

argue that the triptych takes on more reasonable meaning when related to specific biblical texts and their commentaries (Augustine, Petrus Comestor) than when explained on the basis of esoteric lore. Gombrich stakes his interpretation on the identification of the exterior as the world after the flood, and here he seems to expect too much of his reader. There is no ark, there are no corpses, and the "castles" that he sees in the distant landscape are actually stylized hill crests in the tradition of mannerist landscape.

However, even if one does not agree with Gombrich's identification of the exterior wings, his interpretation of the central panel does make sense. If viewed as a continuous historical progression, the four parts of the triptych constitute a meaningful sequence that illustrates the successive stages in the destruction of the world by God. The first signs of its corruption appear already in the third day of Creation; the second stage appears with the creation of Eve; the third, with the descendants of the first parents, who in the fertile antediluvian paradise gave themselves wholly to the delights of the flesh, eating, loving, and reveling (". . . and God said to Noah, the flesh of them all is come before me; for the earth is filled with violence through them; and, behold, I will destroy them with the earth." Genesis 6:11–13). The final stage, that of Bosch's own world, is seen in the apocalyptic holocaust in the right panel. Seen in this light, Bosch's triptych presents us with a meaningful historical sequence of judgments of the Lord against unchaste man and his world. Adam and Eve were to be cast from the Garden of Eden; Noah's descendants were to witness the destruction of the world in the flood; and Bosch's own world was about to experience the fearsome tortures and destruction of Doomsday, the apocalyptic Last Judgment. In Matthew's account of the Last Judgment Christ says, "But of that day and hour knoweth no man; no, not the angels of heaven, but only my Father. But as the days of Noah were, so shall also be the coming of the Son of man. For as in the days that were before the flood they were eating and drinking . . . until the day that Noah entered the ark, and knew not until the flood came, and took them all away; so shall be also the coming of the Son of man" (Matthew 24:36–39).

Thus Bosch's great triptych may be viewed as an ingenious elaboration on the theme of the apocalyptic Last Judgment. The cycle of history is complete in every respect, from the early spring-

time rains of the third day, through the summer fruition of life in the left and central panels, to the wintry death and desolation on the right. And not only has the cycle of nature completed its course, but the cycle of man has, too. He moves from the primeval earth and exotic paradise garden in the beginning to the ravaged urban world, both burning and freezing, in the end. For Bosch there is no return to paradise at the end of time. There is no heaven.

COMMENTARIES ON PAINTING

Felipe de Guevara

It is comical that nowadays there are painters so simple-minded that they think their works have much merit depending on how many days they have worked on them and others so stupid that they discredit their work as of no value if it were executed in just a few.

Some time ago there was a genre of painting called *Grillo*. Antifilo gave this type its name, painting a man and calling him *grillo* [cricket] for a joke. Antifilo was born in Egypt and learned this manner of painting from Ktesideno, and it seems to me to be similar to what we praise in Hieronymus Bosch, or *Bosco* as we call him, a painter who had an unusual predilection for painting figures of graceful form placed in strange situations.

While on the subject of Hieronymus Bosch I would like to inform the common folk, and some others who are less than common, of an error in their judgment of his paintings. Any monstrosities that go beyond the limits of nature that they see in painting they attribute to Hieronymus Bosch and thus make him the inventor of monsters and chimeras. I do not deny that he painted strange figures, but he did so only because he wanted to portray

"Commentaries on Painting" ("Commentarios de la Pintura"), by Felipe de Guevara (c. 1560); trans. by James Snyder (portions from W. Stechow, *Northern Renaissance Art 1400–1600*, Sources and Documents in the History of Art [Englewood Cliffs, N.J.: Prentice-Hall, Inc., 1966]). From *Fuentes literarias para la historia del arte español*, Vol. 1 (Madrid: F. J. Sanchez-Cantón, 1923), pp. 159–61.

scenes of Hell, and for that subject matter it was necessary to depict devils and imagine them in unusual compositions.

That which Hieronymus Bosch did with wisdom and decorum others did, and still do, without any discretion and good judgment; for having seen in Flanders how well received was this kind of painting by Hieronymus Bosch, they decided to imitate it and painted monsters and various imaginary subjects, thus giving to understand that in this alone consisted the imitation of Bosch.

In this way came into being numbers of paintings of this kind which are signed with the name of Hieronymus Bosch but are in fact fraudulently inscribed: pictures to which he would never have thought of putting his hand but which are in reality the work of smoke and of short-sighted fools who smoked them in fireplaces in order to lend them credibility and an aged look.

I dare to maintain that Bosch never in his life painted anything unnatural, except in terms of Hell or Purgatory as I have mentioned before. Granted, he endeavored to find for his fantastic pictures the rarest objects, but they were always true to nature; thus one can consider it a safe rule that any painting (even though provided with his signature) which contains a monstrosity or something else that goes beyond the confines of naturalness is a forgery or imitation, unless—as I said before—the picture represents Hell or a part of it.

It is certain—and anyone who has carefully looked at Bosch's works must realize this—that he paid much attention to propriety and always most assiduously stayed within the limits of naturalness, as much as and even more so than any fellow artist. However, it is only fair to report that among those imitators of Hieronymus Bosch there is one who was his pupil and who, either out of reverence for his master or in order to increase the value of his own works, signed them with the name of Bosch rather than with his own. In spite of this fact his paintings are very praiseworthy, and whoever owns them ought to esteem them highly; for in his allegorical and moralizing subjects he followed the spirit of his master, and in their execution he was even more meticulous and patient than Bosch and did not deviate from the lively and fresh qualities and coloring of his teacher. An example of this kind of painting is a table in the possession of Your Majesty, on which are painted in a circle the Seven Capital Sins in figures and examples; and while this is

admirable in its entirety, it is especially the allegory of Envy
(Fig. 17) that in my opinion is so excellent and ingenious and its
meaning so well expressed that it can vie with the works of
Aristides, the inventor of the paintings that the Greeks called
Ethike—meaning in our tongue pictures that have as their subject
the habits and passions of the soul of man.

THE PANEL OF CEBES

Ambrosio de Morales

The rest of the *Tabla* [Panel of Cebes or Thebes] is readily understandable since the author explains it in detail, so I leave this description to recall a painting (Fig. 6) which for our times is like an imitation of that of Cebes with the condition of the human state represented with much sarcasm and insight. The King, our Lord, owns this panel, an invention of Hieronymus Bosch, a most ingenious painter of Flanders. With subtle detail and skillful execution he painted the figures, and in the panel he shows us a panorama of our miserable lives and the great enchantment that we seem to find in its vanities.

For those who have not seen the painting, I will describe it so that they may, in some manner, enjoy it if only by my words. It is a large piece with three parts, the largest in the middle, the smaller panels to the sides. In the first of the smaller, on the right side where the sequence begins, the creation of the world is represented with the sin of Adam and the angel who casts him and his wife from the terrestrial paradise. It appears that the angel leads them from that panel (which represents the beginning of man's life) directly into the larger central panel where the activities of men who have come into our world, tainted with evil inclinations of original sin, are depicted.

"The Panel of Cebes" ("Tabla de Cebes"), by Ambrosio de Morales (1586); trans. by James Snyder. From "El Bosco y Ambrosio de Morales," A. M. Salazar, in *Archivo Español de Arte,* Vol. 28 (Madrid, 1955), pp. 117–38.

In the upper part of the larger panel, in the center, appears a very large wagon loaded with hay, resembling a tower, with a throng of people milling about it. This "wagon of hay," as it is called in Flemish, means the same thing as a "wagon of nothingness" in Castilian. So, as a wagon of hay, it is in truth a wagon of nothingness, a name most appropriate for it. The wagon is pulled by several demons who guide the driver, carrying the yoke, toward the third panel, where the ultimate departure from this world and life is represented. Atop the great load of hay, or nothingness, or vanity, are many youths and maidens leisurely seated; some plucking musical instruments, others dancing, and still others eating, drinking, and enjoying themselves in diverse manners. A devil making music with a hornpipe serves as their guide, while behind them kneels an angel, tearful and sad with his eyes and hands lifted toward heaven, bemoaning such great perdition as he prays to God in supplication and in tears.

Lower down, around the wagon, journeys an infinite and diverse crowd of people, who with incredible anxiety and persistence try to grab more hay and more vanity from the wagon. Some use hooks, others have shovels and other types of implements, and they wear themselves out grasping for the hay; others, with ladders, climb up frenzied to reach the top before more people arrive, and they try to take more than they can carry. One falls because of his heavy load, another snatches what someone has gathered by shrewdness and force, and one kills another in order to steal his hay away from him. And so these people go on, very satisfied, as if they were really acquiring some rich booty. They rush in order to be first to grab the hay, pushing others aside. Some, more brash, push forward, opening a path, and others collapse on the ground as the fury that drives them on is spent, only to be trampled on by those who survive.

Behind the wagon, in the principal and honored positions, ride the king and the princes, and they, as a clever warning by the painter, appear right next to the wagon, but because of their authority and importance, do not reach out to grab the hay, the vanity, as the others. Instead, with a marked seriousness, the king gestures for his servants to move ahead and fetch much hay for them all.

Further down are some who return with their bundles, con-

tented but very tired and sweaty. Represented here are the different types and estates of man, many of whom are engaged in fierce quarrels, some killing as they grab for a little more hay, vanity, nothingness from one another. Many run toward the wagon, agonized by the thought that it might get away or that the hay might run out. Parents take their children by the hand to show them the great riches, exciting them so that even they approach the wagon and eagerly carry away their own bundles, not content with what their parents fetch. Others pay much money to buy the hay that others bring back. There are so many details of this sort that it is impossible to describe them all, and there is really no reason for doing so. All of this ends abruptly as the demons guide the wagon into the final panel, where man's fate after this life is represented. Hell is characterized by the variety of tortures that the miserable souls, whose lives were passed in the vanity of sins, must now suffer, being themselves just like the hay that dries and dies away without the fruit of virtue.

HISTORY OF THE ORDER
OF ST. JEROME

Fra José de Sigüenza

Among these German and Flemish pictures, which as I said are numerous, there are distributed throughout the house many by a certain Geronimo Bosch. Of him I want to speak at somewhat greater length for various reasons: first, because his great inventiveness merits it; second, because they are commonly called the absurdities of Geronimo Bosque by people who observe little in what they look at; and third, because I think that these people consider them without reason as being tainted by heresy.

I have too high an opinion—to take up the last point first—of the devotion and religious zeal of the King, our Founder, to believe that if he had known this was so he would have tolerated these pictures in his house, his cloister, his apartment, the chapter house, and the sacristy; for all these places are adorned with them. Besides this reason, which seems weighty to me, there is another that one can deduce from his pictures: one can see represented in them almost all of the Sacraments and estates and ranks of the Church, from the Pope down to the most humble—two points over which all heretics stumble—and he painted them with great earnestness and respect, which as a heretic he would certainly not have

"History of the Order of St. Jerome" ("Historia de la Orden de San Jeronimo"), by Fra José de Sigüenza (1605); trans. by James Snyder (portions from W. Stechow, *Northern Renaissance Art 1400–1600*, Sources and Documents in the History of Art [Englewood Cliffs, N.J.: Prentice-Hall, Inc., 1966]). From "Historia . . . ," Part III, Book 4, chap. 17, in *Nueva Biblioteca de Autores Españols*, Vol. 12 (Madrid, 1909), pp. 635 ff.

done; and he did the same with the Mysteries of Redemption. I want to show presently that his pictures are by no means absurdities but rather, as it were, books of great wisdom and artistic value. If there are any absurdities here, they are ours, not his; and to say it at once, they are painted satires on the sins and ravings of man. One could choose as an argument for many of his pictures the verses of that great censor of the vices of the Romans, whose song begins with these words: "Quidquid agunt homines, votum, timor, ira, voluptas: / Gaudia, discursus nostri est farrago libelli. / Et quando uberior viciorum copia," etc., which, translated into our tongue, could be put this way by Bosch: "All of man's desires, dreads, rages, vanities, appetites, pleasures, satisfactions, discourses I have made the subject of my painted work. But when there was such an abundance of vices," etc.

The difference that, to my mind, exists between the pictures of this man and those of all others is that the others try to paint man as he appears on the outside, while he alone had the audacity to paint him as he is on the inside. He initiated this idea with a singular motive that I can explain with this example: poets and painters are birds of a feather in most everyone's judgment, with faculties that are such companions that only the brush and the pen separate them. And so their arts are the same thing; the subject matter, the intentions, the colors, the liberties, and other aspects have so much in common that only the formalities of our metaphysicians can distinguish them one from the other. Among the Latin poets there is one (and there is no other who merits the name) who—while he could not equal the heroic poetry of Vergil (although he was similar to him), nor the comedy or tragedy of Terence and Seneca, nor the lyrics of Horace, yet had the promise that might have ranked him with the foremost in literature—decided to forge a new path and invented a comic style of poetry that he called Macaronic, which was to display such skill, invention, and ingenuity that he would always be considered the prince and leader of this style. Thus all the quick-witted would read him, and the rest would not throw him aside, as he said: "Melegat quisquis legit omnia" (Let him read me who reads everything). It seems that because of his status and calling he was not allowed to practice this profession (he was a cleric and I'll not give his name here [Teofilo Folengo], because it was his secret), and he invented

a comical pen name, calling himself Merlin Cocajo, which fits well
with this aspect of his work as it did with another who named
himself Aesop. In his poems he displays with singular skill how
much good can be found in the most venerated poets, in moral
issues as well as in things of nature, and if I were to take on the
role of a critic here, I could show the truth in this matter by
comparing and contrasting many passages.

I am convinced that it is with the poet Merlin Cocajo that
Geronimo Bosch would have wanted to compare himself; not be-
cause he knew him—for I believe the painter did grotesque scenes
earlier than the author—but because he was inspired by the very
same thoughts and motives. He knew that he had a great talent
for painting and that in many subjects he did he had already been
overtaken by Albrecht Dürer, Michelangelo, Raphael of Urbino,
and others. Thus he embarked upon a new road, one on which he
would leave the others behind while he was not behind anyone
else and on which he would turn the eyes of all toward himself:
a kind of painting comical and macaronic (on the outside) yet
mixing with such jests many things that are beautiful and ex-
traordinary with regard to imagination as well as execution in
painting, now and then revealing how skillful he was in that art—
just as Cocajo did when he spoke seriously.

The panels and other pictures we have here may be divided
into three different categories. The first comprises devotional sub-
jects such as events from the life of Christ and His Passion—the
Adoration of the Kings and the Carrying of the Cross. In the former
he expresses the pious and sincere attitudes of the wise and virtu-
ous, with no monstrosities or absurdities; in the latter he shows
the envy and rage of the false doctrine that does not desist until it
has taken away the life and the innocence that is Christ, and here
one sees the Pharisees and scribes with their furious, cruel, and
snarling faces, who in their habits and actions convey the fury of
these passions.

Several times he painted the Temptation of Saint Anthony
(this is the second category of his paintings) as a subject through
which he could reveal singular meanings. In one place one ob-
serves this Saint, the prince of hermits, with his serene, devout,
contemplative face, his soul calm and full of peace; elsewhere he is
surrounded by the endless fantasies and monsters that the arch-

fiend creates in order to confuse, worry, and disturb that pious soul and his steadfast love. For this purpose he conjures up animals, wild chimeras, monsters, conflagrations, images of death, screams, threats, vipers, lions, dragons, and horrible birds of so many kinds that one must admire him for his ability to give shape to so many ideas. And all this he did in order to prove that a soul that is supported by the grace of God and elevated by His hand to a like way of life cannot at all be dislodged or diverted from its goal even though, in the imagination and to the outer and inner eye, the devil depicts that which can excite laughter or vain delight or anger or other inordinate passions. He made variations on this theme so many times and with such invention that it arouses admiration in me that he could find so much to deal with, and it makes me stop to consider my own misery and weakness and how far I am from that perfection when I become upset and lose my composure because of unimportant trifles, as when I lose my solitude, my silence, my shelter, and even my patience. And all the ingenuity of the devil and hell could accomplish so little in deceiving this saint that I feel the Lord is just as ready to help me as him, if I would only have the courage to go out and do battle. This painting is seen often enough. In the Chapter House there is one, another is in the prior's cell, two are in the Gallery of the Infanta, and in my own cell there is a fine one in which I sometimes read and lose myself.

In the chamber of His Majesty, where he has a bookcase like those of the monks, there is another excellent piece. In the center, in a circle of light and glory, he placed our Saviour; around Him are seven circles in which are seen the Seven Deadly Sins (Fig. 17), in which all the creatures that he redeemed offend Him without realizing that He is watching them and sees everything. In seven other circles he placed the Seven Sacraments with which He enriched the Church and where, as in precious vessels, he put the remedies of the faults and afflictions that beset man, and because he painted it as a mirror in which the truth of Christianity is reflected we might all see ourselves in it. Whoever painted this was not against our faith. There one sees the Pope, the bishops and priests, some teaching, others baptizing, and others taking confession and administering other sacraments.

Besides these pictures there are others, very ingenious and

no less profitable, although they seem to be more "macaronic," and these constitute the third category of his work. The concept and artistic execution of these are founded on the words of Isaiah, when upon the command of the Lord he cried out with a loud voice: "All flesh is grass, and all the goodliness thereof as the flower of the field." And on this theme David said: "Man is like grass, and his goodness thereof is as the flower of the field." One of these pictures has as its basic or principal subject a loaded Haywain (Fig. 6), and atop it sit the sins of the flesh, fame, and those who signify glory and power, embodied in several naked women playing instruments and singing, with glory in the figure of a demon who proclaims his greatness and power with his wings and trumpet.

The other painting has as its basic theme and subject a flower and the fruit of type that we call strawberries (Figs. 12–14), like those of the strawberry plant elsewhere called *maiotas,* which leaves hardly any taste behind once it is eaten. In order for one to understand his idea, I will expound upon it in the same order in which he has organized it. Between two pictures is one large painting, with two doors that close over it. In the first of the panels he painted the Creation of Man, showing how God put him in paradise, a delightful place full of greenery, as the lord over all animals of the earth and the birds of the heavens, and how He commands him as a test of his obedience and faith not to eat from the tree, and how later the devil deceived him in the form of a serpent. He eats and, trespassing God's rule, is exiled from that wondrous place and deprived of the high dignity for which he was created. In the painting called *The Haywain* (Fig. 6) this is more simply presented, and in the picture of *The Strawberry Plant* this is done with a thousand fantasies and observations that serve as warnings. This is all presented on the first wing.

In the large painting that follows he painted the pursuits of man after he was exiled from paradise and placed in this world, and he shows him searching after the glory that is like hay or straw, like a plant without fruit, which one knows will be cast into the oven the next day, as God himself said, and thus uncovers the life, the activities, and the thoughts of these sons of sin and wrath, who, having forgotten the commands of God (penance for sins and reverence of faith for the Saviour), strive for and undertake

the glory of the flesh, which is like the transient qualities of hay, short-lived and useless as are the pleasures of the senses: status in society, ambition, and fame. The Haywain, on which the Fame of this world journeys, is pulled by seven fierce beasts, frightening monsters, where one sees men painted that are half-lions, others as half-dogs, still others that are half-bear, half-fish, and half-wolf, all of them being symbols and embodiments of pride, lust, avarice, ambition, bestiality, tyranny, instinct, and brutality. Around this cart are all the classes of men, from the Pope, the emperor, other princes, down to those of the lowest status who do the most vile tasks of the earth; for all flesh is grass and the children of the flesh govern it all and they use any means to attain this vain and transitory fame. And all of this shows how fame is sought—some put up ladders, others use hooks, others climb, and still others jump as they look for methods and instruments in order to make their way upon it. Some who were already on it have fallen off, others are trampled under the wheels, while others are enjoying those vain honors and name. And the result is that there is no class or calling, no office, whether high or low, human or divine, that the sons of this century do not alter or abuse in order to attain and enjoy this glory of grass. All of them hasten, and the animals that pull the cart struggle because it is so heavily laden, and they pull hard to finish the journey quickly in order to leave their load and return for another, all of which is to signify the brevity of this miserable journey and how little time it takes to pass on and how similar all ages are in evil deeds.

The end and goal of all of this is painted in the last wing, where we view a very frightening hell, with weird storms and horrid monsters, all enveloped in darkness and eternal fire. And in order to demonstrate that there are not enough rooms for the crowd that enters, he shows them constructing new chambers, and the stones that are raised in the construction of the building are the souls of the miserable damned here transformed into instruments of their own punishment, the same that they used in order to attain glory. And in order to let it be known that even the worst sinners are never wholly forsaken in this life from the help and divine mercy—even in the act of sinning—one sees the guardian angel praying to God on behalf of those next to him atop the wagon who are engaged in sinful acts, and the Lord Jesus Christ,

arms outstretched revealing His wounds, awaits those who repent. I confess that I read more in this painting in one brief glance than in many books over many days.

The other painting of the vanity and glory and the passing taste of strawberries or the strawberry plant and its pleasant odor that is hardily remembered once it has passed is the most ingenious thing of great skill that can be imagined. And I tell the truth when I say that if one undertook this aim and someone of great talent described it, he would make a very useful book, because in this painting we find, as if alive and vivid, an infinite number of passages from the scriptures that touch upon the evil ways of man, for there are in the scriptures, in the prophets and Psalms, many allegories or metaphors that present them in the guise of tame, wild, fierce, lazy, sagacious, cruel, and bloodthirsty beasts of burden and riding animals that man searches for and converts for his pleasure, recreation, and ostentation by his inclinations and customs and the mixture that is made of one and the other. All is presented here with admirable likeness. The same applies to the birds, fishes, and reptiles, and others that fill the Divine Book. Here is also demonstrated the transmigration of souls that Pythagoras, Plato, and other poets who made learned fables of these metamorphoses and transformations displayed in the attempt to show us the bad customs, habits, dress, disposition, or sinister shades with which the souls of miserable men clothe themselves— that through pride they are transformed into lions; by vengefulness into tigers; through lust into mules, horses, and pigs; by tyranny into fish; by vanity into peacocks; by slyness and craft into foxes; by gluttony into apes and wolves; by callousness and evil into asses; by stupidity into sheep; because of rashness into goats; and other such changes and forms that are superimposed upon and built into human existence. And thus these monsters and fantasies are made for such vile and vulgar ends as for the pleasure of vengeance and sensuality, of appearance and esteem, and other such things that do not even reach the palate nor wet the mouth, but are like the taste and delicate flavor of the strawberry or strawberry plant and the fragrance of their flowers, on which many people still try to sustain themselves.

One could wish that the whole world were as full of imitations of this picture as it is of the reality and actuality from which

Geronimo Bosch drew his "absurdities"; for leaving aside the great beauty, the inventiveness, the admirable and well-considered treatment that shows in every part (it is amazing that a single mind can imagine so many things), one can reap great profit by observing himself thus portrayed true to life from the inside, unless one does not realize what is inside himself and has become so blind that he is not aware of the passions and vices that keep him transformed into a beast, or rather so many beasts. And he would also see in the last panel the miserable end and goal of his pains, efforts, and preoccupations, and how all is transformed in those infernal dwellings. He who puts all happiness in music and vain and obscene songs, in dances, in games, in the hunt, in feasts and ostentation, in domination, vengeance, and in the worship of his own holiness and hypocrisy, that one will see his counterpart in the same painting and that the brief joys are transformed into eternal wrath, with no hope or grace. I shall say no more about the "absurdities" of Geronimo Bosch except to report that into almost all of his paintings—that is, into those that contain this fantastic element (we have seen that others are simple and saintly) —he always puts a fire and an owl. By the former he gives us to understand that we must always keep in mind the Eternal Fire and that in this way all toil is rendered easy, as one can see in all those panels with Saint Anthony. And by the latter he wants to say that his pictures were done with great attention and care, and that with care they should be viewed. The owl is a nocturnal bird, consecrated to Athena and to study, a symbol of the Athenians, among whom flourished Philosophy, which one pursues in the quiet and silence of night, consuming more oil than wine.

THE LIFE OF JEROME BOSCH

Karel van Mander

Numerous and strange are the inclinations, the styles, and the techniques of painters, and he who follows the natural talents bestowed on him will become the better master. Who shall describe all of the awesome fantasies that filled the mind of Jerome Bosch and were put down by his brush, with ghosts and hellish monsters more often gruesome in appearance than pleasing? He was born at 's-Hertogenbosch and lived at a very early time, although I can not say just how long he lived or when he died. Nevertheless, his rendering of draperies and fabrics was quite different from the early manner of that time, which displayed many crooks and folds. He had a sure, rapid, and appealing style, executing many objects directly on the panel, which, nevertheless, remained beautiful without further changes. He had, as did other old masters, a manner of sketching and drawing objects directly on the white ground of the panel and laying over them a transparent, flesh-colored prime coat, and he often allowed the undercoats to contribute to the total effect.

Some of his works are in Amsterdam. Somewhere I saw a *Flight into Egypt* by him, with Joseph, in the foreground, asking directions from a farmer while Mary sits on the donkey. In the

"The Life of Jerome Bosch," by Karel van Mander (1604); trans. by James Snyder. From *Het Schilder Boeck* (*Book of Painters*) (Amsterdam, 1618), fol. 138v–139r; also published in Amsterdam in 1617 as *Het Leven der Doorluchtighe Nederlandtsche en Hoogduytsche Schilders*.

distance appears a strange rock formation in the appearance of an inn with strange things going on; there are also some odd figures paying money to watch a large bear dance. All of this appears unusually queer and jestful. Also by him, in a place on the Waal, is a scene of Hell [*Christ in Limbo*], from which the old patriarchs are delivered while Judas, thinking that he could join them, is pulled up by a rope and hanged. It is astonishing to see here all of the weird freaks and the clever and naturalistic way in which he executed the various flames and smoke. Also in Amsterdam there is by him a *Carrying of the Cross,* which is more restrained than his usual custom. In Haarlem, at the house of the art-lover Jan Dietringh, I have seen various works by him, including altar wings with some saints represented on them. Among them there was one of a holy monk in disputation with a number of heretics, all of whom cast their books into a fire. The one whose book could not be consumed by the flames would be proved to have the right faith. The book of the saint leaps up from the fire. The flaming fire was nicely painted, as was the smoldering wood covered by burning ashes. The saint and his companions appear in solemn stance, while the others have strange, grotesque faces. There is another piece of some miracle in which a king and others have fallen down and are in great fright. The faces, the hair, and the beards have been executed with full competence and ease. As in other places, his paintings can be seen in the churches of 's-Hertogenbosch, and in the Escorial in Spain are works by him that are highly esteemed.

THE WORKS OF
HIERONYMUS BOSCH IN SPAIN

Carl Justi

THE RELIGIOUS WORKS

The Prado Gallery received an important authentic painting from the Escorial that has had much influence on the revived appreciation of Bosch. *The Epiphany* (Fig. 3) was sent to Philip II from the Brussels collection of Jan de Casembroot and was placed in the *Iglesia vieja*. It is in the conventional form of a triptych, with the patrons and Saint Peter and Saint Agnes on the wings in a rich landscape setting seen from a high vantage point: The horizon is placed high up in the arch, while the figures reach only a third of the height of the panels. Mary, in a wide dark-blue cloak, has a high forehead, with a sober face that through its sullen indolence was perhaps intended to impart a sense of dignity to her but which adds little to her charm.

A number of curious details in costume, setting, and landscape are woven about this old core. The setting of the major scene is a ruinous, rustic frame house which occupies the entire width of the foreground. The damaged mud walls and thatched roof would make Ostade envious. In the courtyard Joseph is drying diapers. The rustic architecture contrasts with the exotic

"The Works of Hieronymus Bosch in Spain" ("Die Werke des Hieronymus Bosch in Spanien") (excerpted), by Carl Justi; trans. by James Snyder. From *Jahrbuch der preussischen Kunstsammlungen*, Vol. 10 (1899), pp. 120–44; reprinted in *Miscellaneen aus drei Jahrhunderten spanischen Kunstleben,* Vol. 2 (Berlin, 1908), pp. 61–93.

character of the surroundings, including the dress and gifts of
the Magi and the three strange fellows who look on from the
door. Even the most experienced archaeologist would be lost
trying to account for the wardrobe of these figures. Instead of the
usual coins on a plate, the gold offered by Saint Melchior is a
small chased or solid gold group, the Sacrifice of Isaac. Saint
Balthasar wears as a *mozzetta* a precious piece of Byzantine metal-
work in the form of a dome-shaped reliquary with the figures of
Solomon and the Queen of Sheba within arched niches. The Moor,
finally, holds a round silver capsule decorated with reliefs; on its
lid an enamel bird, perhaps of oriental manufacture, with a straw-
berry in its beak, spreads out its wings.

As the foreign princes approach the stable they are watched
by pilgrims of more modest origin, shepherds and bagpipers in
long hooded mantles, who follow on their steps. Since they must
remain apart from the audience for the illustrious company, they
satisfy their pious interests by peering through the holes in the
mud wall and by climbing upon the thatched roof and in the
barren tree.

Behind this unfolds a wide and hilly plain with copses and
a little river. From the sides hordes of Bedouins rush along. On
the left, a party on horseback comes to a halt, and a herald gal-
lops ahead towards the group on the other side about to pass
through the river. The grassy plain, dried during the tropical sum-
mer, with trees of mellow yellow-grey hues, reminds one of van
Goyen. The sun appears as a golden ball high in the sky, with no
rays of light.

The local colors, such as the red or slate-blue of the roofs
and the foliage, are bleached by the relentless light; the air is
very clear. In the background is an exotic city. Its topography de-
parts from the conventions of the locale, far from the towns of
Flanders and Brabant, in fact, far beyond Europe. Amid the sea
of houses rise large circular buildings, but they have no similarity
with the Cathedral of Aachen or Saint Gereon. They are fantastic
forms, with egg-shaped cupolas like thick-bellied Indian turrets, a
stepped cone on a cylindrical base, and a truncated pyramid with
covered platform. This was the period when the Far East became
known, and through Antwerp, the new gateway for overseas com-
merce, quaint reports of an ancient culture thrilled the Old World

that eagerly awaited such news. And so it seemed out of fashion to Bosch to embellish the narratives of the kings from the Orient with Burgundian court fashions or Brabantine townscapes. While he placed local people in the more serious passion paintings, he desired to add something of the flavor of the Orient to the wondrous infancy story. In spite of the episodic and marginal notes, this unusual painting does not lack coherence. In the technical sense it may be considered Bosch's most accomplished work.

PROVERBS AND GENRE PAINTINGS

Another page of his art is opened when Bosch presents us with popular folk scenes, satirical genre subjects, and illustrations to proverbs with marginal Flemish verses. They are usually painted in water color on canvas. Appreciated for their amusing content, for their numerous allusions and little witticisms, they were circulated as prints, but since these passed through many hands and were often attached to the walls of rooms and taverns, they are now very rare. So far no original paintings have been traced. In the sixteenth and seventeenth centuries a great number of them were still in the castle of Madrid and the Pardo hunting lodge. The inventories of Philip II and Philip IV list *The Blind Leading the Blind,* a work known through the prints of Pieter van der Heyden and the replicas of Pieter Brueghel, who made a whole chain of blind men from the original two. There is also *The Boar Hunt of the Blind.* Still others have been transmitted through the centuries through Brueghel's free reproductions. He also transmitted Bosch's light tonality (*peinture ultra-claire*). Furthermore, there were the *Flemish Dance* and a marriage, probably a peasant marriage, a *Lent and Carnival,* presumably that described by Vasari as a piece where Prince Carnival himself feasts and casts out Lent only to be repaid in the representation on the pendant. The *Judgment,* a large oil painting on canvas, shows a personification of Justice dragging a poor sinner to the place of execution while the wife follows on horseback. *The Witch and the Child,* the *Organ Blower,* and others are also known. There has been published recently by G. Glück a fine tondo of the prodigal son that one could well call a genre piece of *The Tramp* [the *Landloper*].

There is another oil painting in Madrid that is a tondo placed

on a black panel depicting a surgical operation (Fig. 2). In the foreground a man seated in an armchair next to a small table is seen against a landscape that slopes toward the right, marked off by light blue hills and illuminated by a soft light. The surgeon, standing behind the chair with knife in hand, is about to cut out an object that is in the patient's forehead. In his absentmindedness and eagerness he has cocked a funnel instead of a doctor's headgear on his head. The fear of the instrument of surgery weighs more heavily on the patient than the pressure of the object on the brain. A stout old man, tonsured and dressed in a blue cowl, holds a pitcher with some surgical balm or refreshment; he stands before the patient apparently reciting some words of comfort. An old woman, leaning with both arms on the table, looks on, with a medical casebook, over her head. This placement of the funnel, on the one hand, and the treatise, on the other, seems to suggest that the art of pharmacy and the wisdom of the book have given way here to the cold metal of the knife: *Quod medicamenta non sanant, ferrum sanat* [what medicines do not cure, the knife heals].

The painting was known as the *Picture of the Fools* (*la pintura de los locos*). Don Felipe de Guevara, who owned a copy of it in tempera, described it as the *Operation of Folly* (*cuando se cura de la locura*). Thus it is a performance envisioned for the surgeons of the future; incidentally, according to Swift, it had already been foreseen by a member of the Academy of Laputa who sought to reconcile the conflicting opinions of statesmen by exchanging parts of their brains. The same subject was painted by Jan van Hemessen in his rather crude fashion and later, with more humor, by Jan Steen and Frans Hals, with reference to the Dutch proverb "to cut the stone from one's head" (*jemand an den Kei snijden*), which means to cure one of his folly. On the black ground are the elegant golden words in verse:

> *Meester snijt die Keye ras*
> *Myne name is bibbert* [lubbert] *das.*

THE DREAMS

In all of these religious and profane works one sees Bosch on new paths in subject matter. Concerning the latter, Michiels stated that with them Bosch opens *le cortège des peintres moralistes,*

implying that he was the first painter of that genre, which until then had been known only in its marginal elements but not as a subject in its own right. Indeed, Bosch is at the very beginning of that ancient group of Netherlandish genre painters that includes Pieter Brueghel, Aertsen, Beukelaer, Metsys, and Lucas van Leyden.

In another group of works, the allegorical and satirical paintings, which are his most famous legacy, Bosch seems to turn back to the past for his content and form. These works were called his "dreams," *sueños de Bosco,* because of their haphazard and even wild combination of realistic elements that resemble dream images even though they were created with a calculating intelligence.

The realist thus transforms himself into the visionary. We find this change of temperament also with other observers of human folly—Callot, Teniers, Goya—artists who gained their reputations through their recording of the customs, feasts, and debauches of their times as well as their pictures of witches and devils. Indeed, realism and the grotesque spring from similar roots. Everyday realism requires the spice of humor, and the comic vein demands utmost precision in realistic detail: "it can not be colorful enough."

Often a small, realistic touch is enough to create a ridiculous effect in an otherwise serious picture, and the realm of nature is the true source for painters of the grotesque, since fantasy alone would produce only boring spooks.

The writers of earlier centuries, Sigüenza, Martinez, Baldinucci, P. Orlandi (in his *Abecedario*), suggested that Bosch sought out this gruesome wilderness since he had no hope of making it on the well-traveled roads of other artists. But evidently these things sought out and haunted *him*.

Four of these Dream pictures are known, and they are no doubt the most important of his works: *The Seven Deadly Sins* (Fig. 17), *The Haywain* (Fig. 6), *The [Garden of] Earthly Delights* (Fig. 12), and *The Temptation of Saint Anthony* (Fig. 9). The last one is in Lisbon; the others are in the Escorial [now in the Prado]. All are relatively small and in the form of triptychs with grisailles painted on the exteriors. Within this small format he compressed an endless wealth of details grouped about some main motif. They are variations on the theme of Evil, with the wings displaying the beginnings and the end and the main panel the conflict itself. Concerning each it has been said at one time or

another that a complete description would require an entire book and that he has concentrated in a small area, like a convex mirror, what others would expand into books. If Holbein had wished his *Dance of Death* or Sebastian Brant his *Ship of Fools* represented in a single panel, they would have had to ask Bosch to do it. He chose an appropriate form; the crowding itself produces a comic effect and the grotesque elements only work properly on a small scale. Only the old Flemish tradition with its precise, severe, hard, and bright-colored style could produce such effects; the art of projecting largeness onto a tiny area once more triumphs in Bosch's paintings.

The Seven Deadly Sins are painted on a table top (the Louvre has another such table picture with the story of David by Hans Sebald Beham, and there is another in the gallery in Kassel by an unidentified Swiss artist, which has the form of an astrological system displaying the idea of harmony based on the number seven in the planets, the liberal arts, and the virtues). In the Escorial Table Top we see the other side of the coin: the seven deadly sins according to moral theology.[1] This theme was also represented in a very different, theatrical manner in tapestries as a pompous triumphal procession. Such a series is in the Royal Palace in Madrid.

A circle of twelve scenes, linked only by the common program, appears before us. In the center of the panel shines a circle of rays within which the Saviour appears in a sarcophagus, his left hand raised in warning; below are the words *Cave, Cave, Dominus videt* [Look out, the Lord is watching]. Around the periphery is a broad zone divided into seven parts by radial lines that issue from the center; it contains seven representations of bourgeois life, a true mirror of burghers and peasants in everyday settings with no fanciful elaborations. Four take place in interiors, three in the streets. A peasant in the midst of overturned furnishings raises a long knife against a neighbor, while a courageous woman holds back his raised arm: Wrath. Another scene shows a nobleman with a falcon on his wrist walking along a street; a man carrying a heavy sack trudges ahead of him and peers back furtively; in a doorway and in the window of a stall are people ex-

[1] Now in the Museo del Prado, Madrid.

changing gossip. No one will doubt that Bosch intended to describe here how "envious looks sting the rich man." Don Felipe de Guevara praised this representation of an effect not easily painted, and he was reminded of Aristides of Thebes, the painter of the states of the soul and its suffering according to Pliny. These seven pictures are entirely in the character and style of popular drama. The situations that provoke the passions and the sins are rendered with only a few figures, without a Chorus, and with a restrained expression; Pride, for example, is represented by a single woman who, seen from behind, is busy preparing her coiffure. Outside the great circle, in the corners of the panel, are four small roundels; here are presented the days when man must face up to his accumulated moral debts: the Deathbed, Last Judgment, Heaven, and Hell. But these roundels are painted in the traditional religious fashion and look as if they were separated from the other seven scenes by a century.

Philip II held this work in special esteem; he had it hung in the living room of the Escorial, the same room in which was the alcove where he died. I saw it there still in February of 1873, but it has since been removed and made inaccessible.

The allegory of the Haywain has always been best understood, it seems; it is the triptych that was owned by Felipe de Guevara and that Philip II had transferred to the *Iglesia vieja* of the Escorial. It transfers the classical theme of the triumphal chariot to a homey, rustic setting. One can also compare the idea to Sebastian Brant's *Great Ship that transports all the Fools in the World;* Bosch, too, has depicted a Ship of corruption.

The biblical words, "All flesh is grass" (Isaiah 40:6), provided Bosch with the idea of representing the vanities of the world in the form of a harvest festival. He places us in a broad, charming landscape with a distant view over hilly country fresh and green and watered by rivers; on the right side, we see mountains and castles like those on the Rhine. A full, well-observed hay wagon is on its homeward journey. Just as in Leopold Robert's *Mowers of the Pontine Marshes,* there is a merry couple atop the wagon, the girl is singing from a sheet of music while the young man accompanies her on the mandolin; a guardian angel raises his hands in prayer; an odd personification of *Fama,* whose nose is turned into a trumpet, announces the harvest festival. In the foreground religious

women in nun's costumes are busying filling sacks of hay under the supervision of a fat abbot. An unusually elegant entourage for such a rustic festival follows the wagon: the leaders of the Christian world, led by the Pope, perhaps Alexander VI, the Emperor, the Electors all in their most noble finery. A true kermis cannot pass without its "broken bones," and so our procession does not lack the dramatic interest of a brawl, a fight for the hay. Several people, most of whom ought to be thinking only of the struggle for salvation, are trying to climb onto the wagon with ladders and hooks, tumbling, scrappling, and falling under the wheels. Finally, the team of seven monsters who pull the wagon leave no doubt that something is wrong here. The mood of the scene is thus "much ado about nothing," or follows the definition of the ridiculous as "folly shown in concrete actions and situations." The zeal and earnestness that should be directed to the battle of Good against Evil, Light against Darkness, are directed by the people here toward the senseless vanity of the world, rather than the real and serious problems of life. The evil barn, the goal (*paradero*) toward which the wagon is moving, appears in the right wing.

On the left wing, with the Garden of Eden and the Creation of Man, one spots immediately the fall of the rebel angels high in the heavens announcing the origin and beginnings of evil. It is treated differently here from the usual Christian battle of Titans. At first one might think that this represents the episode that took place on the fifth and sixth days of creation, when from the fruitful clouds the smaller creatures of the animal world descended to earth. On closer inspection one notes that along the parapets of the highest clouds (under the divine Majesty in an iridescent glory) are swarms of small angels in agitated, defensive positions against the swarm of odd creatures who are driven downward. These include scorpions, newts, crabs, and insects, species that were reduced to smaller scale following the bad times later on. Such creatures, according to Goethe, are, to be sure, part of the whole of creation and yet often turn our earthly paradise into a hell (the symbolism here is also derived from everyday experiences); according to Bosch's realistic notion they once made even heaven uncomfortable and were cleared out by the servants of the place during one big weekend cleaning.

When the wings of the triptych are closed, all demons and spooky symbols disappear, and breathing more comfortably we are

placed before a broad Brabantine landscape with a highway across the foreground. In the distance are reminders of the country life of that period, with peasants dancing to the tune of bagpiper and a traveler bound to a tree while bandits fall upon his baggage; in the distance, for our consolation and that of all respectable people, is the place of execution. A large peasant figure fills the foreground and hastens along the road, armed with only a stick. Probably the theme of the Haywain inspired this image of the peasant as the maker of hay. It is he who, in fact, provides nourishment for all these classes and gives them the time and means for all of their conflicts; in the distance we see him enjoying one of his harmless pleasures and experiencing one of those catastrophes that come along daily, particularly when those high-minded nobles are not able to pay their brave mercenaries to protect the countryside.

The strangest and most obscure of Bosch's allegorical-moralizing productions is a picture for which no one has been able to find a proper title (Fig. 12). The Spanish call it *Worldly Doings* (*el tráfago*) or *Luxury* (*la lujuria*) and the *Vices and their End*. The setting looks like a park that has gone to seed, with exotic plants and animals, a kind of earthly paradise that is accented by the costumes of its inhabitants. Here again Bosch has been inspired and his imagination stirred by the news of the recently discovered Atlantis and drawings of tropical nature there. One recalls that Columbus himself as he approached terra firma at the mouth of the Orinoco believed himself to have found the location of the biblical Paradise. One sees the same strange trees and strange fauna in other representations of Paradise. In the traditional prelude of the left wing, where newly created Eve is presented to Adam, the large tropical species are eye-catching: an elephant, a giraffe, a marsupial (?), and a unicorn. There are also flying fish, a kangaroo, a three-headed bird, and a giant lizard. In the background a strangely shaped water plant rises, its members consisting of parts of several species of cactus, agavas, and conchs; comparable to late Gothic decorative fountains, it sends forth jets of water, but also living creatures. This strange tree grows from a ball, a giant strawberry, a symbol of earthly desires. Probably it is meant to be a subspecies of the Tree of Knowledge.

Such formations, five in number and probably offshoots of the tree discussed above, form the crowning background of the main,

central panel. Before it lies a small grove of trees, a garden of Armida; a pond appears amid the bushes, around which circles a procession of riders, two or three beside each other, on panthers, horses, rams, bulls, lions, camels, bears, griffins, unicorns, and hogs. Groups of nymphs stand in the water enticing the riders. Thus it is a witch's parade, a ritual of some nature cult. In the foreground of the central panel, the scene becomes a luxuriant tropical marsh landscape. Fauna and flora grow here to colossal proportions: we see giant birds, giant strawberries, giant grapes. The nymphs seem to have achieved their purpose. Numerous large and small groups are scattered through this jungle where nature herself seems to partake in the lustful fantasy. She fashions curious bowers that provide shade and invite one to dreamy rest. Perhaps Bosch had read about houses made of palm leaves in the tops of trees. Some figures stroll through these wonders of nature, talk with the huge, intelligent birds, or take refuge from the heat in the water. Others have made themselves comfortable among the leaves of a giant agava or in ball-shaped structures like bird or wasp nests (some of which float in the water), conchs, coconuts, glass cylinders, and even in underground caves like the hidden dens of crickets. Finally one sees a gigantic marsh plant, a *victoria regia*, from which grows an apple, while in its transparent pod a couple has taken repose.

Who would dare to trace the labyrinthine ways of this moralizing painter's highly personal symbolism? Did he intend here to lay down his veiled philosophy of sensuality and to ridicule the reestablishment of its tenets as proclaimed by the Renaissance? The poets often took delight in placing the sensuous paradisiacal enjoyments in the lap of an equally drunken Nature whose vegetative processes overpower the spiritual essence. In the witch's cavalcade, Bosch wants to show how lust nourishes itself on all passions (here indicated by the animals) and how it is aroused by them. In *The Garden of Delights* he paints the eternal capacity of carnal appetite to adapt and change itself, animating the outer world with its fantasies.

The rehabilitation of the flesh has rarely ended well for those who adopt it; from the Elysian fields it is not far to Avernus and Solfatara, and the reader already anticipates what will follow in the inexorable right wing of the triptych. Indeed, Hell is the counterpart or antithesis of this magical garden. It is at one and the same time

black and dazzlingly illuminated with the discomforts of a coal mine or a laboratory. Perhaps it is only a Purgatory so that an interpretation more in accord with our humane understanding is possible: that here human nature is subjected to a process of purification during which those aspects of it considered evil are dissolved by heat and its elements are thus restored to their original purity. That this is no easy process is evident in the manifold procedures, as for instance the great glass retorts and distilling vats in which the sinners are attacked by a chemical means. Naturally, the punishment fits the crime: we see, for example, a man strung up on a large harp like Saint Lawrence on the grill; or a huge hurdy-gurdy turned by a monster whose sounding board becomes the penitential cell of the poor souls; one unfortunate is literally just an ear. It appears that hellish cacophonous sounds were known long before our time. Admittedly we think of the end of the world as being of another temperature since scientists have informed us, and we must believe them, that the world is destined to a freezing death. The old temperature was preferred by painters for they could not do without its effects of illumination, but here the last scene of the tragedy is lost in utter darkness.

Even more than in these allegorical and didactic pieces Bosch found "space for the beating of the wings" of his soul in a subject that from early times on had served as an entrance way for the grotesque in the church. The ascetic legend of the temptation of the patriarch of monasticism in the Theban desert, his battles "with the evil spirits under the heavens," this product of a region where even today people believe themselves to be constantly in the company of invisible creatures, *The Temptation of Saint Anthony* . . . is Bosch's best known and most popular work; he painted the theme many times and it was often copied. The best example is in the possession of the Royal Castle Ayuda in Lisbon; here the exterior wings are painted in grisaille with Passion scenes, *The Arrest of Christ* and *The Carrying of the Cross*. Each of the three panels has a central focal point about which the spooks revolve: in the major panel it is a banquet, the goblet being offered by richly appointed ladies, with musicians in attendance and a heretical priest officiating; to the right appears the temptation by a naked witch standing in the hollow of a tree; on the left the hermit is lifted into the clouds by evil spirits and, finally, the exhausted saint is carried back to his cell.

Those of earlier times were edified by this picture; moved by such a force of faith, they saw in it a fantasy about the twenty-first Sunday after Trinity (Ephesians 6:10 ff.): "We have not come to battle with flesh and blood but with the princes of this world who rule in the darkness of this world." Prior Sigüenza noted this. The lonesome form of the old man, who is attacked from every side by a world of demons as in Gogol's short story but who at the last moment finds the never-failing formula of exorcism, might be a portrait of our Hieronymus himself, whose intelligence and humor were solid enough for him to remain the master of his own demonic imaginings. Even the scenery could provide material for more than one painting: the burning city with the collapsing church tower, the volcanic mountain, the lake with the ghostly ship, the hill whose green surface covers a giant crawling on all fours, the ruined tower carved with reliefs in whose dark chapel the eternal light burns, the fortress walls crowded with hosts of armed men, the green meadows and wooded areas in between to provide visual relief. Such details of landscape are always depicted with a painterly delicacy unheard of at that time; Bosch's atmospheric effects often anticipate the Dutch masters of the seventeenth century.

Monstrous forms, combinations of abnormal members, parts of human and animal anatomy, of animals and plants, have always been used in decorative arts; they are, in fact, nearly as ancient as decorative art itself. Everyone is familiar with their role in Romanesque and Gothic architecture as well as in the Italian Renaissance. The name "Grotesque" dates from the time of these pictures. These Alexandrian-Roman and new-Italianesque grotesques differ from the mediaeval ones through the greater selectivity of the shapes, through the beauty of the component parts, and through the rhythmic flow of the combinations; their repertory is restricted to a narrow range of traditional forms: griffins and sphinxes, centaurs and satyrs. Is there a more charming motif than that of a youthful figure emerging from a flower? There is evidence in the biographies of some of the greatest Italian artists that the unbridled phantoms of the Northern imagination had an appeal for the South as well: Michelangelo copied an engraving by Martin Schongauer, *The Temptation of Saint Anthony,* the only subject of this kind among the works of the Alsatian master. His first sculptural work was a grinning satyr's head, and as a designer of ornament he always retained a liking for the grotesque. Vasari tells us about a similar

boyhood jest on the part of Leonardo which was a gruesome invention. Cranach, too, and Dürer in his *Knight, Death, and the Devil,* made their contributions to the field. It is apparent that the subject evoked much interest during this period.

In this genre Bosch was the most fertile and inventive, with his own system of shaping monstrosities. In combinations of the bizarre and ridiculous he far surpassed anything created before him, but in the details of his inventions he remained closer to nature than anyone else, and therein lies their unusual comic value. His representations of fishes and birds would do honor to any atlas of natural history, and one could apply to them the words of Viollet-le-Duc concerning a gargoyle in the Sainte Chapelle: "It is difficult to elaborate further a realistic study of a creature that does not exist." Yet Bosch's creatures always had an intellectual purpose instead of being mere arbitrary creations. He is especially humorous in his use of inanimate objects, such as products of handicraft, instruments, and vessels, to serve as parts of living beings or their costumes. There are iron machines that enclose animals and ships that are, at one and the same time, living marine creatures; beings that hide like hermit crabs in empty shells within a horse's skull or a pitcher. There are air ships in the shape of fish formed of thin vapor, anticipating our modern dirigibles, and there is an old woman who wears for her mantle and hood the trunk of a hollow willow tree.

HIERONYMUS BOSCH

Charles de Tolnay

In the triptych of *The Garden of Earthly Delights* in the Prado, in which the symbol reigns, Hieronymus Bosch does not rest content with pictorial and literary tradition, or with his own imagination, but, anticipating psychoanalysis, uses the whole acuity of his penetrating mind to draw from his memory and experience dream symbols that are valid for all mankind. But to him they are not simple phenomena of psychic automatism, nor the pure play of the mind. The artist is not dominated by his subject matter but himself dominates it with sovereign authority, and in his hands the symbols become instruments which he uses for his own purposes. The specific meaning he gives them becomes intelligible only in the light of his basic theme: the nightmare of humanity. Bosch is simultaneously the dreamer and the judge of dreams, actor and stage-manager in one person.

Within Bosch's work *The Garden of Earthly Delights* is the most perfect expression of the Late Gothic current. The small figures that fill the whole surface of the centre panel are arranged in the rhythm of a sumptuous decoration in keeping with the Flamboyant style and with the exuberance of a "thousand-flower carpet." Linked with the effect of the three superimposed but interconnected pictorial planes, peopled by these figures right to the horizon that

"Hieronymus Bosch." From Charles de Tolnay, *Hieronymus Bosch*, English ed. (London, 1966), pp. 30–33; trans. from French edition (Basel, 1937). Reprinted by permission of the author and the publisher, Holle Verlag Gmbh.

is set far up near the top of the picture, is the illusion of a mirroring depth, a *fata morgana,* in which light blue, pale pink and olive-green play in luminous soft reflections.

In the foreground idyllic groups of men and women with delicate bodies gleaming like white pearls ceaselessly form and break up around an axis composed of scarlet coral. Mingled with the human throng are animals of unnatural proportions, birds, fishes, butterflies and also water plants, giant flowers and fruits. Nothing seems more chaste than the love-play of these couples. But just like psychoanalysis, the dream books of the time disclose the true meaning of these pleasures: the cherries, strawberries, raspberries and grapes that are offered to the human figures, and which they devour with enjoyment, are nothing but the godless symbols of sexual pleasure. The apple-boat that serves the lovers as a refuge is reminiscent of the female breast, the birds symbolize lewdness and ignominy, the sea-fish lust or anxiety, the shell is the symbol of the female. Bosch here paints a striking picture of repressed desires.

The artist's purpose is above all to show the evil consequences of sensual pleasure and to stress its ephemeral character: the aloe bites into naked flesh, the coral holds bodies fast, and the shell closes upon them. In the Tower of Adulteresses, whose orange-yellow walls gleam with crystalline reflections, the deceived husbands dream amidst horns. The glass sphere in which a couple are caressing, and the glass bell that unites a sinful trio, illustrate the Dutch proverb: "Happiness and glass, how soon they pass."

The red arrow of the coral leads the eye to the middle plane of the picture where the eternal circus of the passions follows the labyrinth of pleasures. The human figures are frenziedly riding fantastic or real animals, which they hold back or spur on according to the rhythm of love. The cavalcade circles around the Fountain of Youth, in which young Negresses mingle with fair-haired girls of milk-white complexion. Swans, ravens, and peacocks, symbols of sensual enjoyment and vanity, settle on the heads of the bathers; some of them are wearing as a head ornament the pagan crescent.

On the uppermost plane the Fountain of Adultery rises in the midst of the Pond of Lust: a steel-coloured sphere with cracked walls bearing a crown made up of a crescent and horns of pink

marble, a glittering symbol of the heretical character of this sin and the dangers which it brings upon the world. The four Castles of Vanity, made up of plants, marble rocks, fruits and beads, gold and crystal, and peopled by acrobats and birds, tower up into the sky as monstrous blossoms of the absurd.

To an increasing extent master of his technique, Bosch makes the hollowness and fragility of transient things more and more palpably evident to us. He gives up the *alla prima* manner and models with a gentle chiaroscuro: flesh and marble are composed of the same living substance.

On the left wing the *Earthly Paradise* captivates by the purity and harmony of its colours. Bosch has utilized the knowledge of natural history current in his day to gather together, for the creation of Eve, animals, plants and minerals from the various regions of the earth. Everything in this peaceful garden seems to breathe serenity and innocence, but in reality it is marked with the stigma of unnaturalness and corruption.

The Eve whom the Lord is bringing to Adam is no longer the woman created from Adam's rib, but already the image of seduction, and the astonished look which Adam is giving her is a first step towards sin. The duality of the still pure man and the woman who carries within her the seed of sin is repeated behind them in the flora and fauna: the stunted palm, round which the serpent is coiled, standing on a curious orange-coloured rock, is opposed diagonally to the blossoming palm. A few spots spoil the pure picture of animal life: a lion is devouring a deer, a wild boar is pursuing a strange beast. Precisely on the axis of the composition there rises —neither plant nor marble—the Fountain of Life, a pink flower soaring Gothically upwards on the inky blue stones of a small island. At its tip it bears the scarcely visible sign of the crescent and in its core, like a worm, the owl, bird of misfortune. The four rocks that enclose this "botanical garden" on the horizon are tall, fantastic aviaries; with their bizarre shape and the symbols with which they are decorated they form a skilful introduction and transition to the Castles of Vanity on the central panel.

The panel showing *Hell* presents the third phase of the Fall. The earth itself has become a hell; the very objects that had been instruments of sin have become gigantic instruments of punishment. These chimeras of bad conscience, which enliven the night with

hallucinatory clarity, possess all the special significance of sexual dream symbols: vase and lantern, knife and skates refer to the two sexes. Out of the barrel-organ, the mandolin and the harp Bosch forms an orchestra of instruments of vengeance that draw their harmonies from men's suffering. The hare, which so quickly digests the sinner it has devoured, combines lust with the fear of death. The gigantic ears are omens of misfortune; the huge key hanging from a staff, to which it has been attached by a monk, betrays the desire for marriage, which is forbidden to the clergy.

In the centre sits a white monster. Its wooden clogs, "blue boats" of destruction, contain legs shaped like trees hollow to the bark, whose branches bore through its body, the broken shell of an enormous egg. Its lecherous idiot's head bears a platform on which demons and witches are leading unnatural sinners round a huge bagpipe, emblem of the male sex. An inn is let into its rump above which flies the banner of the bagpipe; a witch is serving the sinners seated at table. Apart from them, a corpulent man in the attitude of melancholy sits with closed eyes above the abyss; when we recognize in his features the face of Hieronymus Bosch, the whole picture appears in a new light: the artist himself is dreaming this dream, his soul is the place of the thousand agonies and the thousand torments.

As a synthesis of all destruction, the vision of the world dissolving in flames illumines with a ghostly light the dark night of the background. Enormous conflagrations, before which rise the silhouettes of ruins, disclose the spectral shapes of clouds and mountains; the rays of their yellow fires cross one another in a flickering interplay, like searchlights directed upon the hurtling hosts of souls and demons.

The universal meaning of this "Divine Comedy," which Bosch concludes with what is perhaps the finest fiery landscape ever painted, is directly expressed on the reverse of the wings where it is introduced by a definition of the universe. The theme is the "Creation of the World," for the representation of which the artist invents an essentially new iconography. The world, hitherto depicted as a little toy in the hand of God, covers almost the whole surface of these panels, and the small figure of the Creator, relegated to a corner, becomes of secondary importance. Bosch sees the universe as a transparent ball of glass in which reflections create

the impression of roundness; within its womb rests the primeval landscape of the earth with its fantastic flora, surrounded, according to the medieval conception, by a belt of water; a pallid gleam as of moonlight illumines this mysterious vision of a world in which man has not yet found his place. With this unusual representation of the universe Bosch introduces into the history of art what is, so far as I know, the first pure landscape. Just as bold as Leonardo in his decision to depict our world without human figures, he differs from the Italian in that he was content to evoke the poetry of enigmatic nature, whereas his Italian contemporary sought, beyond this, to reconstruct the genesis of our world.

HIERONYMUS BOSCH

Ludwig von Baldass

HIS IMAGE OF THE WORLD

Hermann Dollmayr pointed out as early as 1898 that the best hope of solving the problems posed by the subject-matter and contents of Bosch's pictures would lie in approaching them from the eschatological side, in other words by studying those concerned with the Four Last Things. But despite occasional references in mystery plays or friars' sermons, no direct connection has hitherto been found between late medieval eschatological literature (cf. articles by Wadstein, *Zeitschrift für wissenschaftliche Theologie*, Vols. 38, 39, 1895/96) and the works of the artist. But if we look closely at his *œuvre* as a whole his general outlook begins to emerge in coherent form. It is clear that he regarded the world he depicted as dualistic, based on the contrast between heavenly and infernal powers and subject to the menace of the Last Judgment awaiting it. Dollmayr was therefore quite right to begin his considerations of the artist's subject-matter with a reference to Zoroaster's doctrine of the conflict between Ahura Mazda and Ahriman. Bosch painted, in the last analysis, a paraphrase of the ancient Parsee philosophy, though he clothed it in the garb of late medieval Catholicism. Intensive study of his pictures leads to some recognition of his ideas

"Hieronymus Bosch." From Carl Linfert, *Hieronymus Bosch,* English ed., trans. Robert Erich Wolf (New York: Harry N. Abrams, Inc, 1960), pp. 83–93; trans. from German edition (Vienna: Anton Schroll & Co., 1943). Reprinted by permission of Anton Schroll & Co. and Harry N. Abrams, Inc.

of the world, its creation, the forces that act upon it and the passage of time into eternity, though hitherto few of the symbols through which he often expounds his meaning have been elucidated.

It is an altogether unique circumstance in the history of Western art when the whole attitude of an artist to this world and the next can be deduced merely from consideration of his works, especially when these have only survived in part. Bosch's general outlook was already formed when he began to paint, and it remained essentially the same throughout his entire career, extending over forty or more years: his views underwent a regular course of development, but only in detail. As time went on he showed the Devil under various aspects and often treated the same Biblical themes in different ways. But he never changed his basic vision of the world.

Its essence is already discernible in the table-top paintings. Christ is the world's centre. Deadly Sins infest the surface of the earth, but in the dark depths of space the Four Last Things bide their time. In precisely similar fashion the back of the Berlin wing sets the symbol of Christ at the centre of the world, while on its surface His earthly body suffers the eternal cycle of His Passion and the nocturnal space beyond is peopled by demons. This work expresses the most vivid contrast between the religion of Christ, who gave His heart's blood for the redemption of humanity, and the powers of Hell. The source of this dualism is shown by Bosch in his versions of the Creation story.

It is illustrated in detail on the left wing of the *Haywain* triptych; but the details do not correspond precisely with those in the text of Genesis, which does not mention the Devil and simply introduces the Serpent as an evil counsellor, subsequently punished by having to creep on its belly. The artist is more conscious of Zoroastrian dualism, which had already influenced Christian literature. The question of what books or other sources he consulted still awaits investigation. The Fall of the Rebel Angels is not referred to in Holy Scripture. The idea was only developed at a later period through the interpretation of a passage in St Luke's Gospel (10:18) and another in Revelations (12:9 ff.). These explanations were probably given after the early Christian era, as the Fall of the Angels is not represented in art before the Middle Ages. This episode is presented, in the wing under discussion, as a proceeding

followed by the descent upon earth of the devils, the Creation of Eve, the Fall of Man and the Expulsion from Paradise into the world occupied by the devils. The fact that Eve, contrary to the story in Genesis, becomes aware of her nudity and adopts the fig-leaf before the Fall takes place proves that, in accordance with the usual late medieval conception, the Tree of the Knowledge of Good and Evil has become a symbol of the recognition of sex, though this interpretation of the Tree is in direct opposition to God's command to the primal pair: "Be fruitful and multiply." This notion of the Fall of the Rebel Angels and the Fall of Man is supported by a passage in Revelations (12:12): "Woe to the inhabiters of the earth and of the sea. For the devil is come down unto you, having great wrath. . . ." As God the Father not only creates Eve but also appears, enthroned in clouds, above the Fall of the Angels it is clear that He permits, at any rate, these events to take their course.

Eduard Meyer, in the second volume of his *Ursprung und Anfänge des Christentums* (Stuttgart and Leipzig, 1921, page 79) formulated in the following uncompromising terms the decisive influence exercised by Zoroastrian dualism. "The dilemma is inescapable. If God is omnipotent and the only creator of all things, He also created evil, both physical and moral, including the spirits and human beings created by Him. In that case He would not be infinitely good, but as ruthless as Nature. Moreover, if the greatest wisdom is identical with the highest good, He cannot be infinitely wise. Alternatively, if God is infinitely wise, infinitely good and consequently infinitely merciful, He cannot be omnipotent. For these very qualities set limits to His omnipotence and, both physical and moral evil are to be attributed to a diametrically opposed power, hostile to Him from the start." Bosch seems to have been perfectly well aware of this dualistic element in Christianity, at any rate in the moral sphere, for it does not occur to him to question either the infinite wisdom of God or the suitability of the world for His purpose. The artist was evidently convinced of the Divine Omnipotence, as *The Garden of Delights* proves.

The triptych as a whole, with opened wings, shows how sin came into the world through the Creation of Eve, how fleshly lusts spread over the entire earth, promoting all the Deadly Sins, and how this necessarily leads straight to Hell. But when the wings are closed they illustrate the Creation of the World and its plants,

while at the top of the picture the Deity is represented with an open book and a verse of the psalm celebrating Jehovah's creative power is inscribed. It is obvious that in this case the outer and inner faces of the triptych form a unity as regards content and that the words quoted from the psalm refer not only to the earth and its vegetation, including the "plants of evil," but also to mankind with its activities and passions. "For he spake, and it was done; he commanded, and it stood fast."

The version of the Creation story painted on the left wing of the *Haywain* triptych was paraphrased on the left wing of the *Last Judgment* altarpiece. Only the wall of Paradise is missing. The Creation of Eve is transferred to the foreground. The scene behind, with the fox lying in wait for the cock, shows that in this Paradise not everything remains innocent, for peace does not reign in the animal world. There is a notable further alteration. As before, God the Father, a full-bearded figure holding the globe, is enthroned in clouds. Eve, however, is not now being created by a crowned and aged Almighty but by a youthful Christ, as also on the inside of the left wing of the *Garden of Delights* triptych. In that work God the Father as Creator is only visible on the outside of the wing and the Fall of the Rebel Angels is omitted. The centrepiece does not display any demons. The created world has grown sinful through its own agency. On the outer faces stone buildings, like fortresses, with pointed turrets, have already sprung up on earth. They reappear, with more mineral than vegetable substance, brightly coloured, in the central panel. In the middle of Paradise, as also shown in the *Très Riches Heures* at Chantilly, the Fountain of Life rises. In this connection the Tree of Life should be recalled, for the sake of which, in Genesis, man was driven out of Paradise "lest he put forth his hand and take also of the tree of life and eat and live for ever." The rose-coloured Fountain of Life is in this case not a symbol of the Saviour, as in the Ghent *Adoration of the Lamb,* but signifies heresy. It is occupied by the owl and decorated with the crescent moon of unbelief. Representation of the Fall of Man is no longer necessary. Mischief came into the world through the Creation of Eve alone and in this wing the world rather than the Garden of Eden is the subject. The Tree of Knowledge is either missing or has been placed on the extreme left and animals are depicted preying on one another. The overall composition of the work also en-

forced omission of the Fall of the Rebel Angels. In the centrepiece of the *Haywain* triptych the counterpart of God the Father presiding over that aerial conflict is provided by Christ as the Man of Sorrows appearing through clouds. In *The Last Judgment* Christ as Judge occupies the same position. The representation of the Saviour at a similar point above the Garden of Delights as composed by Bosch would unquestionably have been regarded as blasphemy.

The conceptions of the Creation of the World in the Eden wing of the *Haywain* triptych and of the Creation of Eve in the left wing of the *Garden of Delights* triptych differ only in degree, not in essence. It is basically of no consequence whether the devils took possession of the entire earth before the Expulsion of Adam and Eve from Paradise or whether the earth had been initially created evil, so that mankind had no need to yield to temptation by devils, human innate instincts being already sinful. In neither case could Bosch dispense with devils for his final effect in the depiction of Hell. The first alternative is not only the traditional one but also that evident in most of his works. Accordingly the undoubted change in his opinions may not have occurred until towards the end of his active period, as his then brighter and more varied palette also seems to indicate.

There is no need for any further surprise at the spread and domination of evil throughout an earth thus given over to the occupation of devils or one created, in accordance with the later theory, as a world of unbelief and heresy. Most men, on either view, exemplify this evil principle. They obstinately pursue selfish ends in thoughtless and unrestrained devotion to their passions. Evil sometimes appears in the seemingly harmless garb of folly or frivolity, but usually as Deadly Sin. The circle of Hell depicted on the table-top in the Escorial proves that not only commission of the Seven Deadly Sins but also that of other vices involves the penalty of Hell. The Seven Deadly Sins are therefore merely symbolic of the general sinfulness of the world. Not all of them are allotted equal space on the table-top. Anger has by far the most extensive area. It is placed, moreover, in the most conspicuous position, having the same front presentation as the five circular paintings, and is the only one of the seven others which exactly faces the spectator. By thus stressing this scene Bosch contradicted the medieval convention of regarding Pride as the chief vice. But though in this case

he made Anger the most dangerous of the Deadly Sins, he later changed his mind. In *The Haywain* Lust assumes the most important position, on top of the load of hay. It gives rise, in those wishing to participate in the carnal pleasure it typifies, to the other Deadly Sins. Furthermore, in *The Garden of Delights* the male perpetrators of these sins ride gaily round a group of women.

Although in the table-top Christ appears as the centre of the world, there is little trace on its surface of His influence. Occasionally a crucifix or a rosary hangs at the girdle of a sinner or one of such figures holds a prayer-book. But they are only giving lip-service to Christianity. Their hearts are not in it. As a rule the mendicant friar is the only representative of official religion, which can no more prevent people from sinning than secular justice can stop theft and fraud, robbery with violence and murder by erecting the gallows and the wheel. The bad example of monks and nuns, who are quite given over to mundane pleasures, adds to the growing prevalence of sin. For they associate with buffoons and jugglers, who in their turn are on the way to becoming wizards and witches.

Bosch's renderings of everyday life in his pictures of the follies of this world and of the Deadly Sins, as well as in some of his panels dealing with the life of Christ, for instance in the backgrounds of the Madrid *Adoration of the Magi,* are completely free from social or political implications. In strong contrast with the literature of the day Bosch makes only two references, in the mounted figures of the *Haywain* centrepiece and those of the resurrected in the Munich fragment of a *Last Judgment* respectively, to contemporary history, social rank or ecclesiastical and secular dignitaries. Nor does the symbol of a burning church, discernible in the backgrounds of several of his pictures, imply any criticism of the spiritual leaders of the time. It simply calls attention to the threat constituted by the general sinfulness of mankind to the continued existence of the Church of Christ. For the most part Bosch regards people as all alike, so much so that in his last great allegory they are all dipicted naked, naked as they will be in Hell.

His consideration of human conduct made him a prophet. He thus met a common requirement of his day (cf. J. Rohr, *Über die Prophetie im letzten Jahrhundert vor der Reformation,* in Vol. 19, Bonn, 1898, of the *Jahresbericht* of the Görres-Gesellschaft). But Bosch's prophecies, as distinct from most of those made both

north and south of the Alps, are wholly non-political. Unconcerned with the future of this world, whether in connection with the approach of Antichrist or millenary anticipations of universal peace, they dealt entirely with life after death. He shows a world already turned into Hell by the imminence of the Last Judgment. Devils and demons have acquired complete control over the bodies of sinful human beings and subject them, while still on earth, to the torments that await them in Hell. In that age even art often concentrated upon eschatological phenomena, such subjects as the Art of Dying, the Dance of Death, the Apocalypse and the Last Judgment. Bosch's outlook was more closely related to that of the various fifteenth-century artists who illustrated the Dance of Death than to that of Dürer in his apocalyptic works. The pessimism, for instance, evident in all Bosch's paintings, is still more clearly expressed in the visions of his contemporary and compatriot, Denis the Carthusian, where it is shown in latent form throughout his dealings with subjects high and low, sacred and profane.

The contrast between Bosch's extremely vivid and imaginative ideas of the behaviour of devils on earth and in Hell and his relatively insipid depictions of the bliss of Paradise is not surprising. He was by temperament more prone to visualise the aspiration of the resurrected dead to the radiance of eternity than to conceive their actual residence in Paradise. But copies suggest that he did paint at least one picture of a world restored to the condition of Paradise after the Last Judgment. The copy as a whole makes the impression of a representation of the Garden of Delights with altered symbols. For the rest, it is intelligible enough that an artist convinced that very few of the resurrected would ascend to Heaven after the Last Judgment would only be interested secondarily in the illustration of their celestial joys.

The idea of the earth as a stage abandoned to the unrestrained activities of demons or as actually created evil is fundamental in Bosch's thought. It also conditioned the way in which he illustrated the life of Christ, whom he regarded as the world's centre, and the truths declared by the gospel of the Catholic Church. He depicted the birth of the Infant Christ into a world of unbelief as contemporaneous with the crossing by Antichrist of the threshold of the New Testament. He proceeded to portray Christ's actions on earth, with diminutive devils already venturing into His presence.

Finally he showed the sufferings of the Saviour, with their appeal to human pity, in the midst of a sea of hatred and callous indifference. True Christians, like Christ Himself among His tormentors, have subsequently to endure persecution by demons. Patience and constancy alone enable mankind to resist such afflictions and temptations.

This basic idea, colouring the whole of Bosch's general outlook, explains several other aspects of his art. As he is concerned to depict the world at large, there are no chief figures, no heroes or leaders, in his great allegories of *The Haywain*, the centrepiece of the Vienna *Last Judgment* and *The Garden of Delights*. Nor is any special prominence given, in the Hell pictures, to a principal Devil or master of the infernal regions. Where such a personage is represented at all, as in the *Hell* wing of the Vienna *Last Judgment*, other giant demons are made much more conspicuous. The point seems important for the understanding of the artist's mind. He only occasionally portrayed, as in the Rotterdam wing depicting demons, the actual realm of Satan; for the most part he simply showed the destiny awaiting the great majority of mankind. Yet at the same time his general outlook forbade him to deal emphatically with personal traits in the individuals he painted in action. They were not, in fact, for him, individuals, but representatives of humanity.

Every item in his pictures contributed to the effect of the work as a whole. Consequently, all irrelevant, incidental details were suppressed. His delight in storytelling was deliberately and firmly guided into perfectly definite channels. Concerned as he was with a rendering of the world at large, his human figures seldom seem to exist in their own right, but only as personifications of passions and vices. It was inevitable, therefore, that they should so frequently look, especially in the three triptychs mentioned above, like actors on the stage.

Bosch's ambition to present in his pictures a pattern of the world led him into symbolism rather than the production of true allegory. The Old Testament scenes he depicted on columns, the armrests of thrones and the robes of his figures appear not only in such subjects as the childhood of Christ but also, strangely enough, in his paintings of episodes from the lives of the saints, who had already achieved salvation. The Old Testament stories are not illus-

trated for their own sake but as prefiguring parallel texts in the New Testament. In the same way beasts, plants and even inanimate objects have a symbolic meaning which is the only reason they are included in the work. The artist's imagination goes still further, creating from miscellaneous details, for the sake of their symbolic significance, new forms of life such as demons and "flowers or fruits of evil." The items are thus all interrelated: each stroke of the brush is subordinated to the effect of a total view of the world.

It is peculiarly characteristic of Bosch's general outlook that his vision is based not upon this world but the next, being governed absolutely by the negative medieval attitude to life, not the affirmative temper of the ensuing age. The fact is all the more striking on account of the artist's uncommonly perceptive eye for the pictorial attractions of his earthly environment and ability to impart coherence to his landscapes. Yet Bosch took no interest in nature for its own sake. It acquires character in his works only when the Devil sets "plants of evil" in it or man the gallows and wheel. The activities of demons and the follies of humanity, always associated, stamp their common seal on all existence.

The physical objects studied by Bosch, or the figments of his imagination which appear in his paintings were accordingly introduced into his work for the sake of the inner significance he believed them to possess. This procedure, too, was medieval. Every image was considered from a moral and teleological standpoint, and it was not depicted for its own sake but either on account of the gospel text it was supposed to embody or because it carried a reference to eschatology, to the Four Last Things. The idea of a profane art, not involving moral judgment, such as that of modern times or even of the Renaissance, was not recognised by Bosch.

His attitude to human folly, for example, proves the point. People are foolish because they take more interest in mundane affairs, especially sensual pleasures and ignoble lust for gain, but also in thoughtless frivolity which he typified by dancing, than in the salvation of their souls. The garb of folly is a superficial dress which most men are in fact obliged to wear. Even the professional Fool behaves more modestly and decently than monks and nuns. Human folly, too, is therefore regarded by Bosch *sub specie aeternitatis*, from the standpoint of eternal salvation. Spiritual and profane matters are not yet considered separate concerns, as they are, for

instance, by Erasmus of Rotterdam. The latter, a compatriot of Bosch, younger by a generation than the artist, was able to publish his *Praise of Folly* in Bosch's lifetime, though it is true that this delightful work celebrates the frivolity of everyday life, not the sinful form of folly. Erasmus took an entirely mundane view of his subject, in spite of being a doctor of theology and an orthodox Catholic who dealt often enough with purely spiritual matters. The contrast between the two men mainly illustrates that between their generations. Bosch remains completely absorbed in the pessimistic view of life current in the late Middle Ages. He sees everything in the light of the approaching Last Judgment and can thus detect and demonstrate, in his strange and powerful visions, the close connection between folly and sin, which are so often indistinguishable. On the other hand the humanist Erasmus, one of the leading spirits of the early sixteenth century, separates earthly from heavenly concerns and can therefore smile indulgently at circumstances which would elicit from Bosch only moral condemnation.

It is a remarkable fact that profane art developed so much later in painting than in literature. The Western plastic arts, even taking the Bayeux Tapestry into consideration, produced hardly any contemporary work to rival the lyrics and epics of chivalry at their climax in the thirteenth century. It was not until the fifteenth that paintings of non-religious subjects could compare in feeling with the creations of pious sentiment, as happened in the Netherlands with the picture of the Arnolfini betrothal [van Eyck] and those executed for courts of law. Bosch's representations of human folly cannot be regarded, owing to their content, as secular. They have little in common with paintings of the Seasons, which have no moral interest, though such works did influence Bosch in a formal sense. In his subjects he stood much closer to the German engravers who preceded Schongauer. He was inspired by religious or rather by both religious and ethical views of society. His pictures do not describe, but preach and are therefore medieval in spirit. Such an art could not of course arise until the end of the Middle Ages, when the rebirth of a sensibility to environment enabled artists to devote themselves sincerely to reproducing the beauties of nature. The representations of human folly, however, indicate a reaction against this kind of sensibility. The very art, therefore, which made use of every liberating technical device accessible in

that period remained completely medieval in the subjects treated and consequently confined to a limited set of ideas.

Unique in the history of art, the outstanding feature of Bosch's achievement as a whole, which was so long misunderstood, is the coherence and lucidity of his conception of the world, manifest in every painting he produced. Such qualities are only to be found in the true spiritual leaders of humanity.

HIS PLACE IN THE
HISTORY OF ART

Today Bosch's place in the cultural history of his time can only be conjectured. His paintings and drawings all convey the same view of life, of the world and of the relation of mankind to the supernatural. The extent to which he took over this conception from others or developed it himself is unknown. It is only clear that he acquired it as a consistent whole. Nor can it be assumed that all his works were produced for patrons of like mind. Consequently the general outlook implicit in his works cannot be explained as due to the orders of clients, except in the case of the rare devotional pictures.

Bosch's fundamental outlook on life was thoroughly pessimistic. In his opinion people were both foolish and wicked, since at bottom the one adjective implies the other. Individuals, he considered, indulged their passions without restraint and their passions led them into Deadly Sin. During this same sixteenth century an identical idea was expressed by the Swabian chronicler and collector of proverbs Sebastian Franck. Rudolf Stadelmann in his *Vom Geist des ausgehenden Mittelalters* (Halle, 1927, page 244) has pointed to Franck's favourite image of the "blinkered horse" as significant of a fatalism past all hope or relief. He complained that his contemporaries were as deaf to advice as to warnings, to offers of help as to threats. They were like the frightened horse that rushes blindly and incessantly in any direction once taken. "He ignores every attempt at persuasion, till they are dashed to pieces. Let none utter a saving word. The holy oil shall not avail, nor the baptismal rite, to charm such unheeding serpents."

Bosch had already illustrated Franck's words, depicting the universal folly of all men and how "they are dashed to pieces," in other words consigned to Hell. The idea of predestination is nowhere unmistakably defined, but obtrudes itself irresistibly. The pessimism is absolute and perceives no ray of alleviation. It is highly significant that in the centrepiece of the Vienna *Last Judgment* the earth itself has become Hell and, overpopulated as it is, can no longer show one just man. This detail alone reveals even more plainly than the eschatological literature of the last phase of medievalism the despair which had invaded the best minds of the epoch.

Bosch presents his theme dispassionately. His sermons in paint constitute primarily a mirror for mankind. The mature works make their points so unemotionally that they can hardly be described as satirical. Nor is any definite view of the order of society evident: no particular class is attacked more than another. Even the friars are no more severely criticised for their worldly behaviour than was quite usual in the late Middle Ages. Since the artist considered the folly and malice of humanity to be universal, his figures in contemporary dress are only rarely developed to the extent of providing them with any trace of individuality, such as can be detected in his Rotterdam *Vagabond*.

People being in his opinion all alike in their folly and wickedness, he seems to have thought it not worth while, as a rule, to give such close attention to their individual features as would be required for a portrait. Similarly, objects in the environment of his human figures were only regarded as important in so far as they characterised the actions of the persons depicted. Such objects were never painted by Bosch for their own sake, as they had been, for instance, by Jan van Eyck. This indifference to the pictorial values of inanimate objects is the most convincing proof of the medieval affiliations of Bosch's art. They only disappear in his treatment of landscape, for here he was concerned to indicate his view of nature as more than a decorative and incidental scene of action. He regarded landscape as the uncontaminated and inviolate work of the Creator, chiefly affected by mankind in the erection of the gallows and wheel. He was more interested in sinners in Hell than in living men and more still in his devils and demons, including

the witches and beggars who provided such rich material for his imagination as an artist. Even his landscapes are animated, when they include "plants of evil," by demons.

His work is full of symbols. It should be borne in mind that in the late Middle Ages thought and feeling were very commonly expressed in this way. The crescent moon, the owl, the swan, the magpie and the toad, to mention only the most frequent symbols in Bosch's pictures, are clear signs of the unbelief and subjection to the Devil of the persons associated with them. In his mature and late works symbolism is carried to such lengths that the spectator tends to look for the underlying idea which every single object painted might be intended to express. In addition to symbols of human folly and sinfulness Bosch of course introduced those of Christianity, such as the pelican and unicorn, designed to recall some specific truth of the Gospels. His subjects are accordingly replete with hidden references which have to be brought to light in order to obtain a clear notion of the view of life implicit in the work. Huizinga in his *Waning of the Middle Ages* rightly called symbolism the instrument through which the medieval mind worked.

Bosch, more than any other visual artist of his time, was in the habit of seeing all things in significant relation both to one another and to eternity. Huizinga remarks that everything capable of formulation in thought was given visible form. It was then highly unusual for a painter's work as a whole to illustrate a general moral outlook so comprehensively. No parallel in art to Bosch existed north of the Alps in his day.

It is characteristic of the deep pessimism evident in all his works that the artist should have turned away from the life about him and considered it entirely evil. There is probably some connection between such an attitude and the tendency to archaism apparent in certain of his paintings, his return to the idealism of International Gothic or the style of Rogier van der Weyden. Bosch could not find in contemporary art the sublime aspirations, symbolically expressed, to elucidate the meaning of truths enunciated in the Gospels. He therefore tried to assimilate a style more firmly rooted in idealism, through which colour, for example, enhanced the significance of the subject by not only simply decorating it but

actually explaining it. Unfortunately only inadequate information is available as to the colour symbolism employed in the Middle Ages (cf. Wackernagel, *Kleinere Schriften,* Vol. 1, Leipzig, 1872).

Bosch's world seems to modern eyes one of unrelieved lack of faith, folly and Deadly Sin. The exaggerated emphasis on sin in ethical doctrine reappears in the theology of the last phase of medievalism, exemplified by a compatriot of the artist, Denis the Carthusian. According to Huizinga (op. cit.) this "last of the scholastics" was concerned to exacerbate to the last degree, by descriptions calculated to inflict the anguish of guilt, the terror of sin, death, judgment and Hell. This procedure led to the increased belief in devils which remained rampant, in the form of countless trials for witchcraft, even in the first centuries after the Reformation. The reformers had taught that the power of the Evil One was in effect absolute. Satan did not manifest himself, they affirmed, so long as people obeyed their natural sinful impulses and consequently entered upon the broad path to Hell without the Devil's assistance. He only appeared, either as one individual or many, when Heaven took steps to deprive him of his prey. But demons mainly persecuted the saints, on their retirement from the world in the hope of overcoming evil by an ascetic, solitary life of meditation and prayer. Nothing could be clearer than this picture of medieval dualism, the two spiritual poles referred to by Huizinga (op. cit.).

Bosch's imagination turned so readily to the contemplation of symbols that he soon grew dissatisfied with the late medieval conception of an anthropomorphic devil, mainly human, with only a few features borrowed from animals. He invented new demons, composed wholly of symbols. He represented again and again broken, hollow eggshells, withered branches, skeletons, empty or leaking pitchers and waterlogged craft in association with symbolic beasts and single parts of the human frame, such as feet, hands and ears, of exaggerated size. Both protective armour, particularly helmets, and aggressive weapons, of which arrows, knives with notched blades and hammers occur especially often, also contribute to his effects.

As a painter he is remarkably reluctant to provide explicit illustration of the teaching of the Gospels, preferring to represent it

by symbols and concise renderings of corresponding passages from the Bible. His sacred personages have a dignified but also modest aspect, as though the terrible load of evil that oppresses the whole world prevented them from allowing free development of their characters. On the other hand the tolerant attitude of pious persons under persecution is always most vividly portrayed. Stadelmann (op. cit., page 17) has rightly pointed out that passive, not active, emotional tension was characteristic of society in the fifteenth century. Nowhere is such tension more clearly perceptible than in Bosch's painting. Yet the tormented bodies in his pictures of Hell are not always represented as really suffering. They often seem mere actors, pretending to be terror-stricken by a certain punishment.

There can be no doubt that, for all Bosch's profound pessimism, he was not only a pious Christian but also an absolutely orthodox Catholic. This is proved by the permission granted him by Philip the Handsome, heir presumptive to the Spanish throne, to execute a great altarpiece of *The Last Judgment*. An even clearer proof is the lively interest taken by the grandson of that prince, King Philip II of Spain, in Bosch's work. Obviously that most Catholic of all kings and arch-enemy of every description of heresy, sectarian deviation and lack of faith could not find, in the pictures of which he was so fond, the slightest hint of anything contrary to the strictest injunctions of the Church. It was not until the medieval spirit of Bosch's painting, which was still understood in the age of Brueghel, had at last passed away and its rich symbolism had become unintelligible, that Bosch was thought to have been a heretic. In 1605 Sigüenza found it necessary to contest this opinion. He, too, relied in the first instance upon the views of Philip II, but he also called attention to the subjects treated by Bosch. As Carl Justi proved, the next error was committed in 1645, when Quevedo assumed Bosch to have been an atheist. In late medieval times no one had as yet objected to individuals expounding Divine truth and openly assailing the standards of the age, even if such attacks occasionally involved monks and nuns. But after the Counter-Reformation such activities were regarded as an outcrop of heresy or even as positively un-Christian.

Bosch's works, accordingly, represent a period in which the end of the world was regarded as imminent. The impending terrors

of the Last Judgment were already being anticipated with the keenest dread and at the same time with stupefaction at the refusal of humanity at large, despite its constantly deepening preoccupation with the idea of death, to mend its ways and turn its back upon worldly interests. For, on the contrary, earthly pleasures were being pursued as intently as ever.

Huizinga (op. cit.) notes as the basic and governing feature of the medieval mind at this date its visualising faculty. Bosch represents, at its most pronounced, this tendency of an age which had ceased to think "in any but visual terms." The vast panorama he reveals swarms with symbols, conceptual associations and allusions. They are all presented in readily recognisable form and colour. Even the abstruse becomes self-evident.

As an ideal example of the spirit of the late Middle Ages Bosch occupies an unmistakable position in the intellectual development of European art. More than any other artist he stands at the frontier between two epochs. The content of his work is purely medieval, but their form, however much it may have echoed the International Gothic style, does not by any means derive only from medieval achievements. Whatever importance may be assigned, in judging the paintings, to their content, it must never be forgotten that Bosch's reputation rests entirely upon their artistic qualities. Quite apart from technical finish, these include in particular his freedom of expression and independent treatment of his theme, as well as his relatively early abandonment of all iconographical prescription. But he also shows a new feeling for the emotional impact of landscape and for direct rendering of it. All these features of the art of Bosch bring it into close relation with that of Leonardo da Vinci, who belonged to practically the same generation, and the work of the young Albrecht Dürer.

It is of interest to compare Bosch's place in the history of European art (as described above) with that which he also indubitably occupied as a link, in the development of Netherlandish painting, between Jan van Eyck and Pieter Brueghel. His work has only to be set beside that of any of his leading contemporaries to reveal its importance. He was not in the least influenced by the psychological discrimination which Hugo van der Goes applied to sacred subjects, by the lyricism and secular narrative power of Memling, by Gerard David's subtle pictorial variations or by the

higher professional standards in every direction attained by Quentin Massys. Bosch's effects were more personal and direct than those of any of these painters. He disdained the material splendours of brocaded robes, oriental carpets and marble pillars which they cultivated, but he achieved aesthetic results in which colour was not only a factor of expression but also acquired a value of its own quite distinct from the material it represented. Though Bosch's style, accordingly, renders him altogether unique among Netherlandish painters, he nevertheless at the same time repeatedly solved technical problems on a more advanced level and in a more striking way than his contemporaries could contrive.

In the bent of his mind he was a true son of the late Middle Ages. But it would be a mistake to classify him as merely one of the last Gothic painters who brought that period to an end. The "Flamboyant" manner remained in vogue in the Netherlands throughout almost the whole of Bosch's active life. The two successive phases of this style were mainly exemplified in his native Holland by the Master of the *Virgo inter Virgines* and Cornelis Engelbrechtsz. They occasionally, like Bosch, multiplied technical devices and stressed outline, but, unlike him, they aimed at enhancing the effect of their themes by exaggerating such formal elements in their productions. He himself never made the slightest attempt, in any way, to attract attention to technique. For the very reason that he alone of the last Gothic painters concentrated primarily upon illustration he had no difficulty in subordinating problems of form to psychological content. His effects, in strong contrast with those of the other masters of his day, were always simply obtained.

Form and content are indistinguishable in his work: separate study of these elements cannot in his case do justice to his art. It is intelligible enough, therefore, that even the most eminent of his professional colleagues in the Netherlands, those of his own generation as well as those who began to paint when he himself had reached the height of his career, remained as indifferent to his pictures as he to theirs. However, the artists whose initial activities coincided with his old age could no longer ignore him. He does not seem to have trained any pupils, but many copies, some of excellent quality, were made of his works. Imitators who could not

ever have attended his studio repeated his subjects in agreeable little paintings derived from his mature and late styles.

The last generation of late Gothic painters, active about 1520, also turned out paraphrases of Bosch's compositions, borrowing certain passages which they combined with other motives. The young specialists in landscape were above all indebted to his work and the last great advance in that of Patinier, for instance, would be inconceivable if he had not studied his handling of nature. Bosch's influence can even be traced in the backgrounds of several of Patinier's pictures, and Herri Met de Bles also copied his methods. There seems, too, some suggestion of them in the first *genre* productions of the sixteenth century, for example those of Lucas van Leyden, who was especially interested in Bosch's heads. The Brunswick Monogrammist, moreover, developed in purely secular style the cruder features of Dutch common life to be found in Bosch's Fool series.

About the middle of the century Bosch became the fashion at Antwerp. His form as well as his content, which was obviously still fully intelligible at that time, were studied. Copies, engravings and paraphrases of his works, however coarsened in the process, were produced. The Master of *The Prodigal Son,* for instance, painted a *Temptation of St Anthony,* now in the Kunsthistorisches Museum at Vienna, with completely new inventions of individual items in the "infernal" passages, though these were rendered in Bosch's manner. This revival of interest in his art had an important outcome in the entire career of Pieter Brueghel, whose works would be in every respect inconceivable without the prior example of Bosch. Brueghel undoubtedly secularised his predecessor's ideas. It is significant that Philip II did not collect their restorations by Brueghel, who carried many aspects of Bosch's style further, but by no means all of them. The multitude of the earlier artist's symbols, it should be remembered, veiled profound insight into humanity, a wisdom which Brueghel turned to ridicule. He made nothing of the philosophy of endurance of which Bosch had made so much. He took only an occasional interest in the lives of hermits in the desert, and was far less concerned than Bosch with the Four Last Things. His world is no longer one filled with devils nor do the enemies of Christ now display any per-

sonal hatred but merely brutality and indifference. He often shows a taste for moral and philosophic rather than religious ideas, stressing the folly rather than the sinfulness of human conduct. The progress of such secularisation becomes clearer still at the next stage of development, that of Rubens in landscape and of Adriaen Brouwer in *genre* painting. In neither case is any further connection perceptible with the characteristic mentality of the late Middle Ages.

ASTROLOGY AND JEROME BOSCH

Andrew Pigler

Compared to the eccentricity of the subject-matter, and the piling up of intricate details, in most paintings by Jerome Bosch, that in the Boymans Museum at Rotterdam is surprisingly straightforward (Fig. 1). It is a mature work painted in about 1510, in which the form and significance of a relatively few objects seem to have been pondered deeply. Its main figure, a tragi-comic, emaciated creature, is "engraved" in the very centre of the circular panel with the precision of a bas-relief; it should be easy enough, one would think, to arrive at its meaning. But this has not proved the case. True, the explanation provided by Gustav Glück, that the man represents the Prodigal Son, has, in spite of one or two dissident voices, gained general currency.[1] But his hair and the heavy burden he carries will not fit this identification. It has also been suggested that the figure represents a wanderer or vagabond,[2] but this is not convincing either, since it takes no account of the intro-

"Astrology and Jerome Bosch," by Andrew Pigler. From *The Burlington Magazine* (1950), pp. 132–36. Reprinted by permission of the author and the publisher.

[1] G. Glück: *Aus drei Jahrhunderten europäischer Malerei*, Vienna [1933], pp. 8–19, 318.
[2] L. Baldass in *Jahrbuck der Kunsthistorischen Sammlungen in Wien*, N.F., i [1926], pp. 115–117. E. Sudeck: *Bettlerdarstellungen vom Ende des XV. Jahrhunderts bis zu Rembrandt*, Strasbourg [1931], p. 17. L. Baldass: *Hieronymus Bosch*, Vienna [1943], pp. 17, 232. E. R. Meyer in *Phœnix*, i [1946], No. 7, pp. 1–7.

duction of certain other elements in the picture. Indeed, Max J. Friedländer has come out with a very characteristic observation about it: *Dieser Szene,* he writes, *wie allen Genreszenen Boschs, ist statt der eindeutigen Realität eine schielende und zwinkernde Fraglichkeit eigen. Nie verlässt uns die irritierende Empfindung, dass etwas "dahinter stecke," dass der Meister mit dem, was er zeigt, etwas verheimlicht, auf etwas anspielt.*[3]

This is not the first time that such a figure appears in fifteenth-century art. When about sixty years before Bosch, Jacopo Bellini made a drawing of a similar figure in his sketch-book, now in the Louvre Print Room, he gave it a normal, commonplace character, unruffled by spiritual torments. Here he has a great many of the same attributes as in the Bosch picture: a heavy burden on his back, a stick in his right hand, threadbare shoes and stockings, and a dog to accompany him. But in spite of these similarities, the spectator will be perfectly willing to accept the statement in the index of subjects at the end of the sketch-book (in a fifteenth-century hand) identifying Bellini's figure with a charcoal burner (*carboner*) peddling his wares.[4] Bosch's subject does not, however, admit of such a simple solution.

In the following paragraphs our intention is to clear some of the fog that surrounds the subject-matter of Bosch's painting by indicating for the first time the source from which the artist drew. It has nothing directly to do with such matters as social and spiritual life, suggested by Tolnay, Baldass, and Fraenger[5] as the point of departure for their interpretations of Bosch's subject matter, but with a theme widely known and studied in late medieval times: we refer to astrology, a science as assiduously cultivated in the sixteenth as in the fifteenth century. It would be surprising indeed if this science were not also met with in the work of Bosch.

[3] M. J. Friedländer: *Die altniederländische Malerei,* Vol. 5, Berlin [1927], p. 102. ["This scene, like all of Bosch's genre scenes, lacks unequivocal realism, displaying instead a dubiously squinting and sniggering quality. We are never quite free of the irritating sense that there 'must be something behind it,' that the master is clandestinely alluding to something more than he shows."]

[4] V. Golubew: *Die Skizzenbücher Jacopo Bellinis,* Vol. 2, Brussels [1908], pl. xcvi(70).

[5] Ch. de Tolnay: *Hieronymus Bosch,* Basle [1937]. L. Baldass: *Hieronymus Bosch,* Vienna [1943]. W. Fraenger: *Hieronymus Bosch, Das Tausendjährige Reich,* Coburg [1947].

It is a well-known fact that there exists an earlier version of the Rotterdam "vagabond" on the reverse of the shutters of the *Hay Wain* triptych from the Escorial, now in the Prado. Here we find the same emaciated figure, only on a larger scale, with a heavy basket on his back, a stick in his hand, shuffling along and casting worried and irresolute glances behind him. Here is once more the unfriendly-looking dog at his heels. Students have made a serious mistake in failing to examine these two scenes in conjunction. If they had done so, they might have realised that the two figures are derived from late medieval astrology, from the occult science dealing with the influence that the planets exercised on the earth and mankind and, furthermore, that they represent a so-called "child" of the planet Saturn. Both show the real type of the Saturnine character, of meagre countenance, of withdrawn and melancholy disposition, with the slow movements of a man who cannot make up his mind.[6]

Where did the artist derive his inspiration for this theme? Evidently from some of the numerous series of fifteenth-century pictographs known as *Planetenkinderbilder*. These woodcuts, engravings, and drawings generally show the planet dominating the human beings ranged below it, but the most popular works—especially the German woodcuts—tend to omit the planet deities and to concentrate on what is taking place on the earth.[7] Bosch has adopted this second course. His figure is very similar to the heavily burdened traveller in the middle forground of a Florentine engraving of about 1460 (Fig. 18). In this, as well as in a similar German drawing by the "Master of the Amsterdam Cabinet," in the *Medieval House-book* at Wolfegg swine are made to play an important part; the earth being Saturn's element, naturally the pig digging in the ground is esteemed his favourite animal.[8] The same animal is to be seen in the middle-ground of the Rotterdam painting (its presence there inducing some scholars to connect the scene with the story of the Prodigal Son). In the *House-book* draw-

[6] A. Hauber: *Planetenkinderbilder und Sternbilder,* Strasbourg [1916], p. 126.
[7] A. Hauber: *op. cit.*, p. 264.
[8] Compare A. Chastel in *Phœbus*, i [1946], p. 131. Concerning the connection between Bosch and the "Master on the Amsterdam Cabinet" (about fifteen years older than himself), see D. Bax: *Ontcijfering van Jeroen Bosch,* 's-Gravenhage [1949], p. 239.

ing, a man in the foreground is apparently occupied in disembowelling a horse: in the left foreground of the Prado painting is the skeleton of a horse. But this is not all. Further facts connect the objects in Bosch's two works with the planet Saturn, who is the cause of so much misfortune on earth. Partly identified with Chronos, the deity of Time, Saturn has become the ruler over the destinies of men. He holds the reins of justice in his hands, he decrees capital punishment. It is quite usual, therefore, to find gallows, with the executioner's victims dangling from them, in representations of this planet in the fifteenth century. In his Madrid painting, Bosch has not forgotten this traditional detail either. In the same way, scenes of quarrels, violence, and plundering are also ascribed to the baneful influence of Saturn. The pole at the top of the hill in the right background of the Rotterdam painting is a pillory too, from which corpses have already fallen. One might go further and suggest that the shape itself of the Rotterdam painting (a circle within an octagon) is a reference to the astrological origin of its subject. However, Bosch has omitted certain details that take a prominent place in the *House-book* drawing already mentioned—the farmers, for instance, and the delinquents in the stocks—and has introduced other motifs, so that it must not be assumed that these specific examples (Fig. 18) were necessarily the ones that he chose as models.

It is possible to demonstrate the influence of the *Planetenkinderbilder* in other, earlier works of the Master of s'Hertogenbosch, notably in the version of the *Sorcerer* in the Musée Municipal at Saint Germain-en-Laye. Among the "children" of Luna the itinerant magician is always to be found, standing before a small table and enrapturing his gullible, ignorant audience with his conjuring tricks. The comparison with the corresponding scene in the *House-book* is particularly convincing (Fig. 19). From the point of view of the actual scene represented, the only difference between the two is that in the drawing the sorcerer takes the frog out of the fool's mouth, whereas in the painting the animal has already jumped out of the open mouth and is lying on the table.[9] In the *House-book* drawing the sorcerer's wife, his little dog, and an ape accompany him; in the Bosch only the dog is seen. But

[9] See F. Schmidt-Degener in *Gazette des Beaux-Arts* [1906], i, pp. 151, 154.

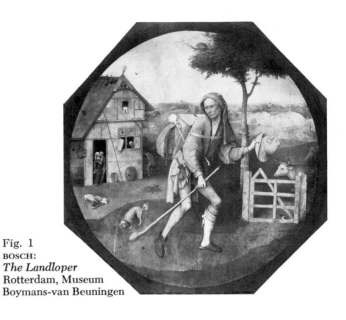

Fig. 1
BOSCH:
The Landloper
Rotterdam, Museum
Boymans-van Beuningen

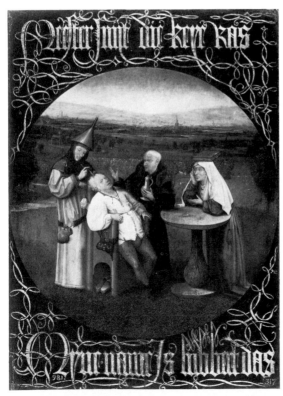

Fig. 2
BOSCH:
The Cure of Folly
Madrid, Prado

Fig. 3
BOSCH:
The Epiphany Altar *(The Adoration of the Magi)*
Madrid, Prado

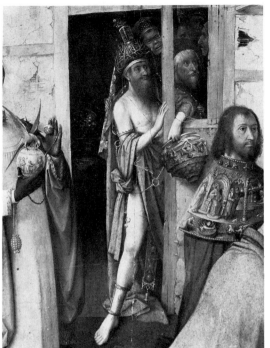

Fig. 4
BOSCH:
Detail of Fig. 3

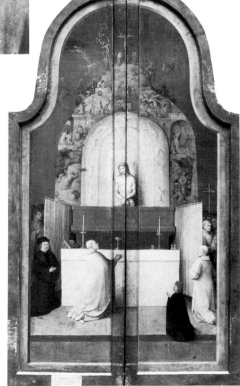

Fig. 5
BOSCH:
The Epiphany Altar, exterior
Madrid, Prado

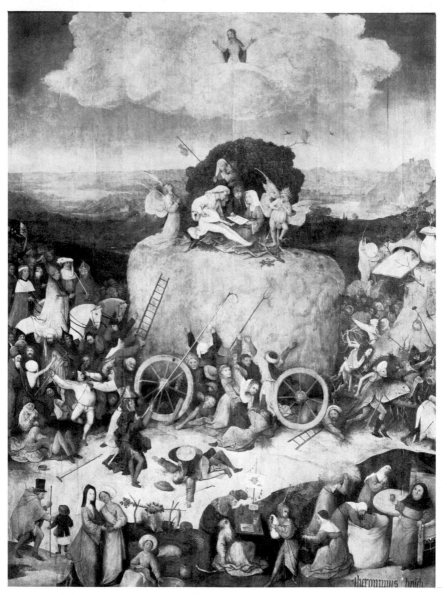

Fig. 6
BOSCH:
The Haywain, central panel
Madrid, Prado

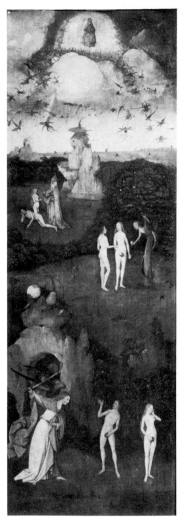

Fig. 7
BOSCH:
The Haywain, left wing
(The Expulsion from Eden)
Madrid, Prado

Fig. 8
BOSCH:
The Haywain, right wing
(Hell)
Madrid, Prado

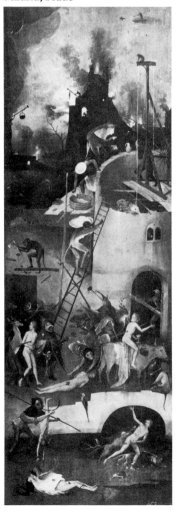

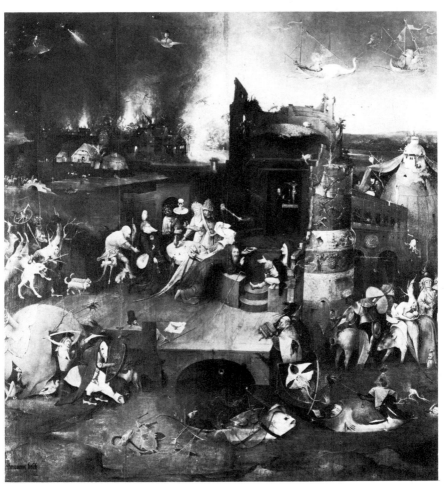

Fig. 9
BOSCH:
The Temptation of Saint Anthony, central panel
Lisbon, Museu Nacional de Arte Antigua
*(Courtesy of the Ministério da Educação Nacional,
Direcção-Geral do Ensino Superior e das Belas-Artes)*

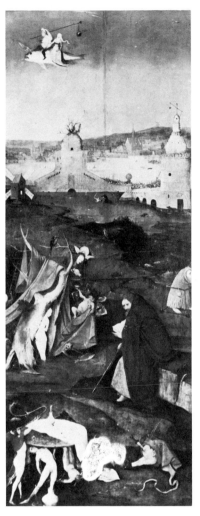

Fig. 10
BOSCH:
The Temptation of Saint Anthony,
left wing
Lisbon, Museu Nacional de
Arte Antigua
*(Courtesy of the Ministério da
Educação Nacional, Direcção-Geral
do Ensino Superior e das
Belas-Artes)*

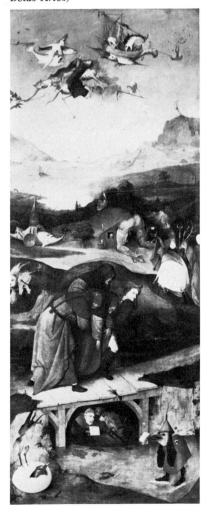

Fig. 11
BOSCH:
The Temptation of Saint Anthony,
right wing
Lisbon, Museu Nacional de
Arte Antigua
*(Courtesy of the Ministério da
Educação Nacional, Direcção-Geral
do Ensino Superior e das
Belas-Artes)*

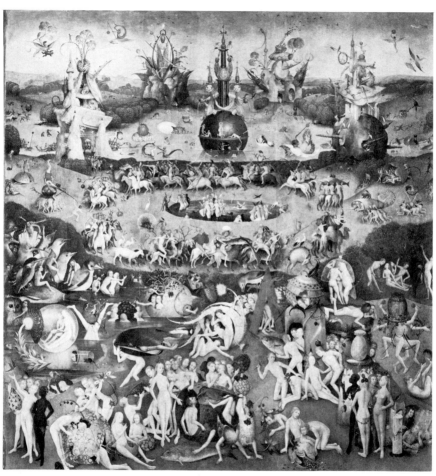

Fig. 12
BOSCH:
The Garden of Earthly Delights, central panel
Madrid, Prado

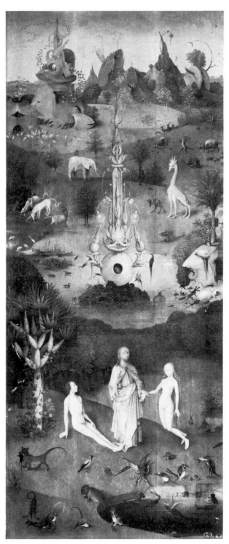

Fig. 13
BOSCH:
The Garden of Earthly Delights,
left panel *(The Creation of Eve)*
Madrid, Prado

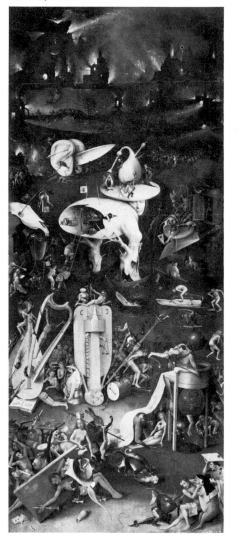

Fig. 14
BOSCH:
The Garden of Earthly Delights,
right panel *(Hell)*
Madrid, Prado

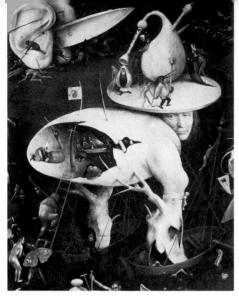

Fig. 15
BOSCH:
Detail of Fig. 14

Fig. 16
BOSCH:
The Garden of Earthly Delights, exterior
Madrid, Prado

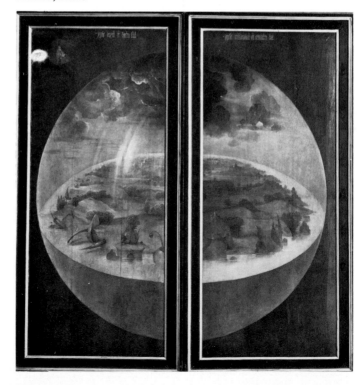

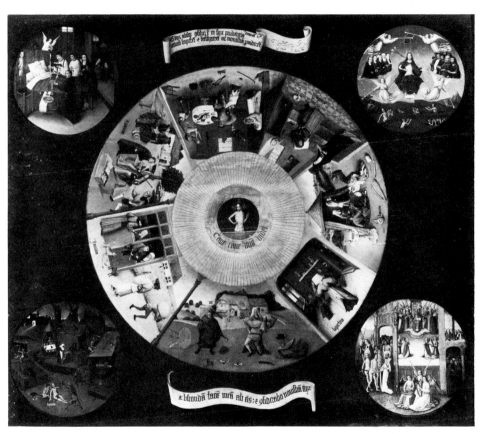

Fig. 17
BOSCH:
The Seven Deadly Sins (The Prado Table Top)
Madrid, Prado

Fig. 18
Saturn
Florentine engraving, ca. 1460

Fig. 19
THE MASTER OF THE
AMSTERDAM CABINET:
Luna
Drawing in the *Mediaeval
House-book*, Wolfegg

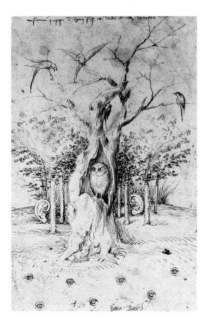

Fig. 20
BOSCH:
*"The field has eyes,
the wood has ears"*
Berlin-Dahlem, Staatliche
Museen

Fig. 21
BOSCH:
Owls in a Tree
(reconstruction by Rosenberg)
Rotterdam, Museum
Boymans-van Beuningen

there exists a drawing in the Louvre[10] which, in company with
Baldass, we believe to be a drawing from the Saint Germain-en-
Laye picture, in which the woman and the ape as well as the dog
are present.

It is possible to go one step further along these lines. We
suggest that the terrestrial events represented in the *Planeten-
kinderbilder* not only inspired the fantasy of Bosch, but also the
Giorgionesque painter of the small panel in the National Gallery
(No. 1173) described as *The Golden Age*. The latter appears to
have used the illustrations from the planet Jupiter: the similarity
between it and the Florentine engraving of *Jupiter* is particularly
striking. In both cases we find a youth sitting under a baldacchino
and a youth kneeling before him at the foot of the throne, and
some of the same animals—a leopard and a stag—appear in both
landscapes.

However, to return to the Rotterdam picture: no doubt Bosch
developed the astrological idea by adding more popular elements
of his own. Thus, the contrast between the boot on one foot and
the shoe on the other, the cat's hide hanging from the basket,[11]
the young owl seated on a branch of the tree above his head,[12]
and his angry little dog, are further symbols and signs of his miser-
able condition, of the misfortunes that have befallen him, and will
befall him on his journey. Perhaps he knows that his wife is al-
ready in the arms of a soldier, although he has only just left the
cottage that is his home.

Since astrological ideas were so familiar everywhere in Eu-
rope in the fifteenth and sixteenth centuries, it is not surprising
that motifs that appear in the Rotterdam painting seem to have
been understood, or at any rate used, for a long time after its
execution. This will be clear from one of the illustrations in the
Emblemata by Andrea Alciati in the 1547 edition, repeated in the
Paris edition of 1602. The woodcut, designed by Bernard Salomon
and entitled *Bonis auspicijs incipiendum,* has beneath it the fol-
lowing four lines, which, together with the scene itself, suggest
that Bosch's painting was the source of inspiration:

[10] Repro. L. Baldass: *Hieronymus Bosch,* Vienna [1943], Fig. 122.
[11] Ch. de Tolnay: *op. cit.,* pp. 46, 72. Compare D. Bax: *op. cit.,* p. 225.
[12] Compare C. Ripa: *Iconologia,* Padua ed. [1630], iii, p. 115.

Auspiciis res cœpta malis, bene cedere nescit.
Felici quæ sunt omine facta, iuvant.
Quidquid agis, mustela tibi si occurrat omitte:
Signa malæ hæc sortis bestia prava gerit.[13]

This echoes the troubled and pessimistic attitude of the Dutch painter: the attitude that new enterprises had better not be undertaken in the face of such presages of disaster. The only important difference is that the dog in the woodcut takes on more the semblance of a weasel. But this is a mere detail and does not affect the main argument.

Bosch was living near the Flemish-Dutch border (*c.* 1450–1516); Alciati the jurist (1492–1550) worked at Milan and Pavia. With no apparent contact between them, the two men have expressed the same ideas in their works. As far as it has proved possible to compare the various editions of the *Emblemata,* only the French illustrator of the editions of 1547 and 1602, Bernard Salomon, has noted the identity of the theme. In the earlier editions, for instance in the Venetian edition of 1546, a woodcut of quite another composition illustrates this emblem. Where (if we are correct) Bernard Salomon became acquainted with the work of Bosch, we cannot say, the provenance of the Rotterdam picture being only known since the second half of the nineteenth century. It is true that it was then in the Theodor Schiff Collection in Paris, from where it passed to Vienna, to Albert Figdor,[14] so that it is just conceivable that it was already in France in 1547. The supposition that a drawing served as mediator between panel and woodcut cannot be excluded.

Let us cast one further glance at the triptych from the Escorial. In the central panel on the inside is represented the *Hay Wain* (detail, Fig. 6). What does this really signify? Some critics have found an origin in the Bible, but without the good fortune of coming on the precise passage to elucidate it. Tolnay believed he had found an explanation in a Netherlandish proverb[15] but his

[13] [See Fig. A in Pigler's article. The illustration and the lines of the text warn the reader that it is bad luck to begin new things under an evil sign, since nothing will progress; a good sign insures success. Stop if a weasel approaches; this crooked beast is a bad omen.]

[14] Compare G. Glück: *op. cit.,* p. 10, note.

[15] Ch. de Tolnay: *op. cit.,* p. 63, note 57.

assertion is untenable. For what about the presence of Christ, appearing in the clouds above, if the mysterious scene is merely the representation of a proverb? In the opinion of Baldass, the wain is the chariot of sensual pleasure attended by the personifications of the seven deadly sins and drawn to Hell by devils.[16] In our opinion the reference to the seven deadly sins may possibly be correct, but this whole interpretation of the *Hay Wain* is exceedingly doubtful.[17]

The solution to this problem is, we believe, to be found in two verses from Amos (2:13–14): "Behold, I am pressed under you, as a cart is pressed that is full of sheaves.[18] Therefore, the flight shall perish from the swift, and the strong shall not strengthen his force, neither shall the mighty deliver himself." The symbolical hay wain is a solemn warning and lesson to mankind of the inevitability of punishment. Both pictures on the insides of the wings are perfectly consistent with this interpretation. The beginning of the tragedy of mankind is shown in the scene of the Fall of Man and his Expulsion from Paradise on one side; the inevitable end is the scene of Hell on the other. The picture on the reverse of the shutter admirably suits this pictorial programme, by showing the solitary wanderer under the influence of Saturn, suffering the torments of body and soul. If we bear in mind that it was quite common for astrological elements to enter into ecclesiastical art in the later Middle Ages, there will seem nothing strange in the fact that Bosch combined in his triptych religious ideas, and ideas that border on profanity.

[16] L. Baldass: *Hieronymus Bosch*, Vienna [1943], pp. 23, 236 ff.

[17] I was unable to consult the article of L. Lebeer and J. Grauls: *"Het hooi en de Hooiwagen in de beeldende Kunsten,"* in *Gentsche Bijdragen tot de Kunstgeschiedenis*, v. Antwerp [1938].

[18] In the *Vulgate*: *Ecce, ego stridebo subter vos, sicut stridet plaustrum onustum fœno.*

THE PRADO *EPIPHANY*
BY JEROME BOSCH

Lotte Brand Philip

. . . The Adoration takes place in front of the stable of Bethlehem, represented as a tumble-down kind of shanty with two visible openings (Fig. 3). In the opening on the right the head of a donkey in profile appears; in the opening at the left we see a strange and puzzling representation of a number of standing figures (Fig. 4).[1]

"The Prado *Epiphany* by Jerome Bosch" (excerpted), by Lotte Brand Philip. From *The Art Bulletin*, Vol. 35, no. 4 (December 1953), pp. 267–93, where full illustration of the text can be found. Reprinted by permission of the author and the publisher.

[1] M. J. Friedländer, *Die altniederländische Malerei*, Vol. 5, 1927, p. 90, interprets the group inside the hut as persons of the royal cortege of the three Kings. Tolnay, in a lecture at the University of Hamburg, 1932, suggested that the half-nude figure represented John the Presbyter, who, according to legend, was a descendant of one of the three Magi and went, like his ancestor, again and again on a pilgrimage to the Holy Land. In his book, *Jérôme Bosch*, Basle, 1937, p. 44, Tolnay interprets the group as the suite of the Kings waiting their turn "behind the scenes" to adore the Child, thus forming a second link of a chain of eternal adoration. Ludwig von Baldass, *Hieronymus Bosch*, Vienna, 1943, pp. 40, 60, 248, also interprets the figures inside the hut as the following of the Kings. Sir Lionel Cust, in his article on the replica of the Prado painting at Petworth (*Apollo*, 1928, Vol. 8, pp. 55 ff.), takes the figures for the messengers sent by Herod to report upon the event, thus being the first writer on the subject who recognized the hostile attitude of the group. The only author who really stressed the fact of the hostile, heretical appearance of the figures is Jacques Combe, *Jheronimus Bosch*, Paris, pp. 42, 94, who interprets them as a symbol of heresy, as bad, untrustworthy shepherds who seem to spy upon the majestic scene. A precise interpretation, however, has not been attempted. D. Bax (*Ontcijfering van Jeroen Bosch*, The Hague, 1949, p. 248), refers to the group in the doorway in a short passage, calling it the suite of one of the Kings.

This latter opening consists of the frame of a door with an adjacent window-like aperture separated by a wooden post. Standing in the doorway with his right hand against the post, and his left arm protruding through the window and resting on the sill, a half clothed bearded man appears, visible almost in full. Behind this figure inside the hut we see the faces of five other men. The first is seen in full in the window opening, beside the face of the main figure. It is the face of an old man with white hair and beard who is holding the front figure with both hands. The other four faces appear further inside the hut, darker, less distinct and partially overlapped.

The front figure is striking in its strange appearance, and is overloaded with symbols and attributes. Half-nude, his body showing through a sheer shirt, and draped in a scarlet cloak similar to that of Christ as he is represented during the Passion and after the Resurrection, with a crown of thorns around his turban-like helmet, this figure is a picture of the Jewish Messiah. It can be identified with certainty by two of the attributes, which point to two different legends well-known in Jewish scriptures.

The golden chain by which the arms of the figure are fettered points to a legend frequently mentioned in mediaeval Jewish literature, and the fact that the Messiah is chained and a prisoner forms a most important feature of this legend.[2] According to it, the

[2] I came across this legend in reading Heinrich Heine's book, *Ludwig Börne* (*Werke*, 7th ed., Elster, Hamburg 1840), where, in Book IV, it is recounted in a very touching and poetical way. Reading this passage and recognizing the connection between the golden chain of the Jewish Messiah and the attribute given to the puzzling figure in Bosch's altarpiece was the starting point for the entire investigation presented in this paper.

The legend about the Messiah in Paradise which occurs in different versions in several mediaeval Jewish scriptures is recounted in detail, and with distinct reference to the fact that the Messiah is chained, in the *Midrash Conen*, a work written before the eleventh century. Editions: Wilno, 1802; Lemberg, 1850; Adolph Jellinek, Jerusalem, 1938. (The passage in question can be found in the latter edition in Bet ha-Midrasch II, pp. 29 f.) French translation: Jean-Joseph Brierre-Narbonne, *Le Messie souffrant dans la littérature rabbinique*, Paris, 1939, p. 64. The *Pesikta Rabbati*, a scripture still older (second half of the ninth century), recounts a different legend which, in one respect, however, is similar to the story in the *Midrash Conen*. The Messiah also appears as a suffering person; he is kept a prisoner, but instead of being chained, he is put into an iron yoke. Editions: M. Friedmann, Vienna, 1880, pp. 159a and 161a; Brierre-Narbonne, *op. cit.*, pp. 32 and 35. References to the Messiah who is bound occur, according to the information given to me by Dr. Boaz Cohen, in Ibn Esra's *Commentary on the Bible*, Gloss on Canticles

Messiah is born on the day of the destruction of the Temple. From that time on, he lives in Paradise. He resides there as a king with an old chancellor and four privy counselors.[3] He is anxious to rescue his suffering people, but is not allowed to do so until the right time has come. He is a young man of strength and beauty and so impatient to help the Jewish people that he is bound by a golden chain in order to restrain him from starting the work of redemption at the wrong time. He receives the visits of prophets and other Biblical personages who come to comfort him. When he learns anew of the misery of his people, he is overcome with rage and anger and tries to go to their rescue. His companions have to hold him back by force, and could not succeed in doing so without the golden chain by which the Messiah is bound.

The other Jewish legend is found in the Babylonian Talmud.[4] Here the Messiah, in accordance with the famous messianic prophecy of Isaiah 53:3, is a poor man stricken with disease and an outcast. Rabbi Joshua ben Levi asks Elijah: "When will the Messiah come?" "Go and ask him himself," is the reply. "Where is he sitting?" "At the entrance." "And by what sign may I recognize him?" "He is sitting among the poor lepers: all of them untie [their sores] all at once, and rebandage them together, whereas he unties and rebandages each separately, thinking, should I be counted (it being time for my appearance as the Messiah), I must not be delayed." The figure in Bosch's painting is characterized as a leper[5] by the white color of his skin and by a large sore on his leg visible through a fancy gold-framed transparent bandage which resembles the crystal tube in a metal setting familiar in reliquaries.

7:6, and on Isaiah 52:13 (eleventh century). In none of the above cited sources is the legend of the fettered Messiah actually told as a story. They do not give the reason why the Messiah is chained. This feature is only mentioned, and even in the *Midrash Conen* the text reads as though it were assumed that the legend was known. I have been unable to trace the real source of this apparently very old tale. Heine's book is, so far as I know, the only text where the story is actually told.

[3] This feature appears only in Heine's report of the legend; it is not mentioned in any of the scriptures quoted in note 2. So far I have been unable to find an older source.

[4] *The Babylonian Talmud*, English ed. by J. Epstein, London, 1935, Seder Nezikin, Sanhedrin 98a, p. 664.

[5] Baldass (*op. cit.*, p. 40), has noted that the person in question is a leper, but he takes the figure for a leprous nobleman in the attendance of the three Magi. See note 1.

That the painter of a late mediaeval altarpiece, or his clerical advisers, had knowledge of these very popular Jewish legends is in no way surprising. The study of Jewish books had never been abandoned during the Middle Ages and, especially during the time of Mysticism, Jewish material made its way into Christian ideology. Knowledge of Hebrew scriptures played an important part in the public and private disputations on the Messiah which were frequently held between Christian and Jewish theologians throughout the Middle Ages.[6] It also played an important part in the controversial literature, in which Jewish sources were published in Latin translations. In the *Pugio Fidei* by Raymundus Martinus, for instance, a controversy against Islamism and Judaism by a Spanish Dominican of the thirteenth century, the passage from the Babylonian Talmud about the leprous Messiah has been quoted and translated.[7] This book, however, or any later work in which one or both legends were mentioned,[8] can hardly be considered as the direct source of the painting. Both legends, belonging to very old Jewish traditions, furnished the material for the answer to the usual question, "Why doesn't the Messiah come?" [9] It seems only natural

[6] According to Joseph Sarachek (*The Doctrine of the Messiah in Medieval Jewish Literature*, New York, 1932, p. 177), the principal disputations were: 1240 (Paris); 1263 (Nahmonides with Pablo Christiani before King James of Aragon); ca. 1373 (Pampeluna); 1375 (Burgos and Avila); February 1413 and November 1414 (Tortosa); ca. 1430 (Granada). It is also known that Hildegard of Bingen had a disputation with the Jews of Bingen (twelfth century). See Hans Liebeschütz, *Das allegorische Weltbild der heiligen Hildegard von Bingen*, Studien der Bibliothek Warburg, Leipzig, Berlin, 1930, p. 159, note 1.

[7] Raymundus Martinus, *Pugio Fidei adversus Mauros et Judeos*, Leipzig, 1687, Secunda Pars, Cap. VI, 4, p. 351. Martinus also refers frequently to the legend about the Messiah in Paradise. He quotes the *Pesikta Rabbati*. The text of the *Midrash Conen*, however, with the reference to the chain, and the passages in the *Commentary* by Ibn Ezra do not seem to be mentioned by him, though the latter work is well known to him and frequently quoted. See note 2. For calling my attention to the work by Martinus I am indebted to Prof. Louis Ginzberg, and to Dr. Boaz Cohen for help in the tedious task of checking the voluminous book for quotations.

[8] In the introduction to his *Treatise on the Messiah* (Yeshuot Meshiho, ed., Königsberg, 1860, Introduction, p. 3) Isaac Abarvanel (1437–1508), a contemporary of Bosch, alludes briefly to both of the legends. He remarks concerning those who ask complainingly "why the son of Jesse has not come to rule out of prison, why are the steps of his chariot late . . . it is the old plague of leprosy, they say." For quotation and translation of this passage I am indebted to Dr. Boaz Cohen.

[9] Cf. Hermann Gunkel, *Schöpfung und Chaos*, Göttingen, 1895, p. 224.

that they appeared in this answer also, when the question was asked by a Christian. Thus these legends were probably known to Christians since very early times, forming a verbal Christian tradition which had been kept alive all through the Middle Ages, very likely through renewed oral information.[10]

That the Jewish Messiah in Bosch's *Adoration* stands for a symbol of the Synagogue is obvious from the way in which he and his companions are placed in the traditional settings of the Adoration scene. He appears in the door of the ruined hut, which itself is a symbol of the Old Law and is meant as such where it occurs in earlier Flemish paintings of the Adoration of the Magi and of the Nativity, as, for instance, in the painting by the Master of Flémalle in Dijon and in Roger's *Adoration of the Magi* in Munich. To portray the Synagogue as a declining structure is familiar in later mediaeval art. In the miniatures of some fourteenth century calendars—for instance, in the Bréviaire de Belleville[11]—the idea of Judaism in dilapidation is rather drastically expressed by a building from which in successive months an Old Testament worthy pulls

[10] It is probable that Bosch's personal source of information was a converted Jew named Jacob van Almaengien who, like the painter, was a member of the Confraternity of Our Lady in 's-Hertogenbosch. In his article, "Hieronymus Bosch in seiner Auseinandersetzung mit dem Unbewussten," in *Du: Schweizerische Monatsschrift*, Vol. 11, October 1951, pp. 7 ff., Wilhelm Fränger sets forth the details he discovered about this curious fellow-citizen of Jerome Bosch. This discovery, however, does not seem to yield enough ground for the far-reaching conclusions which Fränger draws from it. According to Fränger, Jacob van Almaengien was the Grand Master of a secret sect for whom Bosch painted some of his altarpieces. The hypothesis that Bosch was a member of this heretic brotherhood, which is quite untenable and has already been refuted in some of its details by Bax (*op. cit.,* pp. 297–305), and by Jan Mosmans (*Maria en Sint Jan, onbekend en laat Schilderwerk van Jheronimus Bosch,* 's-Hertogenbosch, 1950, p. 20), was brought forward by Fränger in two previous studies: Wilhelm Fränger, *Hieronymus Bosch: Das Tausendjährige Reich, Grundzüge einer Auslegung,* Coburg, 1947 (English ed.: *The Millennium of Hieronymus Bosch: Outlines of a New Interpretation,* London, 1952); and Wilhelm Fränger, *Die Hochzeit zu Kana. Ein Dokument semitischer Gnosis bei Hieronymus Bosch,* Berlin, 1950.

[11] Paris, Bibl. nat., MS Lat. 10.483/4. See Abbé V. Leroquais, *Les Bréviaires manuscrits des bibliothèques publiques de France,* Paris, 1934, pl. XXVII; text: Tome III, pp. 203 f. Seven examples of a miniature series in calendars showing the same subject are recorded by S. C. Cockerell, *The Book of Hours of Yolande of Flanders,* London, 1905, p. 9. Cf. also *Illustrations from One Hundred Manuscripts in the Library of Henry Yates Thomson,* v, London, 1915, pls. XVI, XVII, XVIII. For drawing my attention to these miniatures I am indebted to Prof. Erwin Panofsky.

out a stone and hands it to an Apostle. Thus, at the end of the year, the structure has become a heap of ruins. It is possible, in my opinion, that the idea of comparing the Synagogue to a fallen structure may have originated in the text of a famous messianic prophecy of the Old Testament: Amos 9:11. "In that day will I raise up the tabernacle of David that is fallen, and close up the breaches thereof; and I will raise up his ruins, and I will build it as in the days of old." This passage could also have been the basis for transforming the stable of Bethlehem into a ruined structure in pictures of the Nativity, thus giving it symbolic meaning as the fallen hut of David in which the son of David was born.

The other opening in the cottage forms the frame for the head of an ass, an animal traditional in pictures of the Nativity and of the Adoration of the Magi, where it appears together with the ox. The interesting feature here is that the donkey alone is represented, and this painting is, so far as I know, the only representation of its kind where such is the case.

There exists a tradition in Christian iconography according to which the two animals have adopted a specific meaning. Whereas the ox that protected the Holy Child with its horns signifies the New Testament, the donkey that tried to uncover the Child with its teeth is a symbol of the old corrupt law. In some examples of the Nativity of the fourteenth and fifteenth centuries the idea becomes quite apparent, especially when St. Joseph is shown stopping the donkey in its evil intentions, as in one of the miniatures of the Book of Hours, MS 303 of the Morgan Library in New York.[12] A quite unmistakable representation of the ass as the animal of the Synagogue can be found in the earlier miniatures of Herrad of Landsberg's *Hortus Deliciarum*. In the large illustration representing the Crucifixion, the female figure of the defeated Synagogue is depicted as actually riding a donkey, while the victorious Ecclesia is sitting on a fantastic animal, a combination of the four symbols of the Evangelists. Thus it becomes clear why Bosch represents only the ass without its companion. It is visible inside the hut as another

[12] See Meta Harrsen, "Morgan Manuscript 303, A Book of Hours for Paris Use," *Die Graphischen Künste*, N.F., Vol. 3, 1938, pp. 91–97, where examples in fourteenth and fifteenth century art and their parallels in earlier mediaeval poetry are named; cf. also Erwin Panofsky, *Albrecht Dürer*, Princeton, 3d ed., 1948, Vol. 2, p. 7.

symbol of the Old Law, forming a counterpart to the group at the left.[13]

Just as important, however, as the fact that the ass is represented alone is the circumstance that the animal is not rendered in full sight, but only partially. The picture visible in the frame is not a donkey but a donkey's head. With this observation we arrive at a still deeper insight into the meaning of this representation. That the Jews adored the head of a donkey in their Temple is one of the oldest calumnies against Judaism known in history.[14] The accusation of ass-worship, a familiar weapon of Jew-haters since antiquity, which also appears in one of the apocryphal Christian books,[15] may even be the underlying reason for regarding the ass as the animal of Synagogue, and for the identification, in mediaeval art and poetry, of the donkey at the Nativity with the Old Law. Jerome Bosch very probably was aware of the original meaning of the symbol, and the donkey head in his painting is a far less harmless reference to Judaism than is the diaper-eating ass of an earlier Nativity scene.

As a matter of fact, the whole scene—the hut in decay, the Jewish Messiah with his companions, and the large animal head— is not harmless at all. It is not only a representation of the Synagogue but an elaborate illustration of evil, as such. We arrive at this conclusion when we seek to answer the question as to who the man in the doorway really is.

This question can be approached from two different angles. We can simply ask where the Jewish Messiah occurs in Christian ideology; or, on the other hand, start to decipher the various other attributes of the man in the hut, and the many symbolic details on

[13] For the ass as the animal of the Jews, cf. also Marcel Bulard, *Le scorpion symbole du peuple juif dans l'art religieux des XIVᵉ, XVᵉ, XVIᵉ siècles*, Paris, 1935, p. 51.

[14] See *Jewish Encyclopedia*, Vol. 2, New York-London, 1912, article "Ass Worship," pp. 222 f.; *Jüdisches Lexikon*, Vol. 2, Berlin, 1928, article "Eselsverehrung," pp. 512 f.

[15] A lost heretical book called *The Birth of Mary*, quoted in Epiphanius, *Heresy*, Vol. 26, p. 12. See Rudolph Hoffmann, *Das Leben Jesu nach den Apokryphen*, Leipzig, 1851, p. 139; and Montague Rhodes James, *The Apocryphal New Testament*, Oxford, 1926, pp. 19 f. The book gives the reason for Zacharias' being slain by the Jews in the Temple. It relates that Zacharias detected that the creature adored by the Jews had the shape of an ass, and that they killed him for having revealed this secret.

the front wall of the building, above the doorway. The two paths lead to the same conclusion.

In Christian ideology the Jewish Messiah occurs only once. He is the Antichrist, the false prophet who will be sent to the Jews as a punishment because they refuse to believe in the true Messiah.[16] Before interpreting the other attributes of the figure and the details of the hut it seems necessary to survey the origin and development of the legend of the Antichrist and to point out its content in the late Middle Ages.[17] It was already fully developed in the pre-Christian Jewish tradition, deriving in part from Daniel, but no doubt to some extent independent of the prophetic books. Its roots are probably in a very ancient primeval myth of creation which was later transformed into an expectation of events at the end of the

[16] In the collective Christian tradition, based chiefly upon the famous passage in II Thessalonians 2:8–12, its parallel in John 5:43, and the exegesis thereof by the Fathers of the Church, the Antichrist is a satanic pseudo-Messianic figure who comes from the midst of the Jews and is accepted by them as their Messiah. Thomas Malvenda in his voluminous work *De Antichristo* (Rome, 1604; Valencia, 1621; Leyden, 1647), in which the traces of the old Antichrist tradition are carefully collected, states (ed. Leyden, 1647, Lib. III, Cap. XI, p. 158): "Judeos servare in Babylonica falsam & ementitam successionem Principum tribus Judae, & stirpis Danidicae, ex qua falsum suum Messiam expectant: cum tamen recepturi sint verum Antichristum, natum ex Tribu Dan." For the Antichrist as the Jewish Messiah, cf. Wilhelm Bousset, *The Antichrist Legend*, London, 1896 (trans. from the German: *Der Antichrist in der Überlieferung des Judenthums, des Neuen Testaments und der alten Kirche*, Göttingen, 1895), pp. 133–138, 166–174, 182, 186. (In the following notes, this work is referred to as Bousset, *op. cit.* The page numbers refer to the English edition.) Cf. also J. J. von Döllinger, *Christenthum und Kirche in der Zeit der Grundlegung*, Regensburg, 1868, p. 430: "Im Allgemeinen dachten sich die Väter . . . die ganze Episode des Antichrists als eine Erhebung des Judenthums. Der Antichrist ist ihnen ein jüdischer Pseudo-Messias. . . ."; and Hans Preuss, *Die Vorstellungen vom Antichrist im späteren Mittelalter, bei und in der konfessionellen Polemik*, Leipzig, 1906, p. 30: "Der Endchrist selbst kommt bloss in Betracht als Judenmessias."

[17] For the origin and development of the tradition, see Gunkel, *op. cit.*, and Bousset, *op. cit.* Cf. also Bousset's article, "Antichrist," in Hastings, *Encyclopaedia of Religion and Ethics*, Vol. 1, 1908, pp. 578–581; F. Sieffert's and C. A. Beckwith's article, "Antichrist," in *New Schaff-Herzog Encyclopedia of Religious Knowledge*, Vol. 1, 1908, pp. 194 f. The content of the late mediaeval saga given here is a summary of the story as it appears in the German woodcut books of the late fifteenth century. The author used the original block-book printed in Strasbourg about 1482, in the New York Public Library, and the facsimile of Xyl. I, Munich, Staatsbibliothek, ed. by Kurt Pfister, Leipzig, 1925.

world. In Babylonian mythology the tale appears with the following features. The Dragon of Chaos, a frightful marine monster who had already been defeated in a primordial battle before the creation of the heavenly lights, was again to rise in the last days and contend in heaven-storming battle with the divine power. In this final battle before the end of the world, the Dragon, incarnation of the power of evil, was to be killed by the son of the upper gods.

Although in popular Jewish belief this battle was simply the final struggle of Satan directly with God, anthropomorphic transformation, which led to the legend of the Antichrist, took place in pre-Christian times. The appearance of the Messiah is spoken of as occurring at the end of all struggles and judgments, and gradually the last enemy of the Kingdom of God came to be thought of as the antitype of the Messiah. Thus the expectation of a personal opponent to the Messiah is found in pre-Christian Judaism. The writer of the Revelation of John thus found a fully developed tradition of the legend, and the Apocalypse as well as the passages in the Gospels and Epistles of the New Testament which deal with the Antichrist are based on such a tradition. . . .[18]

After the time of Jerome and Chrysostom, the assumption that the Antichrist is the devil himself practically dies out of ecclesiastical tradition. He is human, and in the popular belief of the fifteenth century is not even the son of Satan. . . . He is circumcised in Jerusalem and tells the Jews that he is the true Messiah whom they have expected for such a long time. . . . He works signs and wonders, among which the old magician's trick of making a dead and dried-up tree blossom again plays an important part. He even raises the dead through the power of the evil spirit. Thus he gains an enormous number of followers and great power. Finally, he sends messengers to the three Kings of the world and wins them over through money, treasure, and miracles. The connection of the Antichrist with the Kings of the world is a very old and original feature of the legend. . . .[19]

[18] The name "Antichrist" is first found in the Epistles of John (I. 2:18, 22; 4:3; II. 7). In the earlier Jewish tradition, the name of the Anti-Messiah is Belial or Beliar; in later Jewish apocalyptic writings he is called Armillus. The Johannine Apocalypse gives his name as Apollyon or Abbadon.

[19] Though the number of the Kings given in the different sources varies, it is usually three. This seems to be an original feature of the oldest form of the

The Antichrist in Bosch's altarpiece, besides being designated as the Jewish Messiah by the two attributes discussed above, is particularly characterized as a Jew by his long, dark beard. This fits into the specific context of the program of the altar and is remarkable, since in the contemporary block-books the Antichrist always appears as a handsome, blond, and beardless youth.

In art the representation of the Antichrist has never developed a standard type.[20] The rarely represented figure has a different appearance in each new context. Thus most of the other symbols of Bosch's Antichrist are just as unique as the chain and the leper sore taken from the Jewish legends. The scarlet cloak and the crown of thorns are doubtless meant as indications of his deceitful imitation of the life and Passion of Christ. The fact that the thorns are wound around a metal turban probably insinuates the falsehood of this imitation. The thorns cannot really hurt him.[21] On top of the turban

saga which left its traces in Daniel 7:24: ". . . and shall subdue three kings." It formed part of a tradition which was still known to Irenaeus and Hippolytus, and probably the same which was the basis for Jerome's commentary on Daniel (Bousset, *op. cit.*, pp. 64 f.). Jerome knows that the three Kings will be the King of Egypt, of Libya, and of Ethiopia (*ibid.*, p. 28). For the triumph of Antichrist over the Kings, cf. also *ibid.*, ch. 11: "First Victories of Antichrist," pp. 158–160.

[20] Karl Künstle (*Ikonographie der christlichen Kunst*, Freiburg, 1928, p. 524) expresses his astonishment that the figure of the Antichrist, playing such an important part in the homilectic and poetic literature of the Middle Ages, is so rarely represented in art. He names only a representation of the *Last Judgment* in S. Maria in Porto near Ravenna and Signorelli's fresco in Orvieto. He does not mention, however, the many existing book illustrations depicting the figure, such as the miniatures of the *Hortus Deliciarum*, in which Antichrist is repeatedly represented, the woodcuts of the German fifteenth century books on the "Endchrist" and the late mediaeval illustrations of the Revelation. In one of the woodcuts of Dürer's *Apocalypse* (B. 73), the Antichrist has been discovered by Clemens Sommer ("Albrecht Dürer's Woodcuts of the Apocalypse," in *University of North Carolina Record, Research in Progress*, Vol. 21, no. 371, October 1941, Graduate School Series, no. 40, p. 140).

[21] The turban itself is the usual exotic attire to characterize the man from afar. The thorny twig has also another evil symbolic meaning; it is an attribute of the fool and madman. In the *St. Anthony* altarpiece it appears on the head of a figure, the possible interpretation of which as the Antichrist is considered by Bax, and it occurs in numerous other compositions by Bosch. See Bax, *op. cit.*, especially pp. 11, 97, 199, and figs. 3 and 38. I think that the origin of this symbolism is Biblical (Proverbs 26:9). The fact that the figure in the hut is nude, besides being an allusion to the Christ-figure of the Passion and Resurrection, has unquestionably also an evil

Bosch's Antichrist wears a glass through which one of the thorny
twigs grows upward and is transformed into a living branch with
leaves and blossoms. There can hardly be any doubt that this is an
allusion to the Antichrist's magic trick of making a dead tree blos-
som, a miracle illustrated in the *Hortus Deliciarum* and in the
printed Antichrist books of the late fifteenth century. The glass is
probably simply the alchemistic gadget used at the magic perform-
ance.

Between the legs of the figure a little bell, undoubtedly also a
symbol, hangs down from a ribbon adorned with frogs. The frogs,
though a familiar general emblem of evil, seem to imply here a
special allusion to the Antichrist. They probably signify the unclean
spirits who, according to Revelation 16:13–14, look like frogs and
come out of the mouth of the false prophet as the messengers who
go forth unto the Kings of the earth.[22]

There are various possibilities for the interpretation of the bell
and, in fact, the little symbol seems to make several allusions. As we
shall see later, it happens frequently in the art of Jerome Bosch that
ideas taken from different contexts are amalgamated and find their
expression in one single visual symbol. Besides being a familiar
instrument of the fool who, in fifteenth century ideology, is still
identical with the sinner and evildoer, the bell is also an object worn
by shepherds. Although here the bell differs considerably in shape
from the bell of the tree-climbing shepherds in the same panel, it
probably nevertheless characterizes the false Messiah as the Bad
Shepherd. (This would correspond with one of the leading ideas
behind the painting, an idea which will later be discussed in detail.)
The bell, however, indubitably has still another signification. It is
the bell of the Jewish High Priest who, as the particular context of
Bosch's painting indicates, is the Jewish High Priest in a very spe-
cific sense.[23] The distinct juxtaposition of the Antichrist with the
ass in the two openings of the decaying hut makes him appear as
the priest of the ass. Bosch has unquestionably represented him as

meaning, "nuditas criminalis." See Petrus Berchorius, *Dictionarii sev reper-
torii moralis . . . pars prima-tertia,* Venice, 1583, "Nudus, Nuditas." I owe
my acquaintance with this passage to the kind information of Dr. William S.
Heckscher.
[22] Cf. the very interesting passage by Gunkel (*op. cit.,* p. 387, note 2) dealing
with the mythological origin of the symbol; and Bousset, *op. cit.,* pp. 189 f.
[23] Aaron had to wear bells at the hem of his robe. Exodus 28:33–34.

such. This representation is reminiscent of the afore-mentioned story recounted by Epiphanius, in which the old calumny of Jewish ass-worship was repeated.[24] According to the writer of the book, the donkey adored by the Jews had a priest, and at the hour of worship, when the priest entered the Temple, the animal hid inside so that nobody might detect the "likeness of its shape." The priest, so said the writer of the book, was commanded by the lawgiver to wear bells. He gives as the reason for this regulation the fact that the animal would thus hear the priest entering and be able to hide in time. It is, of course, not intimated that Bosch must have known the lost apocryphal book or Epiphanius' quotation. It is very probable, however, that he knew the story or a similar one, and that the Antichrist's bell is meant also as the warning bell of the donkey's priest.

A most striking feature of Bosch's depiction of the Antichrist is the object in his left hand. . . . With its large opening on top and small aperture at the bottom it is reminiscent of the large metal bowls that were still used in the seventeenth century as the middle part of a fire pan, the top opening serving for the fuel and the small hole below to let in the draft. The oven is in fact the only fixed attribute which the Antichrist figure had acquired during the Middle Ages. This is the instrument which the Antichrist probably carried in all the mystery plays. It can be proved from early sixteenth century municipal bills in Dresden that it was this object which was carried by the person who played the part of the Antichrist in the Saint John's Day procession of this city.[25] The burning oven occurs also in a Low German poem on the Antichrist.[26] That the oven came to be the Antichrist's attribute has its roots in Revelation 9:2, and in the allegorical interpretations of this passage. In addition, a comparison is made between Nebuchadnezzar, who thrust the three children into the fiery furnace, and the Antichrist, who in his time will throw the three Kings of the world—that is, entire mankind—into the fire of tribulation.[27]

For Jerome Bosch, of course, the great furnace of the Apoca-

[24] See above, note 15.
[25] Karl Theodor Reuschel, *Die deutschen Weltgerichtsspiele des Mittelalters und der Reformationszeit*, Leipzig, 1906, p. 53.
[26] *Ibid.*
[27] Honorius Augustodunensis, *Sacramentarium,* Cap. xlviii (Migne, *Patr. Lat.,* clxxii, col. 772).

lypse, the bottomless pit, which the expounders compare with the persecution and tribulations of Antichrist, is, above all, the Inferno. Thus he shapes the bottomless vessel into a picture of Hell. According to Dante's conception, the Inferno is a funnel-shaped structure and consists of a vestibule and nine circles, the successive circles narrowing as they descend to the lower end of the cone. In Botticelli's illustrations of Dante the introductory chart of the Inferno gives a picture of this structure.[28] If one compares this *Diagram of the Inferno* by Botticelli with the attribute of the Antichrist by Bosch, striking similarities will be found. That Bosch knew the illustrations of Dante by his contemporary is not altogether impossible, but need not necessarily be assumed. The basis for the relationship of the two representations is the general conception of Hell common in Europe and derived from Dante's description.

The companions by whom the false Messiah is surrounded are doubtless meant as his ministers, often referred to in the patristic commentaries and in later eschatological literature. . . .[29] Above the infernal group, at the top of the door of the ruined cottage, the breaches in the woodwork are stuffed with bundles of straw. Straw is a symbol of the wicked and of the false prophets, who in numerous passages of the Old Testament are compared with remnants of threshed grain ready to be thrown into the furnace.[30]

Still further up, directly below the roof, the decaying building shows curious formations of rotting roofing-felt, with a handful of straw tied and attached to it by a piece of cord. At the left, placed on the upper crossbeam of the cottage, a lizard and a little owl appear as additional symbols of uncleanness and devastation.[31] The

[28] F. Lippmann, *Drawings by Sandro Botticelli for Dante's Divina Commedia,* London, 1896, p. 27.

[29] Bousset, *op. cit.,* p. 188. That Bosch represents his Antichrist with five companions, one old man and four younger persons, is a feature in keeping with the Jewish tale of the fettered Messiah, and may not be a mere coincidence.

[30] Cf., for instance, Malachi 4:1; Jeremiah 23:28; Nahum 1:10.

[31] The lizard belongs to the unclean beasts (Leviticus 11:30). Bosch represents this animal frequently as a diabolic symbol. Cf. Bax, *op. cit.,* pp. 52, 95, 215, 307, and especially p. 110. The owl is also unclean (Leviticus 11:16, 17), and indicates devastation (Isaiah 13:21 and 14:11). The material adduced by Bax to illustrate the symbolism of the owl is enormous. For the many page numbers, see his "Register," p. 319: s.v. "uil." Bax does not, however, give the important passages in Isaiah, nor does he quote John 3:20, the passage which obviously formed the basis for the owl being used as the symbol of Jews, sinful people, and all vices that fear the light. Cf. also

bunch of straw with little flowers spread out on top may allude to
the bundle of tares mentioned in Matthew 13:30, but in any case,
with its long ends coming down like rays, it looks like a star. In
combination with the cloud-like shape of the decaying roofing-felt,
it is doubtlessly meant to be a fake star in a fake heaven, a symbol
of the fake Messiah. This false heaven with its false star forms a
contrast to the real sky with the real star of the Saviour represented
in brightest cloudless beauty at the top of the panel.

Taken as a whole, the Antichrist with his companions at the
left and the large animal head at the right, the two representations
framed by the hut and distinctly contraposed to each other, look
like an illustration of an idea expressed in the Apocalypse. In Reve-
lation 19:20 (and again in 20:10) the false prophet who deceived
men through miracles and the beast whose image was worshiped
are referred to in connection with each other. Both appear as rep-
resentatives of the evil power, and according to the apocalyptic
prophecy they are to be defeated and "cast alive into a lake of fire
burning with brimstone." In the text of Revelation, the "beast"
occurs as the double of the anthropomorphic Antichrist.[32] It is quite
obvious that the writer had a dragon in mind; the apocalyptic text,
however, does not give any description of the creature. Thus in
Bosch's painting the "beast whose image was worshiped" can ap-
pear as a donkey.

It is interesting to observe how Bosch achieves an elaborate
scenic representation of evil which combines an idea of the book
of Revelation with familiar features of the pictorial tradition. The
beast-idol of Revelation 19 is represented by the painter as the tra-
ditional ass of the Adoration scene, the "tertium comparationis"
being the old calumny of Jewish ass-worship. The false prophet
appears in the disguise of the traditional attendant of one of the
Kings, although actually characterized as the priest of the ass-idol,
and that a man with a Negroid face appears among his companions,
a feature paralleled in the traditional following of the three Kings,
makes the disguise still more perfect. The traditional decaying hut
of the Adoration scene, already implying the concept of the declin-

the passages on the owl in H. W. Janson, *Apes and Ape Lore in the Middle
Ages and the Renaissance,* London, 1952, especially pp. 178 and 196, note
91.
[32] Cf. Bousset, *op. cit.,* pp. 183–188.

ing Synagogue, now actually adopts the signification of the Jewish Temple in forming the shelter for the ass-idol and its priest.

The somewhat speculative method of amalgamating ideas taken from different spheres into an organic pictorial unity is characteristic of the art of Jerome Bosch. It is to a great extent responsible for the mysterious charm of his paintings. The modern spectator is usually familiar with only a very few of these ideas, and is hardly ever aware of the context from which they are taken and of their complicated interrelations. For him, chiefly attracted by the pictorial qualities of the painting, this specific kind of representation has only the additional appeal of abstruseness. For the art-lover of his own time, however, Bosch's pictures must have been a most fascinating experience.[33] Recognizing familiar ideas in a brilliant, new, and surprising combination must have induced an immediate psychological effect comparable to the pleasure given by a clever joke.

Besides the elements discussed above, Bosch's representation of evil includes a number of features taken from still another context. These derive from the ideas of a Biblical parable found in John 10, the parable of the Good and Bad Shepherd. This chapter of the fourth Gospel provided the painter with some of the basic ideas of his representation of evil concentrated in and around the decaying hut, and furnished him, as will be shown later, with one of the leading thoughts of his entire composition.

An odd feature of Bosch's scene of the Adoration is the unusual way in which the shepherds are represented. Not only is it remarkable that one of them is peering through the defective wall like a spy, but that his companions should choose to climb up the tree and lie down on the roof of the cottage in order to look upon the scene is an absolutely unique way to represent the Adoration of the Shepherds. In fact, Bosch does not really represent them as adoring, but rather uses the traditional figures of the shepherds to add another feature to his representation of evil.

The cottage in the center panel of Bosch's altarpiece is not

[33] Philip II of Spain, who owned the altarpiece discussed in this paper, though living a hundred years later than Bosch, was probably still able to "read" the paintings without "research." The pleasure he must have found in deciphering them possibly accounts to a great extent for his enormous appreciation of the artist's work.

only the stable of Bethlehem and the fallen hut of David, symbol of the Old Law, but also the symbolic sheepfold of the parable told in John. In John 10:7–9 the Lord calls himself the sheepfold's door, emphasizing that all who enter through this door will be saved, and all who came before him he calls thieves and robbers. In Bosch's presentation, likewise, the door of the stable is still occupied by the "thieves and robbers," the Antichrist with his companions. Bosch's Antichrist is undoubtedly also the Bad Shepherd of the Johannine Gospel. He is the hireling described in John 10:12–13 who sees the wolf coming and flees. It is not only the figure standing in the door with the bell hanging between his legs that proves the relation of the picture to the Biblical passage; it is, above all, the strange behavior of the shepherds.

The chapter begins with the words of the Lord: "Verily, verily, I say unto you, he that entereth not by the door into the sheepfold, but climbeth up some other way, the same is a thief and a robber." This "climbing up some other way," sign of the foolish behavior of the lost soul who does not enter through Jesus, the door, is certainly what Bosch wanted to illustrate by the strange way the shepherds are depicted. The shepherds in Bosch's painting are thus another symbol of evil and perdition. They are not represented as the worshipers of Christ, but belong to the realm of the fallen hut.

The way may have been prepared for this very strange reinterpretation of a traditional feature of Christian iconography— turning it into its very opposite—by some lost representation of the parable of the Good and Bad Shepherd invented by Jerome Bosch before he painted the Prado altarpiece. It may be that Brueghel's representation of the *Good Shepherd,* which has come down to us as an engraving, shows a reflection of this composition.[34] In the engraving the thieves' climbing up the roof is a very prominent feature.

The complex representation of the hut in Bosch's painting is composed in such a clever, cunning way, hiding its real meaning by the use of traditional features, that the naïve worshiper was probably not much bewildered or disturbed by it. . . .

While the Madonna with the Holy Child is distinctly separated from all the infernal symbols of the picture, the spectacular

[34] René van Bastelaer, *Les estampes de Peter Bruegel l'ancien,* Bruxelles, 1908, no. 122, *La parabole du bon pasteur* (engr. by Philip Galle), 1565.

figures of the adorers are depicted in the closest relation with them. The Antichrist fills the space between the standing Negroes and the two kneeling Kings; the donkey appears between the latter worshipers and the tree trunk that divides the group from the figure of the Madonna. The complex of the hut is, in its larger part, the actual background for the three Magi. This is no accidental feature of the composition. Bosch actually saw a very close inner relation between the Antichrist and the three Kings.

Jacques Combe has already mentioned that in the attire of one of the Kings there may be signs which point to the survival of evil.[35] The chief representation, however, on the pompous collar of the younger kneeling King obviously shows the Queen of Sheba visiting Solomon; and the decoration of the Moor's gift certainly depicts the story of the three heroes offering water to David, and not any heretical scene.[36] These two representations taken from the Old Testament prefigure the New Testament story of the Adoration of the Magi. The gift of the oldest King represents Abraham's Sacrifice prefiguring the Crucifixion of Christ. Thus each of the three Kings is depicted with at least one symbol the integrity of which is above suspicion. Since paintings of the Epiphany, when used as center panels of altarpieces, always illustrate the Christian sacrament of the Mass, it is clear that the persons bringing the gifts had to appear with symbols of Redemption. Other symbols on the costumes of the Kings, however, are allusions to heresy and signs of the equivocal character of their wearers. Not only are the waggish fish and bird decorations of the garments worn by the Negroes symbols of evil, but also the helmet in the foreground belonging to the oldest King and the second King's helmet held by the Antichrist show emblems of obviously diabolic character.[37] This, however, is not very sur-

[35] Jacques Combe, "Analytical Notices," no. 108, *op. cit.*, p. 94.

[36] "A swan is offered to a king" (*ibid.*, p. 94) is a misinterpretation. Another incorrect interpretation is "Noah's Sacrifice" for the scene under the *Visit of the Queen of Sheba* on the younger King's collar (Tolnay, Baldass, Combe). It is rather, as Prof. Kurt Bauch kindly informed me, the Sacrifice of Manoah.

[37] The big fish eating the small one at the hem of the boy-attendant symbolizes evil in a greedy world, where the powerful devour the weak (Bax, *op. cit.*, p. 29). The apple on the boy's head, which occurs in very similar manner on the heads of the Negroes and Negresses in Bosch's *Garden of Delights* (Combe, *op. cit.*, pls. 88 and 89), is probably a symbol of *Superbia*, signifying arrogance (Bax, *op. cit.*, p. 20, note 3, and p. 88, note 120). It

prising. The wise men from the East who, according to Matthew 2, came to pay homage to the new-born King of the Jews were pagans and magi and their heathen character is very much emphasized in the Gospel. In fact, the chief tendency of the Biblical story—and on this all ancient and modern expounders agree—is to illustrate the fact that the Jews rejected the true Messiah, while the pagans made the long journey in order to worship the future Redeemer of the world.[38]

In Bosch's painting, however, the three Kings are not represented as pagan converts in contrast to the unbelieving Jews.[39] On the contrary, they have a very intimate relation to the Antichrist, who is here characterized as the Jewish Messiah. The emblems of their costumes cannot be interpreted as symbols of converted paganism, but indicate rather that their wearers are under the temptation of the wicked. As shown above, it is characteristic for Jerome Bosch to combine ideas taken from different contexts. The equivocal character of the worshiping Kings is another example of such a conjunction.

In the mediaeval tradition, the wise men from the East who, in the text of the Gospel, are only called magi, have become three kings who have left their countries in order to bring gifts to the

is possible, however, that it has, besides, a sinful sexual meaning. The pictured flange at the hem of the Negro King's tunic definitely presents symbols of sin in a sexual sense. For the erotic meaning of the bird, cf. *ibid.*, pp. 19, 108. The combination of birds' bodies with human heads probably has its origin in the popular comparison of human beings with birds (*ibid.*, pp. 60 f.). For the sexual meanings of the bird picking at a fruit, cf. *ibid.*, p. 66. This representation is, however, also a symbol of the vice of *Superbia*. Cf. Brueghel's *Superbia* (*ibid.*, p. 70, note 11). On the helmet of the eldest King, the two herons with fruits in their beaks are obviously evil emblems. Bosch frequently uses the long-beaked bird as a symbol of unchastity (*ibid.*, p. 70, note 51; pp. 102, 173). The second King's helmet also shows herons, and demons and monkeys playing with them. For the ape in combination with large, long-necked fowl, cf. Janson, *op. cit.*, p. 120.

[38] See the article by P. P. Levertoff and H. L. Goudge, in *A New Commentary on Holy Scripture*, New York, 1928, pp. 132 f.

[39] The unbelieving Jews are actually represented in some paintings of the Adoration of the Magi. Cf., for instance, the copy of Hugo van der Goes in the collection of Don Juan de Valencia, Madrid (Friedländer, *Die altniederländische Malerei*, Vol. 4, pl. xxxii); the painting by Pieter Brueghel the Elder, in the National Gallery, London (no. 3556); and a composition with many figures by a follower of Botticelli in the Uffizi, Florence (Alinari no. 606a).

infant Messiah. The text of Psalm 72:10, which has made its way into the liturgy of the Epiphany, is probably chiefly responsible for this concept, and the passages of the Apocalypse in which Christ is called "King of Kings" (Revelation 17:14, 19:16) are very much in accord with this conception. In mediaeval representations of the Epiphany, Christ is the King of Kings, and the three Kings symbolize the three continents of the world known at that time.[40] Thus compositions depicting the Adoration of the Magi are representations of Christ as the Master of the entire world. . . .

The same book, however, which emphasizes that Christ is the King of Kings indicates in various passages that the Kings of the earth are seduced and ruled by evil. In Revelation 16:14, 17:18, and 18:3, for instance, this is stated quite clearly. This coincides with the prevailing trait of the legend of the Antichrist, which makes him the seducer and the leader of the Kings of the world.[41] In mediaeval book illustrations the Antichrist is frequently represented as the seducer of the Kings. While in the fifteenth century block-books he appears with only one King at a time, he is depicted with two Kings in one of the miniatures of the *Hortus Deliciarum.*

It is quite obvious that Bosch has combined the two ideas, and that he represents the same three Kings who are worshiping Christ as the three Kings who are under the influence of the Antichrist, and who will be seduced and led to perdition by the impostor.

Although this surprising and daringly direct connection of ideas is unique in Christian tradition, and only possible in the gruesomely pessimistic philosophy behind the art of this late mediaeval painter, the thought seems to have already been potentially in existence. In the *Sacramentarium*[42] Honorius of Autun compares Nebuchadnezzar with the Antichrist, and he states on this occasion that in his time the Antichrist will cast the sons of Noah into the furnace of tribulation. When Honorius explains that the three sons of Noah signify entire mankind from all three parts of the world, Asia, Africa, and Europe, this reads precisely like an exposition of

[40] For the allegorical interpretations of the Adoration of the Magi, cf. the article "Drei Könige," in Michael Buchberger, *Lexikon für Theologie und Kirche,* Vol. 3, Freiburg, 1931, p. 452. The interpretation of the three Kings signifying the three continents occurs in Bede (Migne, xc–xcv).

[41] Cf. above, note 19.

[42] See above, note 27.

the Epiphany. I do not think, however, that the idea of the connection between the three worshipers of the infant Christ and the three Kings led to perdition by the Antichrist has ever been actually expressed in literature.

By placing the three Kings in this manner between good and evil, Bosch makes them a symbol of the world existing between the divine and the infernal powers. This, I think, is the essence of the painting; through it all other features of the altarpiece can be explained. . . . The subject of Bosch's Epiphany is the world. Indeed, the entire painting is determined by this theme. While the middle distance and the background in earlier altar paintings usually show the Kingdom of God as a paradisaic realm, in the composition by Bosch even these subordinate areas depict the opposite, namely the godless world possessed by the devil. Also on the reverse side of his altarpiece Bosch has given a picture of the evil world. There even Christ and the Passion are seen *sub specie mundi*.[43]

This new perspective brought about a very serious change in the character of the Christian altarpiece. . . . Since Bosch not only pictures the world as evil, but the Passion as the result of its wickedness and Christ as a helpless sufferer from it, the original purpose of the altarpiece has actually been abolished. Christ and his life no longer appear as powerful reassurances of the accomplished Redemption. . . . This change brought the altar painter and the altar painting into what may be called a tragic predicament. Bosch, the first "painter of the world," appears as the moral rejector of his own subject. . . . But the work of Bosch, having the world as its theme, very definitely led to secular art. While the religious painters of the following generations had to make use of the accomplishments of the Italian Renaissance in order to establish a new ecclesiastical art, Bosch's work became the basic influence for the work of Pieter Brueghel who, two generations later, resumed the ideas of Jerome Bosch and transformed them for his own secular creations.

[43] For detailed discussions of these areas, cf. the original article.

WITCHCRAFT IN A WORK BY BOSCH

Charles D. Cuttler

It has long been considered by almost all writers on the subject that Hieronymus Bosch incorporated within his paintings forms and ideas related to witchcraft. In the Lowlands the fear of witchcraft had already resulted in the notorious *Vauderie d'Arras* of 1461, an instance of mass hysteria which was to produce so many horrible deaths in the following centuries. Witchcraft was certainly nothing foreign to the men of the Lowlands in the later fifteenth century, and it is natural to look for some aspect of it in the paintings of Bosch. Numerous scholars have asserted a connection between Bosch and witchcraft, but unfortunately, no scholar who has published his discoveries or opinion has been able to quote chapter and verse. In 1909 Muther saw in the Lisbon triptych of the *Temptation of St. Anthony* (Fig. 9) the revelation of a witches' sabbath,[1] an undocumented idea which has persisted and is still to be found in the most recent literature in the articles and books by Chastel, Tolnay, Baldass, Combe, among many, where it still lacks documentation. These writers concentrated their attention upon the group about Anthony in the central panel, which in form and aspect is at decided variance with the few known contemporary representations of the heretical sabbath rites.

"Witchcraft in a Work by Bosch," by Charles D. Cuttler. From *The Art Quarterly*, Vol. 20 (1957), pp. 128–40. Reprinted by permission of the author and the publisher.
[1] Richard Muther, *Geschichte der Malerei*, 1909, Vol. 2, 199.

Representations much earlier than the fifteenth century are not to be looked for, since witchcraft as a developed concept only appeared late in the history of the medieval world. Not an isolated phenomenon, it had evolved in the transformation of the seven, sometimes eight, capital sins into the Seven *Deadly* Sins.[2] The growth of belief in witchcraft and other aspects of magic served to confuse and further hinder medieval man from achieving his salvation. Sin became more complex even as the possibilities for committing sin increased in number. Witchcraft was a relatively new danger whose roots, however, are to be found in basic Christian belief.

The late medieval conception of evil, and witchcraft is one of its clearest manifestations, had a long and varied evolution. When early Christianity assimilated the Persian dualistic conception of the conflict of Good and Evil, it abandoned the Hebraic monism of the Book of Job wherein Satan is merely the instrument of God. This Oriental dualism is expressed in medieval monasticism as a direct contest between the monk and evil; demonic forces were overcome as long as the monk lived a life in Christ, existed as a true *miles Christi*. Within the Christian theological framework, however, this simple concept of dualism was gradually replaced by a more complex attitude. From the theological standpoint seemingly there was a partial return to the Hebraic concept of Satan as an instrument of God; yet in the popular mind the Devil was eventually to receive augmented and even magical powers. The augmentation as well as the manner of augmentation was new and significant. Demonic power indirectly received an impetus from the ideas of magic attached to Arabic astrology, mathematical tables, and chemical formulae brought to Europe as a result of the Crusades; magical ideas to reinforce like ideas always alive in European superstitious belief. The elements for a change in the dualistic conception had existed in scattered form in patristic writings. The reality of magic, the ability of demons to inflict bodily harm or to cause impotency in sexual relations, their ability seemingly to transform men into animals, to act as incubi or succubi, to make weather (usually nasty); these are conceptions appearing in the older literature, many of them in St. Augustine. In the hands of the great scholastics they

[2] Morton Bloomfield, *The Seven Deadly Sins,* Michigan State College Press, 1952.

became part of a tight and fully ordered theology. When St. Thomas
Aquinas asked whether demons can delude men by performing
miracles, and answered affirmatively, he thereby asserted that all
that happens visibly in this world can also be accomplished by
demons; more, his conclusion gave the world into the power of the
Devil.[3] At work with God's permission he could go even further
than before in tempting, cajoling, bedazzling with riches, or destroy-
ing the boundaries between the true and the false by use of his
new powers. Tacit admission of this new and dangerous extension
of demonic power characterizes the tracts and decrees against
witchcraft. Of these, the two outstanding examples from the late
fifteenth century are: the bull of Pope Innocent VIII, *Summis desi-
derantes affectibus*, of 1484[4]; and a handbook for witch detection,
the *Malleus maleficarum*, or "Witches' Hammer," written by two
German Inquisitors, Henricus Kramer and Jacobus Sprenger, pos-
sibly published as early as the following year, 1485.[5]

The fully developed conception of a heretical sabbath made its
initial appearance in a trial of magic at Toulouse in 1335; after that
date it spread rapidly and historians of the movement note a fusion
by 1430 of the scholastic view of witchcraft with the Inquisition's
conception of a witches' sabbath.[6] The *Vauderie d'Arras* was not
far distant; tracts against the crime of witchcraft, or *vauderie*, were
circulated and persecutions increased in number.

Not only is it a chronological possibility for Bosch to have
witnessed or participated in the hysteria at Arras in 1461, but the
central panel of the Lisbon triptych seems to invite a search for
transformed and castigated participants in a black mass in the fan-
tastic crew which surrounds the kneeling Anthony. All previous
efforts at interpretation have been unsuccessfully directed at this
group, which in reality bears an entirely different significance. Had
attention been concentrated on the neglected wings, more reward-
ing motifs to validate the thesis of a castigation of witchcraft could
have been found.

In the middle zone of the left wing a mitred figure leads three

[3] *Summa theologica*, I, Q. 114, art. 4.
[4] *Bullarium S. S. Romanorum Pontificium*, Turin, 1860, Vol. 5, 296–298.
[5] Hain-Copinger, 9238.
[6] Joseph Hansen, *Zauberwahn, Inquisition und Hexenprocess im Mittelalter und
die Entstehung der Grossen Hexenverfolgung*, Munich, 1900, pp. 35, 315.

companions into sinful living exemplified by the structure at his back (Fig. 10). This is created from the form of a kneeling man seen from behind. Between the legs is a raised portcullis with the head of a peering man visible beneath it. To the left of the entrance a woman looks out of an embrasure near which is seen a leaning staff and a barrel. The description of the structure is completed for us by the flag. This, the staff, the barrel and the woman at the window are also found at the left of Bosch's painting of *The Prodigal Son* (Boymans Museum, Rotterdam), where the flag shows a swan whose white exterior was commonly considered to cover black flesh (Matthew, 23:27). Clearly these are houses of prostitution and in the Lisbon work Bosch takes pains to make certain that the spectator does not miss his meaning; grass grows on the kneeling man's back and short branches grow from his legs to indicate that he is rooted in earth, which to Bosch meant being rooted in sin. The mitred man gestures with a three-fingered hand to indicate the place to his queer companions. One is a fat, spoon-billed bird in monkish costume who may possibly denote sinful monks, another is a stag-headed figure in a red cloak, who calls to mind the elaborate parallel drawn between a lecherous man and a rutting stag in the moralizing tales of the early fourteenth century Franciscan, Nicole Bozon.[7] A fourth figure seen from the back at the edge of the frame is an uncharacterized accessory to the three main figures. The crescent topping the staff of the mitred figure is an unequivocal reference to the Turks, whose heretical beliefs and denial of Christ is indicated. This heretical figure wears a mitre which when examined closely is seen to be aflame. Its decoration differs from normal ornamentation by the omission of the banding and by showing in place of the orphrey a circular motif of no known meaning. Now heretics handed over to the Inquisition had a mitre placed on their heads just before they were led to the stake. This is known from the accounts of the witchcraft trials at Arras where a condemned woman was saved from burning with the last group only because her mitre was not ready[8]; this is probably such a mitre. The flames issuing from Bosch's mitre validate the interpretation; Bosch has allied

[7] Lucy Toulmin Smith and Paul Meyer, *Les contes moralisés. Publiés pour la première fois d'après les manuscrits de Londres et de Cheltenham,* Société des anciens textes français, 1884, p. 56 f.
[8] Otto Cartellieri, *The Court of Burgundy, Studies in the History of Civilization* (trans. Malcolm Letts), London, N.Y. 1929, pp. 196 ff., 203.

witchcraft with heresy. For this he had the authority of no less than St. Thomas Aquinas, who expressly maintained the reality and heretical nature of magic,[9] and of the Inquisition, which vigorously asserted the heretical nature of magic (i.e., sorcery and witchcraft), and prosecuted it just as vigorously. Thus a first instance of the appearance of witchcraft.

A further instance of Boschian awareness of, and close acquaintance with, the witchcraft delusion appears in this same triptych in the fish high in the sky of the left and right wings. A recent writer on this triptych, D. Bax, studiously avoided the witches' sabbath as a motivating factor in its iconography, preferring to find throughout a castigation of Carnival.[10] Witches do appear in his consideration but only tentatively and in minor degree when he discusses the mounted, flying figures in the central panel and on the right wing. Yet all three panels present mounted flying figures, and one motif is constant: the use of a fish as an aerial mount. Combe had noted that a flying fish serves as a mount for Venus in a woodcut employed by Johann Zainer of Ulm for his *Almanach* of 1498,[11] and Bax has agreed that this is a possible source, also that the flying motif might be related to witchcraft.[12] But the original association of Venus and the flying fish is neither derogatory nor related to witchcraft, contrary to the use made of the fish motif in Bosch's painting.

One may thus be pardoned for looking elsewhere than the 1498 *Almanach* for Bosch's artistic source. If attention is given to the upper portion of the left wing of the triptych it is noted that a ship flies through the air on the back of a vicious monster of uncertain breed (Fig. 10). An illumination in an English bestiary has been asserted by Bax to be its source.[13] There is no doubt in the mind of the present writer that Bosch transformed the whale of a bestiary model into the form presented in the Lisbon work. It was normal in the bestiaries for sailors to land their ship on an "island," occasionally shown with full-grown trees, which turns out to be the

[9] *Loc. cit.*
[10] D. Bax, *Ontcijfering van Jeroen Bosch,* 's-Gravenhage, Nijhoff, 1949.
[11] Jacques Combe, *Jérôme Bosch* (trans. Ethel Duncan), Paris, Tisné, 1946, pl., p. 36.
[12] Bax, *op. cit.*, p. 104.
[13] *Idem,* p. 34 ff., fig. 105.

sand-covered back of a whale. When several sailors build a fire on the "island" the results are disastrous. The tale had wide currency in medieval belief and travel lore as well, for it also appears in the fabulous voyages of Irish saint Brendan, or Brandon, who also landed on such an "island" and whose men were also so incautious as to build a fire upon it, though the result in this case was a great inconvenience and not the normal death and disaster associated with the tale as it appears in the *Physiologus* and the bestiaries. This story of the whale is still popular for it can be found in contemporary anthologies of Middle English literature.

Now the whale was never considered a flying fish. But there is another fish in the bestiaries which did indulge in aerial flight, and by such action eventually found itself allied to the Devil who in the Middle Ages had almost exclusive control of the air over Europe. This was the *serra*, or sawfish, which in an English bestiary of about 1170 from Radford Priory, Morgan MS. 81, folio 69, is uniquely identified as having its home at Tyre in Syria.[14] Its activity was not always of an aerial nature. It sailed, swam, even stood erect in the water and frequently caught the wind in its large wings to the consternation of unfortunate seamen thereby becalmed by the monster. Its habit was to pursue ships at sea for "stadiis xx vel xl" [approximately 20 to 40 furlongs] until its wings tired, whereupon it folded them, sank into the depths and returned whence it had come; thus in the *Physiologus*, the English bestiaries, and the Anglo-Norman bestiaries such as that of Guillaume le Clerc, the *serra* symbolizes those who start out doing good deeds but turn aside to fall into a variety of sins, the "premium" going to those who persevere. It was even considered to be the Devil himself.[15]

It is not difficult to understand how the whale, able to destroy men and ships by its sudden submersion, could be allied in medieval thinking to the destroyer of men's souls, the Devil. A glance at the text of the *Physiologus* makes this quite clear.

[14] For the *serra* see the excellent paper of G. C. Druce, "The Legend of the serra, or sawfish," *Proceedings of the Society of Antiquaries of London*, 2nd series, Vol. 31 (1918–19), 20–35, with numerous illustrations; for the Morgan MS. a readily available illustration is found in plate II, Robb and Garrison, *Art in the Western World*, New York, numerous editions.

[15] Druce, p. 30.

There is a great monster in the sea called the Whale. He has two attributes. His first attribute is this: when he is hungry, he opens wide his jaws, and therefrom streams a very sweet savor. And all the little fish gather themselves in heaps and shoals around the whale's mouth, and it laps them all up; but the big and full grown fish keep away from him.

So do the Devil and the heretic, through their pleasant speaking and the seduction of their savor, tempt the simple and those who are wanting in judgment. But they of good and firm understanding are not to be so caught. Job was a fully grown fish, as also were Moses, Jeremiah, Isaiah, and the whole choir of prophets. So likewise had Judith the power to escape from Holofernes, Esther from Artaxerxes, Susannah from the elders, and Thekla from Thamyris.[16]

The relationship between the Devil and the heretic is clearly stated. The enticements of the Devil, who as fallen angel was originally the supreme heretic, can result in leading men to perform heretical acts, thus the Devil is both the instigator of Heresy and its basic support. Now witchcraft was certainly an heretical act. Witches, thought to be faithful followers and worshipers of the Devil, according to the bull of Innocent VIII, ". . . blasphemously renounce the Faith which is theirs by the Sacrament of Baptism, and at the instigation of the Enemy of Mankind they do not shrink from committing the foulest abominations and filthiest excesses. . . ." [17] Since the whale and the *serra* are "belua in mare" (and any monstrous form was generally considered as having demonic origin by the medieval mind), a linkage of these devilish monsters of the sea with the workers of magic and witchcraft was very early a theological possibility.

With the evil character of both monsters well established, as well as a possibility of their relationship to witchcraft, we can now allow ourselves to be struck again by the fact that the *serra* appears in that type of illuminated manuscript from which Bosch extracted the motif of the whale with the ship on its back for use in his Lisbon triptych. Though the writer knows of no textual connection between fish and witchcraft, it cannot be denied that Bosch did not consider his fish as benign; their placement far outside their natural element

[16] *The Epic of the Beast, consisting of English translations of the History of Reynard the Fox, and Physiologus* (Broadway translations), with an introd. by William Rose, London, N.Y., n.d., p. 205.
[17] *Malleus maleficarum* (trans. Montague Summers), London, 1928, p. xliii.

in that realm normally controlled by the Devil is sufficient indication. It is not unreasonable to assume that Bosch extracted more than one motif from the bestiaries; that he also took the *serra,* whose description normally follows that of the whale in the bestiaries, considered it too as demonic, and thereby realized in painted form the aforementioned theological possibility. It need not surprise anyone that the realization comes from a man whose modes of thought were so much in keeping with the excessive use of symbolism which characterizes the late medieval period. In the fishlike monster with the ship on its back, on the left wing of the Lisbon triptych, we find the Devil. We shall also find him in the aerial group on the right wing (Fig. 11).

The foremost rider of this latter group shows an analogy in the grossness of his form to the temptations of Gluttony to which St. Anthony is subjected in the lower portion of the panel. The driver has an egg-shaped body and carries a long pole over his shoulder; it even seems to go through his mouth. From the end of the pole dangles a burning pot. A certain gluttonous connotation arises to suggest a comparison with a representation in a German manuscript of the second quarter of the century. There Gluttony rides on a fox, carries a spitted and roasted fowl over her shoulder and chews on a chicken leg. The line of the chicken leg and the line of the spit are almost parallel, and give a like suggestion of continuity.[18] An earlier German manuscript had presented Gluttony as an armored knight mounting a fish on his shield as his emblem.[19] An association of this rider with the now deadly sin of Gluttony seems to establish itself with little difficulty. But the female passenger who looks out at the spectator reveals none of these gluttonous affiliations and, indeed, seems to be decidedly accessory to her escort.

The reason for this innocuous accompaniment can be attributed to the model transformed by Bosch. That model betrays an undeniable acquaintance with witchcraft, for it is the sole miniature in a tract against the crime of *vauderie* (that is, sorcery, witchcraft) in MS. 11209 of the Bibliothèque royale, Brussels.[20] In the

[18] Fritz Saxl, "A Spiritual Encyclopedia of the Later Middle Ages," *Journal of the Warburg and Courtauld Institutes,* Vol. 5 (1942), 116, pl. 29b.
[19] *Ibid.,* pl. 29a.
[20] As far as is known the MS. belonged to the Dukes of Burgundy shortly after

air at the right of the miniature on folio 3 recto, a couple rides a peculiar mount with demonic head, claw feet and sheep-like body. The man and woman who look out toward the spectator are the heretical practitioners of the black art on their way to join the central group at its devotions. Of pertinent interest is the merger of the arm of the woman with the body of the man, identical in this detail to what is found in the aerial group on the right wing of the St. Anthony triptych. Bosch has copied this motif exactly, and indeed might have known this very work, since a later version of the subject presents the same intriguing main theme but alters the winged accompaniments.[21] Thus the theological possibility is again realized in visual form; the Devil as a fish carries on his back the heretical practitioner of witchcraft.

The fish itself was undoubtedly derived from the demonic *serra,* and the heretical followers the Devil literally supports are clearly derived from the Brussels miniature or its very close family relations, to which Bosch added an overtone of Gluttony. Further confirmation of the relationship between the two aerial groups on the wings and the heretical crime of witchcraft is found in closer examination of the men in the ship on the back of the flying monster on the left wing. The figure looking back through his legs at the tormented saint repeats in modified form the underlying idea expressed more crudely in the central group of the miniature adduced as a source for the aerial riders of the right wing. The linkage is not fortuitous.

The relationship to literary sources evident in these forms and the relationship to artistic sources presented here are thoroughly in keeping with an extremely literal-minded painter's translation of literary subject matter into painted form. This has previously been pointed out by Émile Mâle in reference to the *Visio Tondali,* illus-

its execution, since it is recorded in the inventory of 1467, and its style does not allow it to be given a much earlier date. I wish to thank M. Frédéric Lyna, former director of the Bibliothèque royale, for allowing me to see his discussion of this MS. in the as yet unpublished third volume of his monumental catalogue, and Dr. L. M. J. Delaissé of the Cabinet des MSS. for calling the illumination to my attention.

[21] Paris, Bibl. Nat. MS. fr. 961; illustrated in both English and German editions of Cartellieri, *op. cit.,* in the former, pl. p. 190.

trated on the right wing of the Haywagon triptych in the Escorial,[22] and most recently by Erwin Panofsky in reference to the *Garden of Earthly Delights,* also in the Escorial.[23] The first work is related to Denys the Carthusian's *Quatuor novissima,* the second to Deguile-ville's *Pilgrimage of the life of man.* The existence of such transla-tions, and of the witchcraft miniature, reinforces the possibility of an early training of the painter as an illuminator. In any case, here is further evidence of a close relationship of the painter to the pre-vailing popular literature of his day.

There can be little doubt that Bosch intended by the aerial groups on the wings of the Lisbon triptych, and by the group cen-tered around the mitred figure in the middle zone of the left wing, to castigate the crime of witchcraft. The bestiaries, already demon-strably employed by Bosch, yield both literary and artistic sources; the miniature in the treatise against witchcraft adds yet another artistic source. Thus Bosch reveals in his Lisbon triptych of the *Temptation of St. Anthony* both knowledge and horror of witchcraft, one more motif within the complex structure of the painter's imagi-nation.

[22] Émile Mâle, *L'art religieux de la fin du moyen âge en France,* Paris, 1922, 2nd ed., p. 468.
[23] Erwin Panofsky, *Early Netherlandish Painting, Its Origins and Character,* Cambridge, Mass., 1953, Vol. 1, 357.

ON THE MEANING OF
A BOSCH DRAWING

Jakob Rosenberg

The drawing of *Owls in a Tree* by Jerome Bosch, belonging to the
Boymans Museum in Rotterdam and formerly in the Koenigs Col-
lection, has often been discussed and we can add little here to the
clarification of its iconography. Yet in a work by a great artist even
a few additional observations may be worth while, though they do
not lead to a full solution of its original meaning.

Charles de Tolnay says about the Koenigs drawing:

> It doubtless illustrates the proverb "This is a real nest of owls," and
> belongs to the group of drawings with compositions which are com-
> plete works of art in themselves. This section of a tree-trunk which
> crosses the whole surface of the sheet and is sharply cut off against
> the distant hills of the landscape, the mysterious life of the owls
> which it shelters, reminds one of the art of the Far East and, at the
> same time, of a close-up from a documentary film.[1]

Otto Benesch also believes it to be an illustration of the proverb
just quoted, and he adds a few descriptive sentences:

"On the Meaning of a Bosch Drawing," by Jakob Rosenberg. From *De Artibus
opuscula XL—Essays in Honor of Erwin Panofsky*, Millard Meiss, ed. (New
York, 1961), pp. 422–26. Reprinted by permission of the author and the Insti-
tute for Advanced Study, Princeton.

[1] Charles de Tolnay, *Hieronymus Bosch*, Basel, 1937, p. 49. [See pp. 57–61 in
this book.]

The owls have built their nest in a hollow tree, with which they form almost a unit. They are rather active, as if darkness is nearing —or perhaps, more correctly, as if the morning is breaking and they seek refuge. The magpies are also around, as in the Berlin drawing [Fig. 20]. Although some of them behave as if they are watching the spiders in their webs or the insects in the tree, others cannot refrain from scolding the owls which, with their mask-like faces, have a curious human aspect.[2]

Ludwig von Baldass gives the most elaborate description and offers some very observing remarks. He says:

The motif of the owl around which flutter day birds comes back in the most beautiful and perfect drawing in the Koenigs Collection. We find here three owls around the thick trunk of an oak, two of them with spread wings [this, however, is a mistake because only the central owl spreads its wings, while the one below sits in a hole], the third one perched half-hidden by the tree. A magpie-like bird flies furiously toward this one, another watches a spider in a web, while two more birds look for insects, one on the trunk, the other on the branches, in the manner of woodpeckers. In the distance stretches a vast landscape with trees, softly sloping hills, and a town. A wheel for the execution of criminals is not omitted. The effect of the drawing is that of a complete composition with the broad tree trunk as an excellent center. Yet I do not think it impossible that the drawing has been cut down, at least on its lower part, and is fragmentary. In any case, its lower part, without any foreground, is rather unusual for this period. Perhaps we have here the upper half of a drawing, somewhat cut also on the sides. The seeming completeness of the composition is no argument against such an assumption, since it is easy to find such details in his pictures.[3]

Jacques Combe says about our drawing:

The analogy in the treatment of landscape allows placing in the same period [as the Vienna drawing] the marvelous drawing of the *Nest of owls* in the Koenigs Collection, where once more we find the hollow tree associated with the night bird. But here the hidden symbolism does not impose fantastic inventions on the ico-

[2] Otto Benesch, "Der Wald, der sieht und hört," *Jahrbuch der preussischen Kunstsammlungen*, Vol. 18, 1937, p. 260.
[3] Ludwig von Baldass, *Hieronymus Bosch*, Vienna, 1943, pp. 84–85. [See pp. 62–80 in this book.]

nography. The symbolic image is at the same time an image full of grandeur in the aspect of nature, and, in conformity with the late paintings of the master, the tranquil and grand style which now unfolds brings with it the expression of space and the material character of things . . . as in the coarse beauty of the wrinkled bark of the tree.[4]

Dirk Bax, finally, has the following to say:

> In another drawing three owls in a tree attract birds. In the distance one sees a wheel on a place of execution and a crowd of people moving toward it. This is a symbolical allusion to men shunning the light and walking in darkness, and, at the same time, to the punishment for this weakness. There is, however, no allusion to the proverb "This is a real owls' nest." The proverb means only "This is a decayed and dark place." [5]

These five authors, then, offer different interpretations and agree only on certain points. But before reviewing the problem of the drawing's meaning, we must clear up a stylistic point that has a bearing on the iconographical solution. This is the fact that the drawing is indeed incomplete. Baldass alone, of all the five, suspected it, but we can be more definite about this. One easily discovers the fragmentary character by comparing the drawing with the two others already mentioned, which are complete compositions rather than studies of details: the one in Berlin (Fig. 20), interpreted as an illustration of the proverb "The field has eyes, the wood has ears; I will look, be silent, and listen," and the one in Vienna called *The Tree-Man*. These drawings confirm, as does the whole of Bosch's work, that the artist never brings into his compositions the distant view of a landscape without connecting it with a foreground. The cut-off character of landscape which the Koenigs drawing shows in its present condition has a modern appeal, but runs counter to the stylistic feeling and attitude of late fifteenth-century art.

We offer here (Fig. 21) a rough attempt at a reconstruction of the drawing's total format in accordance with the Vienna drawing, bringing the horizon up to the same height within the composition. This reconstruction also takes into consideration the motif of

[4] Jacques Combe, *Jerome Bosch*, Paris, 1946, p. 47.
[5] Dirk Bax, *Ontcijfering van Jeroen Bosch,* The Hague, 1948, p. 159.

an owl attacked by day birds, a motif that is not sufficiently evident in the present fragmentary form of the drawing but was rightly sensed by Baldass and Bax.

To this motif and its meaning we must first devote some attention. Bosch did not have to go very far to inform himself. He could have picked it up most easily in the *Dialogus creaturarum,* which appeared in Gouda in 1480 and gained wide popularity, as evidenced by its repeated editions. In this book we read about the abominable vices of the owl, which shuns the light and attacks other birds in the darkness: "It is cruel, greatly loaded with feathers, full of sloth and feeble to fly. . . . It lurks in churches, drinks the oil of the lamps and defiles them with its excrement. . . . With this bird many other birds be taken that fly about her and rob her of her feathers. For all they hate her and be enemies unto her." [6] Thus in this late medieval conception (the text of the *Dialogus* stems from the mid-fourteenth century) the owl is charged with many vices. A number of these can be related to the Deadly Sins, which play such a prominent role in Bosch's iconography: to *Luxuria* (because the owl symbolizes night), to *Accidia* (as the text explicitly says), and to *Gula* (because of the owl's gluttony in drinking the lamp oil; in fact, Bosch's representation of *Gula* in the Escorial table board, now in the Prado, has the attribute of an owl). But also *Superbia* and *Invidia* can be read out of the *Dialogus* text in the story of the owl's envy of the eagle and rebellion against this king of the birds. When its evil attempt to become "the ruler of all wild fowls and birds" failed, the owl was severely punished by being condemned to perpetual persecution as an enemy of all other birds. "And for this cause," we are told, "all other birds pursue the owl, and cry out upon her, wherefore in the daytime she dare in no way appear among them but fly all by the night. . . ."

This is enough to make the owl a full-fledged personification of sin, and as such it occupies in late medieval art a place at the side of the ape, as H. W. Janson has shown in his informative book on *Apes and Ape Lore.*[7] He tells us also that in the medieval tradition small birds, since they strive toward heaven, stand for spiritual

[6] Translation (slightly modernized) from *The Dialogus of Creatures Moralized,* ed. Joseph Haslewood, London, 1816, Dialogue 82. This is a reprint of the first English edition of 1511.

[7] H. W. Janson, *Apes and Ape Lore,* London, 1952, pp. 123, 127, 166, 181.

values, while the owl signifies the conscious denial of these values by living in darkness. Thus the attack of the day birds upon the night bird is a well-deserved punishment for its evil doings, just as described in the *Dialogus*.

Did Bosch, then, accept this traditional meaning? He took over a great deal of it but gave it a particular twist, as we shall see. Numerous representations of the motif from the end of the fifteenth and the beginning of the sixteenth century seem to indicate that it was well known in Bosch's time and its meaning generally understood. Janson mentions two interesting examples which support this assumption.[8] The first is an engraving by the Master i. e. (probably after Schongauer) representing *Christ in the Wilderness*, where the owl appears in the oak tree at the right, attacked by day birds. Like the ape in the opposite tree, it is no doubt a symbol of evil, by which Satan tempted the Lord in the wilderness (see Mark 1:13). The other example, obviously with the same meaning, is found in an early work of Jan Gossaert, the triptych in Palermo, where our motif occurs in the *Fall of Man* represented on the left outer wing.[9]

We may add here another prominent although more hidden example: Schongauer's engraving called the *Ornament with the Owl*, the full significance of whose motif the Schongauer literature has hitherto overlooked because it is somewhat obscured by the ornamental design. But it is undeniable that five of the birds in various parts of the composition are crying out against the owl below which carries off a little day bird as prey.

It might be inferred from these examples that no change in the concept occurred during Bosch's time. However, the meaning is no longer the same in a woodcut ascribed to Dürer, of which the only existing copy with text is in Coburg.[10] It was published by "Hans Glaser Briefmaler zu Nürnberg" and bears across the top the printed caption *Der Eulen seyndt alle Vögel neydig und gram* ("All birds are envious and hateful of the owl"). And below the picture appears a poem in four stanzas beginning with the line: "O Neyd und Hass in aller Welt." In this case, then, the emphasis

[8] *Ibid.*, p. 123.
[9] Reproduced in M. J. Friedländer, *Altniederländische Malerei*, Berlin, Vol. 8, 1930, pl. 2.
[10] Reproduced in full size in Georg Hirth and Richard Muther, *Meisterholzschnitte aus vier Jahrhunderten*, Munich-Leipzig, 1893, pl. 50.

is laid on envy and hatred as signified by the day birds who per-
secute the owl. Thus they have been demoted from symbols of
spiritual values to representatives of sin. The implication of this
reversal is obviously that another fellow's corruption does not ex-
cuse one's own sinfulness, an idea stressed by Luther during the
Reformation when he repeatedly invoked the words of St. Paul:
"For all have sinned and come short of the glory of God" (Romans
3:23). Is this new meaning already implied in Bosch's representa-
tion? It would accord with the concept expressed in many of his
works: namely, that all creatures and the world at large are corrupt.
But here in the Koenigs drawing it is more evident that the small
birds participate in the deadly sin of Greed (*Avaritia*), which the
artist stresses as a characteristic common to all creatures. Thus we
see on the right one bird watching a spider in its web, ready to
devour it at the next moment. And on the left two small birds are
pecking for insects, one in the bark of the tree, the other clinging
upside down to a twig. There may have been still other allusions to
sin in the lost parts of the drawing.

But this is not all. It seems clear also, as observed by various
authors, that an owls' nest is here represented. One owl has al-
ready taken refuge in the dark hole of a tree, while another nearby,
with wings spread, has just alighted and wants to get in. So it is
more probably the early morning hour and not the evening twilight
that is indicated. The early morning is also a more appropriate
time for the day birds to look for food and for the crowd of people
to stream toward the place of execution. We may then assume that
in addition to the various allusions to sin implied in the representa-
tion there is also an allusion to the proverb "This is a real owls' nest."
In fact, the latter meaning is more conspicuous and probably had
a greater popular appeal than the rather esoteric implication of a
moral and religious nature. Such interweaving of different layers
of meaning derived from different sources is rather characteristic
of Bosch's iconography, as Lotte Brand Philip has shown in her
brilliant article on the Prado *Epiphany*.[11]

We find the same iconographic complexity also in the two
drawings most closely related to this one, in Berlin (Fig. 20) and

[11] L. B. Philip, "The Prado *Epiphany* by Jerome Bosch," *Art Bulletin*, Vol. 35,
1953, pp. 267 ff. [See pp. 88–107 in this book.]

in Vienna. The Berlin drawing is particularly close to that in Rotterdam in its central motif of an owl in a hollow tree attacked by day birds.[12] But this motif is superimposed on another which illustrates, as we have been told, the proverb "The field has eyes, the wood has ears; I will look, be silent, and listen." Furthermore, in a second hole at the base of the tree we find a third motif: a cock running toward a fox, which has deceived the unsuspecting bird by an assumed air of indifference as it gazes peacefully in the other direction. This is clearly an allusion to man's running into disaster when deceived by the devil. Thus the Berlin drawing not only has an interweaving of various motifs with different layers of meaning, but also suggests what may have been lost when the Koenigs drawing was cut down. Is it not possible that there was once a tree base with the fox-cock motif? That Bosch occupied himself with this subject we know from still another drawing, also in the Koenigs Collection, showing a fox in its hole, lying in wait for a cock which is about to pass by.[13] We may even suggest that further allusions to man's sinfulness and foolishness were found in the foreground of our drawing, as we see them in the Vienna drawing of the *Tree-Man.* (Here, by the way, the motif of the owl attacked by small birds occurs twice, but only as a subsidiary theme.)

These various considerations may help us to realize more

[12] On the whole we accept here the interpretation of Bax (who gives the most complete account of the various meanings of the owl in Bosch's work), and we doubt, along with him, the validity of Benesch's assumption that the Berlin drawing is a kind of allegorical self-portrait, with the wood (*bos*) alluding to the artist's name, the ears and eyes to his features, and the wol to his "ingenium." Benesch also interprets the Latin inscription on top in this way, but Bax and others doubt its authenticity. In fact, this whole concept of a disguised self-portrait seems too self-centered for a fifteenth-century artist.

I may finally mention that the owl surrounded by day birds occurs also as an astrological symbol in the portrait of Johannes Cuspinian by Lucas Cranach, 1503. The humanist portrayed is thereby characterized as a melancholic and a child of Saturn (see M. J. Friedländer and Jakob Rosenberg, *Die Gemälde von Lucas Cranach,* Berlin, 1932, No. 6). Although Bosch's vivid intellect made him well aware of astrology and its symbolical language (see Andrew Pigler, "Astrology and Jerome Bosch," *Burlington Magazine,* Vol. 92, 1950, pp. 132 ff. [see pp. 81–87 in this book]; also C. D. Cutler, "The Temptation of St. Anthony by Jerome Bosch," *Art Bulletin,* Vol. 39, 1957, pp. 109 ff., it seems unlikely that he ever deviated radically from the owl's meaning as an allusion to sin, which we have seen so consistently applied in his work.

[13] Reproduced in Ludwig von Baldass, *op. cit.,* fig. 152.

clearly than before the fragmentary character of the Koenigs drawing, both in form and content, and to sense the rich and complex meaning with which it was originally endowed. Our remarks may also have shown that seemingly contradictory interpretations (such as Tolnay's assumption that a definite proverb is here illustrated, while Bax, denying this, assumes a religious and moral meaning) are not mutually exclusive when seen in Bosch's own spiritual perspective. This perspective embraced a wide and complex cosmos with endless ramifications. The primary concern of the artist, however, remained the power of evil over man and the ultimate punishment he suffers for his folly and sinfulness.

BOSCH'S REPRESENTATION
OF ACEDIA AND
THE PILGRIMAGE OF EVERYMAN

Irving L. Zupnick

Bosch's painting in Boymans Museum, Rotterdam, known either as *The Peddler,* or *The Prodigal Son* (Fig. 1), has inspired more than its share of conflicting interpretations.[1] Indeed, two impressive, if quite contradictory explanations have already appeared in this journal[2]; which, as a measure of its praiseworthy scholarly impartiality, has consented to air a third view. The chief justification for a new elucidation of this fascinating painting is that, in spite of the intensive scholarship and ingenuity that has gone into earlier investigations, we still have the distinct impression that its basic meaning has not been revealed. We must admit that neither of the two titles by which it is known seem to describe its contents; and

"Bosch's Representation of Acedia and the Pilgrimage of Everyman," by Irving L. Zupnick. From *Nederlands kunsthistorisch jaarboek,* Vol. 19 (1968), pp. 115–32. Reprinted by permission of the author and the publisher.

[1] D. Bax, *Ontcijfering van Jeroen Bosch,* 's-Gravenhage 1949, 222–230, considers most of the earlier interpretations in arriving at his own conclusions. Among other later ones that suggest new points of view we should include Wilhelm Fraenger, "Hieronymus Bosch, Der verlorene Sohn," *Castrum Peregrini,* Vol. 1 (1951), 27–39; Kurt Seligmann, "Hieronymus Bosch, The Peddler," *Gazette des beaux-arts* 42 (1953), 97–104; and Clément A. Wertheim Aymès, *Die Bildersprache des Hieronymus Bosch,* The Hague, 1961.

[2] L. Brand Philip, *"The Peddler* by Hieronymus Bosch, A Study in Detection," *Nederlands kunsthistorisch jaarboek,* 9 (1958), 1–81; and D. Bax, "Bezwaren tegen L. Brand Philips' Interpretatie van Jeroen Bosch' Marskramer, Goochelaar, Keisnijder en Voorgrond van Hooiwagenpaneel," *Nederlands kunsthistorisch jaarboek,* 13 (1962), 1–54.

we can only conclude that the major secrets of this painting will not reveal themselves to the methodological techniques which have been applied before. Earlier studies have been painstakingly analytic, considering each of its many details seriatim, showing parallels to other art motifs and to the symbolic, allegorical, and metaphorical, discourse of the times. We must step back from the close perusal of details in order to view the Rotterdam painting from an historical perspective that includes Bosch's other works, and that takes into account the moral philosophy of his period as it was expressed in literature and folklore. Once we do this, we discover a cohesive, synthesizing pattern that brings the details into line. This approach clearly indicates that it was Bosch's intent to illustrate the then popular literary theme of *The Pilgrimage of Everyman*,[3] and to show that Acedia, or Sloth, is the vice that makes mankind most susceptible to the Devil.

The pattern begins to emerge when we consider the relationship between the Rotterdam painting and an earlier work by Bosch, the so-called *Vagabond*, which is on the covering panels of his famous *Hay-Wagon* triptych.[4] The *Vagabond* affords significant and fairly reliable clues to the artist's intentions, because as part of a triptych, its meaning is clarified by the contribution it makes to a larger thematic program.

[3] Among the many literary expositions of this popular theme the most famous were the *Visions of Tundale* and *Le pèlerinage de la vie humaine* and *Le pèlerinage de l'âme* by Guillaume de Deguilleville. Recently Rosemond Tuve showed the lasting popularity of the latter work in her book, *Allegorical Imagery*, Princeton, 1966, and *Tundale* was published in Bosch's home town in 1484. The idea was still vital enough to inspire the famous Dutch drama, *Elckerlijc*, at the beginning of the sixteenth century, and this drama in turn seems to have influenced Pieter Bruegel (cf. I. L. Zupnick, "The Meaning of Bruegel's 'Nobody' and 'Everyman,'" *Gazette des beaux-arts*, 67 (1967), 257–270).

[4] The Prado and the Escorial each have a copy of the triptych. The problem of which is earlier is not my concern here; and I am using the Prado's photographs. Charles de Tolnay, *Hieronymus Bosch*, London, 1966, 24 f., and 355 f. [see pp. 57–61 in this book], and Ludwig von Baldass, *Hieronymus Bosch*, New York, 1960, 222–224 [see pp. 62–80 in this book], have both reconfirmed their earlier opinion that the *Hay-Wagon* triptych dates from between 1485 and 1490. The presence of the Pope, the Holy Roman Emperor, and the King of France, among the followers of the Hay-Wagon suggests that it could have been painted in 1488 or slightly later, at a time when these three rulers were in bad repute in the Netherlands for their roles in the events following the arrest of Archduke Maximilian in Bruges.

The *Vagabond* and the *Hay-Wagon* panels of the triptych are obviously related to one another, interchangeable when you close or open the wings, and equally suggestive of motion to the right. In the case of the *Hay-Wagon* the immediate pertinence of the action is indicated by its position as a central panel (Fig. 6), between a depiction of the vanished Eden and another that portrays the punishments in Hell that are to come. The impression of continuing action is reinforced by subtle compositional devices that make the wagon seem to be in motion; the wheels, the diagonal accents of ladders and pitchforks that reach after the departing vehicle, and the uneasy suggestion that the wagon is being drawn into the Hell panel by evil demons.[5]

Tolnay has shown that an old Flemish proverb, "The world is a haystack, and everyman plucks from it what he can," explains the meaning of the wagon that lures its followers to inevitable doom.[6] The vices that make mankind susceptible to worldly things are exemplified, rather than symbolized, by the performances of those around the wagon.[7] Avaritia and Invidia are dramatized by the grasping, contentious behavior of those who seek to pluck hay from the wagon; and Ira is shown in murderous action. The pres-

[5] The mobility of the wagon has interesting connotations. Caesarius of Heisterbach, *The Dialogue of Miracles,* trans. H. von E. Scott and C. C. S. Bland, London, 1921, Vol. 1, 196, has an exegesis of *Joel 1:4* in which the Pharaoh's chariot moves on four wheels (lust, pride, gluttony, and anger) and is pulled by three horses (envy, sloth, and avarice). It is also interesting that wagons had a traditional symbolic meaning as a method of transporting the dead to the other world (cf. O. Prausnitz, *Der Wagen in der Religion; seine Würdigung in der Kunst,* Strassburg, 1916, 101 f.).

[6] Tolnay, *op. cit.,* 355.

[7] J. Th. Welter, *L'exemplum dans la littérature réligieuse et didactique du moyen âge* (*Bibliothèque d'histoire ecclésiastique de France*), Paris and Toulouse, 1927, esp. 450 f., surveys the growth of the exempla as a literary genre that was developed to give vivaciousness and popular appeal to the moral teaching of the clergy. The exempla were collections of narrative tales based upon the Scriptures, folklore, and personal invention, and as such they had more direct appeal than abstract concepts of virtue and vice. As Lilian M. C. Randall has shown, in *Images in the Margins of Gothic Manuscripts,* Berkeley and Los Angeles, 1966, and in "Exempla as a Source of Gothic Marginal Illumination," *Art Bulletin,* 39 (1957), 97–107, the subject matter of exempla, fables, and bestiaries, had already entered into artistic iconography in books illuminated in the thirteenth and fourteenth centuries. Although Bosch had ample precedence for his employment of motifs that recall the exempla, he seems to have been at least among the first artists who used them consistently as major subjects for easel paintings.

ence of temporal and spiritual rulers accompanied by their retinues is a display of Superbia.[8] The group sitting on top of the wagon, between an angel and a trumpeting demon of temptation,[9] is preoccupied with sensual enjoyments that exemplify the often interrelated sins of Gula and Luxuria.[10] Finally, according to Bax's astute analysis,[11] in the figures on the elevated foreground plateau Bosch exploits popular imagery which associated particular social classes such as nuns, abbots, gypsies, and quack medical practitioners, with certain forms of moral laxity. All of the Seven Deadly Sins, with one exception, are clearly identified with the pursuit of worldly vanities. The exception is Acedia; the Sloth that leads to neglect of religious obligations, and the weakness that can be blamed for one's lack of fortitude to resist evil. This vice is not directly indicated here; however, its presence is implicit, and as we shall see, it is the primary and the root sin that Bosch warns us against in the covering panels that depict the so-called *Vagabond.*[12]

The striding man on the cover of the *Hay-Wagon* triptych,

[8] I have already considered the political ramifications of their presence in note 4, above. The moralistic meaning of the rulers is quite obvious; the political meaning is disguised by it.

[9] A similar demon is identified by an inscription on a tapestry in Burgos Cathedral (cf. D. T. B. Wood, "Tapestries of the Seven Deadly Sins," *The Burlington Magazine,* 20 (1911–1912), 215 and fig. I, 2.).

[10] For example, in Caesarius of Heisterbach, *Dialogues,* Vol. 1, 295.

[11] Bax, *Nederlands kunsthistorisch jaarboek,* 13 (1962), 39–48, makes more sense than Philip, *Nederlands kunsthistorisch jaarboek,* 9 (1958), 53 f., who interprets these figures as a helter-skelter mixture of symbols for the Five Senses, Four Humours, Four Elements, and the Seven Deadly Sins. Bax's interpretation is more in keeping with the directness of Bosch's means of communication throughout the triptych. Bosch universalizes his condemnation of man's depravity by showing all of the social classes engaging in acts that classify their particular follies. There is no real evidence upon which to presuppose that Bosch tried to communicate entirely through abstruse, overcomplicated abstractions of outmoded medieval philosophy.

[12] Morton W. Bloomfield, *The Seven Deadly Sins,* East Lansing, Michigan, 1952, 74 f., in tracing the history of the concept of a root sin (i.e., a vice that made man succumb to the other vices more easily), claims that in the twelfth and thirteenth centuries Superbia (the major monastic vice) yielded its predominant place to Avaritia in the minds of the rising bourgeoisie. Siegfried Wenzel, *The Sin of Sloth; Acedia in Medieval Thought and Literature,* Chapel Hill, N.C., 1967, 47–49, 58 f., and 68 f., however, shows that some very influential theologians and official Catholic policy supported the idea that Acedia, particularly when it led to neglect of one's religious obligations, was the most insidious of all sins. See notes 38 and 39, below.

painted circa 1488,[13] bears an uncanny resemblance to a similar figure in a picture in the Accademia of Venice, painted shortly after 1490 by Giovanni Bellini.[14] Bellini's painting is one of five extant panels in a series that surrounded a mirror, turning the mirror itself into a reflection of the familiar symbolism of Sapientia for the didactic edification of the viewer.[15] Edgar Wind has suggested that this particular painting represents *Comes Virtutis*, assuming that the charioteer is Comus, god of revelry, offering a reward to a man of valor;[16] but his efforts to justify his interpretation are far from convincing. The earlier and more preferable interpretations, which reflect the contrast between the two men, see the charioteer as Luxuria, and the distracted warrior as either Perserverantia, Fortitudo, or Continentia.[17] This view, which understands Bellini's painting as a warning that virtue should beware of vice, is more in keeping with the other four paintings, which seem to be equally didactic in tone.[18] Further, inasmuch as it is possible that some of the paintings are lost,[19] it seems more than likely that the picture we are considering represents part of a series that represented the *Seven Deadly Sins*.

The pose of Bellini's sinewy striding figure, whose emaciation

[13] See note 4, above.

[14] Fritz Heinemann, *Giovanni Bellini e i Belliniani*, Venice 1962, Vol. 1, 73 (Nr. 26, 1).

[15] The traditional image of Sapientia shows the personification looking into a mirror, since the first step to wisdom is to know one's self. The didactic subjects depicted around this mirror (reproduced in Heinemann, *op. cit.*, figs. 82a, b, c, d, and 286), were intended to stimulate the viewer's thoughts in the proper direction.

[16] Edgar Wind, *Bellini's Feast of the Gods; A Study in Venetian Humanism*, Cambridge, Mass., 1948, 48 f., and n. 14.

[17] For examples, see: Gustav Ludwig, "Venezianischer Hausrat zur Zeit der Renaissance," *Italienische Forschungen herausgegeben vom Kunsthistorischen Institut in Florenz*, Vol. 1 (1906), 236 f; G. Gronau, *Giovanni Bellini*, Stuttgart and Berlin, 1930 (Klassiker der Kunst 36), 91; C. Gamba, *Giovanni Bellini*, Milan, 1937, 121; G. F. Hartlaub, *Zauber der Spiegels; Geschichte und Bedeutung des Spiegels in der Kunst*, Munich, 1951, 51; and most recently, Heinemann (see note 14), *op. cit.*, 73.

[18] The interpretation of Bellini's mirror series is a problem worthy of more intensive study than we can give it here; however, the authorities quoted in the preceding note seem to agree that in general the paintings in the series are supposed to remind the viewer to be on his guard against the incursion of evil influences.

[19] Heinemann, *op. cit.*, ibid, mentions at least one missing picture; therefore, it is not impossible that a seventh picture was in the series.

is more typical of Bosch's characterizations than it is of Bellini's, exemplifies uncertainty, or resolution made irresolute. Our warrior is a sort of classicized Everyman, fighting life's battles in defense of his soul. He is all but interrupted in medias res, while on his way to a test of his fortitude. Bellini shows him walking away from, rather than coming to receive, the charioteer's offering, making it clear that it is an enticement or distraction rather than a reward. Sometimes bacchic charioteers were used to represent wine or the vice, Gula; however, it was more common to contrast Acedia and Fortitudo, and this could be the case in the present instant.[20]

In comparison with Bellini's somewhat obscure, classicistic iconography, Bosch's *Vagabond* uses a more direct means of communication. The walking man is obviously meant to convey a warning to us, since he tends to move in the same direction as the Hay-wagon. Because of Adam's Original Sin, the behavior of this traveler during his journey through life inevitably will be considered on the Day of Judgment. He passes through a landscape that is strewn with warnings, dangers, and distractions. The skeleton of an animal stripped of flesh by carrion birds is a memento mori, and the execution taking place in the distance is a reminder that life is fraught with danger. Two scenes in the background summarize the vices shown on the *Hay-Wagon* panel. The robbery exemplifies the danger and the transitory nature of material possessions, which can goad us to evil deeds.[21] The couple dancing to a shepherd's bagpipes are an exemplification of the carnal and sensual delights that distract us from spiritual virtues and do us moral harm.[22] The traveler is about to cross a bridge, engaging in a

[20] Wenzel, *The Sin of Sloth*, 1967 (see note 12), 20, 55, 64, and 76, points out that Caritas sometimes replaces Fortitudo as the opposite of Acedia, but this is not the case in Bellini's painting.

[21] Bax, *Nederlands kunsthistorisch jaarboek*, 13 (1962), 13, interprets the robbery motif as a symbol of Ira, but I fail to see the connection. It seems to be more to the point that the motif of the dangers of highwaymen to pilgrims is used twice in Deguilleville's *Pèlerinage* (cf. *The Pilgrimage of the Life of Man, English by John Lydgate A.D. 1426 from the French of Guillaume de Deguilleville A.D. 1335*, London, 1899 (*Early English Text Society*, E.S., No. 77), 1, 10 and 38 f.), in which it is shown that possessions add to one's troubles in life by inciting the envy and greed of evil men.

[22] An interesting insight into the history of this question may be found in H. P. Clive, "The Calvinists and the Question of Dancing in the Sixteenth Century," *Bibliothèque d'humanisme et renaissance*, 23 (1961), 298–323.

symbolic act that is repeated in most late medieval literary works that are concerned with the pilgrimage of the soul.[23] The motif of the perilous bridge or "bridge of sighs," which seems to have originated in ancient oriental literature, was a standard allegorical indication of passage to the nether world, and a symbol of the ordeal faced by the soul on its way to salvation.[24]

A snarling dog with a spiked collar menaces the traveler who tries to fend it off with his staff.[25] In showing this act of self-protection Bosch consciously alters a traditional artistic image. In the *Luttrell Psalter,* for example, the illustration below *Psalms 37,* which parallels the angry plotting of the wicked with the viciousness of dogs,[26] shows a traveling tinker who is bitten in the leg.

[23] For example, see Howard R. Patch, "The Bridge of Judgement in the *Fioretti,*" *Speculum,* 21 (1946), 343 f. The motif, which also appears in *Saint Patrick's Purgatory* and *Tundale's Vision,* is almost universal. See also Samuel C. Chew, *The Pilgrimage of Life,* New Haven-London, 1962, 147 f.

[24] P. Saintyves, *En marge de la Légende dorée; songes, miracles, et survivances,* Paris, 1930, 132 f., traces the bridge motif to the Zend-Avesta, and finds its earliest appearance in Christian literature to be in the fourth century, in the *Apocalypse of Saint Paul* and the *Dialogues of Gregory the Great.*

[25] Aymès, *Bildersprache,* 1961 (see note 1), 30, who assumes that Bosch was a Rosicrucian, interprets the dogs with spiked collars in Bosch's paintings as symbols of the Inquisition (cf. Psalms 22:16 and 20). Aymès' presupposition that Bosch was anti-Inquisition is not supported either by historical facts, or by what we know of the artist's life; and it seems to be negated by the fact that he belonged to a Catholic lay-brotherhood for thirty years. The usual meaning of this collar is given in a *Histoire de Pais-Bas* by an anonymous writer close to Maximilian (cf. *Corpus Chronicorum Flandriae,* ed. J. J. de Smet, Brussels, 1856, vol. 3, 699), which tells us that after Philippe de Hornes was sentenced in absentia to fifty years in exile for his alleged participation in the assassination of Jehan de Dadizeele, "il portoit au col ung grand colier d'or, ayant plusieurs clous, à façon d'un colier dont l'on est accoustumé armer les mauvais chiens, disant que c'estoit pour se deffendre contre les Gantois" ["on his neck he wore a large golden collar with several spikes, the type with which one used to arm bad dogs, saying that it was for defense against the Gantois."] This historical note, by the way, seems to clarify and explain Bosch's use of this motif as part of the wearing apparel of one of the persecutors of Christ in his *Christ Crowned with Thorns* in the London National Gallery. A similar meaning is found in an illuminated fifteenth century manuscript in the Walters Gallery (cf. Grace Frank and Dorothy Miner, *Proverbes en Rimes,* Baltimore, Md., 1937, 39 (VII), 86) in which the spiked dog's collar signifies "a self-important fellow," or an exceedingly aggressive type.

[26] Eric G. Millar, *The Luttrell Psalter,* London, 1932, 31 and fig. 21c. The illustration can be associated with *Psalm* 37:12: "The wicked plotteth against

The same misfortune befalls a traveler on a Fool-card in the late medieval game of Tarot.[27] One suggestion for interpreting Bosch's self-defensive motif is to be found in Alciati's *Emblemata,* in which an illustration showing a traveler distracting a dog with a stone, is accompanied by the inscription, "Che Altro pecca, & altro n'ha la punitione." [28] Although a stone is used instead of a staff, the intention is certainly the same; to demonstrate the act of warding off a threatened punishment.

Since the dog is so important to the composition, in that he instigates the action of the major figure, we are compelled to view him as an important key to the meaning of the picture, and to consider him as symbolic of the most direct and immediate peril to our traveler in a world beset by all sorts of dangers.

The dog as a symbol is both common and varied in its meanings; and the fact that at one time or another it has been used to symbolize almost every vice, is certainly not very helpful.[29] Nonetheless, an important clue to Bosch's meaning is suggested by the popular belief, almost universal in late medieval European folklore, that the Devil often assumes a dog's shape.[30] Although the Devil-dog is almost always described as black, many recurrent

the just and gnasheth upon him with his teeth." Cesar Pemán, "Sobre la interpretación del viandante al reverso del *carro de heno* de el Bosco," *Archivio Español de arte,* 34 (1961), 127–128, suggests that the direction in which the traveling figure moves is symbolically significant. That is, as Pemán points out, the fact that the tinker in the Luttrell Psalter moves towards the left indicates that he is succumbing to the spell of the seductress who appears on the same page; whereas the fact that the travelling figures in the Rotterdam painting and on the *Hay-Wagon* triptych walk towards the right shows that in each case they are amending their ways and going "en la buena dirección, de vuelta de sus errores." As tempting as it would be to accept this hypothesis, which would support my interpretation of the two paintings by Bosch, it is not consistent with the fact that the Hay-Wagon that lures sinners into Hell also moves towards the right.

[27] Seligmann, *Gazette des beaux-arts,* 42 (1953), 100 and 103 (see note 1).

[28] The plate from Roville's Lyons edition of 1551, *Diverse Imprese,* etc., p. 162, is reproduced in Henry Green, *Andreae Alciati Emblematum fontes quatuor,* London and Manchester, 1840, 244 f.

[29] Bloomfield, *Seven Deadly Sins,* 1952 (see note 12), 246–249.

[30] See Barbara Allen Woods, *The Devil in Dog Form; A Partial Type-Index of Devil Legends,* Berkeley and Los Angeles, Calif., 1959 (*Folklore Studies,* II, University of California). I would like to thank my colleague Anthony Pellegrini for calling my attention to this reference.

folklore motifs associated with this legendary apparition appear in Bosch's painting. The Devil-dog was supposed to haunt roads,[31] and he could be driven off if you struck him with a stick.[32] The Devil's presence was often experienced as a heavy weight on the victim's back, and as we shall see, the traveler's pack may express this idea in a metaphorical way.[33] It is also worth noting that the Devil was supposed to be powerless to pursue his victim across a bridge or stream,[34] and that he attacked or followed sinners of all types, including those who were remiss in their religious duties.[35]

The color of the dog in the picture makes it unlikely that he is the Devil himself, but much of the imagery clearly comes from the folklore of Bosch's time. If the dog is not the Devil, he is almost as dangerous; most likely one of the Seven Deadly Sins that makes man vulnerable to the Evil One. Since all of the vices are represented on the *Hay-Wagon* panel, with the exception of Acedia, it is this vice which is most likely shown here. The spiked collar shows that the dog is vicious,[36] and sometimes Acedia is described as a rabid dog.[37] In assigning such extraordinary importance to Acedia in his triptych, Bosch reflects a common point of view as old as Saint Bernard's *De Consideratione*, which describes Sloth as "mater nugarum, noverca virtutum." [38] From the time of the Fourth Lateran Council of 1215–1216, when the Church launched its drive to alert the masses to their religious obligations, more than one notable theologian had warned against Acedia as the seminal vice that made one susceptible to all the others.[39]

The traveler bows down under his cumbersome burden of

[31] Ibid, 35 and 37.

[32] Ibid, 20, 42–44, and 98.

[33] Ibid, 19, 47 f., and 56. That is, the pack may equate the traveler's burden of the worldly possessions to which he devotes himself, with the presence of the Devil.

[34] Ibid, 38.

[35] Ibid, 73–74.

[36] See note 25, above.

[37] "Accidia . . . est similis morsui rabidi canis," as quoted from a 1487 *Hortulus reginae*, in Wenzel, *The Sin of Sloth*, 1967 (see note 12), 238, note 74, and p. 109.

[38] *De Consideratione*, Vol. 2, 13; Migne, *Patrologia; Series Latina*, 182: 756 (cf. Wenzel, *op. cit.*, 229, n. 72, and 235, n. 21).

[39] Wenzel, 58 f.

worldly possessions. The wooden spoon on his pack is a popular symbol of self-indulgence.[40] He is no saint, and he shares with those around the Hay-Wagon an appetite for worldly things and pleasures, but his immediate peril is not the burden of weaknesses that weighs him down, it is Acedia, the biting debility of faith, will, and spirit. Whether from a wisdom born of experience, or a fear of the inevitable Day of Judgment, the traveler makes an effort to defend himself from the bite of the dog, and to continue upon the path to Salvation.

If there is still some doubt that the dog symbolizes Acedia on the *Hay-Wagon* triptych, the Rotterdam painting (Fig. 1), which further elaborates the subject of the *Vagabond,* seems to resolve the problem. This relationship is so obvious that it immediately casts doubt on Lotte Brand Philip's theory that the Rotterdam picture should be linked with three other paintings in a series that represents the invidious occupations of the Children of the Planets, the Four Humours, the Four Elements, and the Twelve Signs of the Zodiac.[41] Bax completely rejects Philip's hypothesis, undermines the plausibility of the details upon which her argument is based, and reaffirms his earlier moralistic interpretation;[42] but it is still necessary to put to rest any assumption that the Rotterdam painting is part of anything else, and not complete in itself. It could not have been designed to be divided into two panels like those that cover the *Hay-Wagon* triptych,[43] because its subject matter is fully developed and does not require support from any other painting to make its point. Secondly, in refutation of Philip, it is hardly likely that Bosch, whose passion for completeness is famous, would have been content to create only four pictures of a series that tradition-

[40] Bax, *Ontcijfering,* 1949 (see note 1), 165 f., and 229, n. 87.

[41] Philip, *Nederlands kunsthistorisch jaarboek,* 9 (1958), 10–19.

[42] Bax, in both his *Ontcijfering,* 222–230, and his *Nederlands kunsthistorisch jaarboek,* 13 (1962), 1–54, argues that the Rotterdam painting is concerned with the evil of drunkenness, and shows that most of the details can refer to this, as well as to other vices. Although my reservations about this interpretation will be made clear in the course of my argument, it should be pointed ou that Bax (1962, pp. 1–2) is inconsistent, in averring that although the traveler has avoided the tavern, he is still "off-guard."

[43] Baldass, *Bosch,* 1960 (see note 4), 221 f.; and Philip, *op. cit.,* 20–21.

ally would be composed of seven, and particularly that he would have neglected the invidious professions of the Children of Venus and Mars.

Philip agrees with Pigler that the walking man has the attributes of Saturn,[44] and that therefore he is related to the Earth Element and Melancholy Humour.[45] As evidence she points out that a rooster watching over feeding swine appears in an engraved *Children of Saturn,* and that a dog is to be found in Dürer's *Melancholia I.*[46] Bax quite correctly points out that these ubiquitous symbols can have other meanings; and that it would be more consistent and logical to interpret them in their usual sense as symbols of vices, since there are much better known symbols for Saturn, Earth, and Melancholia.[47] It is also true that the attributes of Melancholia are not inappropriate for Acedia, particularly since an excess of the Humour was supposed to be responsible for the Vice.[48] In addition, one cannot help but be puzzled by Philip's assertion that the people at the inn in the background can be interpreted as zodiacal signs. If, according to her interpretation, the embracing couple makes a far-fetched allusion to Gemini, the urinating man to Aquarius, and the girl looking out of a brothel to Virgo[49] (the Virgin!), this would make the unlikely combination of the months of May, January, and August, with the wintery planet, Saturn. She makes better sense when she interprets the action at the inn at a more direct level of meaning, seeing it as an exemplification of the vices that such a setting would encourage. Certainly, in addition to characterizing the inn, the embracing couple can represent Luxuria, and the urinating man, Gula; while the girl at the window, even though she is not using the mirror, could represent Superbia.[50] The inn bears a sign with a picture of a swan as it does in another representation of a similar structure on the *Saint*

[44] A. Pigler, "Astrology and Jerome Bosch," *The Burlington Magazine,* 92 (1950), 132–136 [see pp. 000–00 in this book]; and Philip, *op. cit.,* 2–7.

[45] Philip, ibid., and 8–19.

[46] Philip, 6.

[47] Bax, *Nederlands kunsthistorisch jaarboek,* 13 (1962), 30–35, and 10 f.

[48] Wenzel, *The Sin of Sloth* (see note 12), 186 f., and 191 f.

[49] Philip, *Nederlands kunsthistorisch jaarboek,* 9 (1958), 17 f.

[50] Philip, 68–70. Although Philip only describes these figures as a means of characterizing the tavern as a house of ill repute, the same types of behavior were commonly used to represent three of the Seven Deadly Sins.

Bavo wing of Bosch's *Last Judgment* triptych in Vienna.[51] We know that Bosch belonged to a Brotherhood that used a swan as its symbolic device, perhaps as a reference to the arts;[52] and Dürer's diary informs us that he breakfasted in an inn outside of Ghent, called "The Swan." [53] But in spite of these innocuous connotations, Bax is probably correct in assuming that the sign identifies the inn as a pub and brothel, and that it has a meaning that is in keeping with the symbolism of the caged bird and the behavior of the people outside.[54] It is indeed the kind of place that is usually described as "The Devil's Temple" and the most likely haunt of the Evil One, in the folklore of the time and in the literature that portrays life as a pilgrimage of peril.[55]

Philip, in identifying three vices with the inn, does not explain how the other four vices can be divided up among the three remaining paintings in her proposed series; however, if we consider other possible meanings for the animals shown in the picture, it begins to appear as if Bosch has represented the complete series of the Seven Deadly Sins. Roosters, for example, have appeared in literature as symbols of Superbia, Ira, and Luxuria.[56] Cows, such as the one behind the fence, have symbolized Avaritia, Acedia, Gula, and even Superbia.[57] Swine were most frequently associated

[51] Margarethe Poch-Kalous, *Hieronymus Bosch in der Gemäldegalerie der Akademie der bildenden Künste in Wien*, Vienna, 1967, fig. 4.

[52] Robert L. Delevoy, *Bosch*, Lausanne, 1960, 10; and Bax, *Ontcijfering*, 228, n. 20. In Andrea Alciati, *Emblemata cum Commentariis*, Padua, 1621, 767 f., a swan is an "Insignia poetarum."

[53] *The Writings of Albrecht Dürer*, transl. William M. Conway, New York, 1958, 118.

[54] Bax, *Ontcijfering*, 94 and 222. In this connection, it is interesting that the fourteenth century mystic, Jan van Ruysbroeck, in his *Spiritual Tabernacle* (cf. *Œuvres de Ruysbroeck l'admirable*, transl. Benedictines of Saint Paul d'Oosterhout, Brussels, 1930, Vol. 2, 207 f., likens the swan to youths who do not fear God, and who immerse themselves in a life of pleasure and lust as a swan does in water.

[55] Bloomfield, *Seven Deadly Sins* (see note 12), 126 f. and 132–136, traces the popularity of this theme from the time of Vincent de Beauvais who devoted three chapters of his *Specula* to Gula and the danger of taverns. See also Laurentius Gallus, *Le Somme le Roi* (transl. Dan Michel, *Ayenbite of Inwyt*, London, 1866, *Early English Text Society*, O.S. 23).

[56] Bloomfield, *op. cit.*, 246 and 249. In a book published nearly a dozen times in the Netherlands between 1484 and 1500, the *Dyalogus creaturarum moralizatus* (ed. Joseph Haslewood, London, 1816), a tale on page cxvii f., tells of a rooster who paid the penalty of death for his overweening pride.

[57] M. Davy, *Les Sermons Universitaires parisiens de 1230–1231; Contribution*

with Gula and Luxuria, which in turn were often linked to Acedia
in its manifestation as a lack of resistance to temptations of the
flesh.[58] The second dog in the picture, who is shown near the fence-
post, could, among its other meanings, represent Invidia or Gula.[59]

The traveler's situation here is just as it was in the painting
on the *Hay-Wagon* cover. He is not connected directly with any
of the other vices that lay in wait, but he is threatened by a dog
that again represents his most immediate danger. This time, how-
ever, some new details have been added to help us to identify the
traveler's most insidious weakness.

Each of the traveler's legs have been treated differently; the
left one is bandaged and slippered.[60] This contrast illustrates a
popular metaphor that has been traced back as far as Saint Augus-
tine's *In Joannem* 48,3,[61] which makes the distinction between the
pes intellectus and the *pes affectus* in discussing the conflict be-
tween thought and inclination in the Slothful Man. Jacques de
Vitry's *Sermones in Epistolas et Evangelia Dominicalia*, for exam-
ple, tells us that "Our spirit has two feet—one of the intellect and
the other of the affect, or of cognition and love—and we must move

à *l'histoire de la prédiction médiévale*, Paris, 1931 (*Études de philosophie
médiévale*), 15, 258, shows a cow as a symbol of Avaritia. Bax *Nederlands
kunsthistorisch jaarboek*, 13 (1962), 4 and 10, records usage of the cow as
symbols of Acedia and Gula. In addition *The Hieroglyphics of Horapollo*,
transl. George Boas, New York, n.d. (*Bollingen Series* 23), 89, uses a cow's
horn to represent Punishment; and finally, Bloomfield, *Seven Deadly Sins*,
245, notes that Deguilleville uses a bull to symbolize Superbia.

[58] The relation of swine to Gula is almost universal, according to Bloomfield,
op. cit., 248–249; however, Wenzel, *The Sin of Sloth* (see note 12), 103–
104, notes that the swine in the Miracle of Gadarene, and in the Parable of
the Prodigal Son have been used to symbolize Acedia.

[59] Bax, *Ontcijfering*, 226 and 230, n. 110 and 111, sees the second dog as a
beagle and a symbol of a rake and a drunkard. Since the animal seems to be
drinking from a puddle, it is possible that, as in *Les Bestiaires d'Amours de
Maistre Richart de Fornival e li Response du Bestiare*, ed. Cesare Segre,
Milan and Naples, 1957, 14, he is eating his own vomit; thus signifying his
envious nature.

[60] Bax, *Nederlands kunsthistorisch jaarboek*, 13 (1962), 3 f., sees the bandage
("slet") as word-play on *sletterij*, signifying drunkenness; and in his book,
Ontcijfering, 225 and 229, notes 74–77, he interprets the slipper as a sign of
poverty.

[61] *Corpus Christianorum*, Ser. Lat., 36, 413; also Wenzel, *Sin of Sloth* (see note
12), 237, n. 66.

both so that we may walk in the right way." [62] The left leg of the traveler, already once bitten and characterized as slothful by its bedroom slipper, is probably his *pes affectus;*[63] his inclinations that make it difficult for our generic Everyman to behave in the way that he knows he should. He stumbles on life's road, but with the help of his staff, which can serve him either as a support, or as a weapon against temptation, he seems to be keeping both feet on the right path. *Psalms* 23:4 is most apt: "Yea though I walk through the valley of the shadow of death, I will fear no evil; for Thou art with me; Thy rod and Thy staff they comfort me."

The other items carried by the traveler are equally interesting. He has two hats, one on his head and a second one that he holds in his left hand. He is either trying to keep the hat in his hand safe from the dog's attack, or he is holding it in front of him as if it had the power to protect him. Bax suggests that the hat motif can be interpreted as a pun on the similar-sounding Dutch words *hoed* and *hoede,* and infers that because the hat is not worn, our Everyman is without precaution, or off-guard.[64] Bax further asserts that his vulnerability is explained by the awl ("aal") on the hat, which might be a pun on the Dutch word for ale.[65] This interpretation is in keeping with Bax's theory that this painting is chiefly a warning against the evils of drink, but it is inconsistent with the fact that the traveler has bypassed the tavern,[66] and that his whole attitude is one of self-defense. If we accept Bax's explanation of the pun about the hat, but take it to be a positive indication of precaution, its meaning can be supported when we interpret the shoemaker's awl,[67] and the hoof that hangs near the

[62] Translation from Wenzel, *op. cit.,* 108, based on the 1575 Antwerp edition, page 792.

[63] Ruysbroeck's *Spiritual Tabernacle* (Œuvres [see note 54], Vol. 2, 44 f.) makes the interesting distinction that those who limp with their left foot are most unworthy of all because they have abandoned God in their desire for worldly riches. He uses limping as a metaphor for spiritual infirmities brought on by avarice, but with most writers it refers to sloth.

[64] Bax, *Nederlands kunsthistorisch jaarboek,* 13 (1962), 2.

[65] Ibid.

[66] Ibid., i.

[67] Woods, *Devil in Dog Form* (see note 30), 20, tells us that steel objects were considered to be talismans against the devil.

man's stomach,[68] as talismans against the Devil, just as the dagger on his belt is meant to protect him against human adversaries. The fact that he relies upon such devices can be seen as further evidence of Acedia, or weak faith in God.[69]

The cat-skin that hangs near the wooden spoon on the traveler's pack is a problematical motif. It is not likely that it is a talisman against disease,[70] and Bax's evidence does not necessarily support his interpretation that it is a symbol of misfortune of poverty brought on by alcoholism.[71] Its position near the spoon gives plausibility to Enklaar's view that the cat-skin is an attribute of a "cat-hunter," or a man who succumbs to erotic impulses,[72] because it would associate the appetites of Gula and Luxuria by showing them side by side. On the other hand, the variety of meanings given to cats in folklore and proverbs makes one uncertain that this is the only possible interpretation. The fact that the cat is skinned makes the motif seem to represent a kind of trophy. We are reminded of the almost universal proverb: "There is more than one way to skin a cat." [73] In an earlier painting, Bosch represented

[68] Bax, *Ontcijfering*, 226 and 230, notes 94–97, sees the hoof in a varied sense as an indication of folly and poverty, but others have seen it as a sign of unchastity. The hoof is not represented clearly enough to identify the animal from which it comes; but as a cloven hoof, it suggests a talisman against the Devil, carried much as a rabbit's foot is today.

[69] Bruegel's drawing, *Spes*, which is part of his series, *The Seven Virtues* (cf. Zupnick, *Gazette des beaux-arts*, 1966 (see note 3), 261 f.), similarly attacks weakness of faith by showing how man's prayers and actions are futile attempts to influence the will of God. My interpretation of the paradoxical nature of Breugel's entire series will be forthcoming in the book, *L'Umanesimo e la follia*, to be published by the Istituto di studi filosofici in Rome.

[70] D. Hannema, "De Verloren Zoon van Jheronymus Bosch," *Jaarverslag Museum Boymans* (1931), 2.

[71] Bax, *Ontcijfering*, 225 f. sees it either as the cheap merchandise of the poor, or as a reference to an empty purse.

[72] D. Th. Enklaar, *Uit Uilenspiegel's kring*, Assen, 1940, 78.

[73] "Faire le poil," for example, in Edmond Huguet, *Dictionnaire du Seizième Siècle*, Paris 1965, Vol. 6, 49; and gives as "se prendre au poil l'un l'autre," in the twenty-first chapter of Book Five, the supposedly fake volume of Rabelais. John Gower in his *Mirour de l'Omme*, lines 7132–7140 (cf. *The Complete Works of John Gower* I, *The French Works*, ed. G. C. Macaulay, Oxford 1899, 83) uses this idiom in a curious way:

> " et pour descrire
> Le temps present, qui bien remire,
> Hom voit plusieurs en tiel degré

a cat with two women and a caged bird in a room adjoining the major scene in his painting of *The Dying Man,* which is part of his *Seven Deadly Sins* in the Prado Museum.[74] There is no reason to assume that the caged bird in this painting means that the two women are prostitutes;[75] and it is more likely that in this case the cat and bird imagery have something to do with the fate of the dying man. The bird may represent the soul that is about to escape the cage of the body, and thus become vulnerable to the cat, which often was used as a symbol of the forces of darkness.[76] The cat-skin

Pilant, robbant leur veisinée,
Et ont leur cause compassé,
Qu'il semble al oill que doit suffire;
Mais l'en dist, qui quiert escorchée
Le pell du chat, dont soit furrée,
Luy fault aucune chose dire;"

implying that cat-skinning is synonymous with thievery, but being more extreme, it cannot go on unnoticed, even in Gower's own harsh times. Another possible explanation for the cat-skin motif is the common proverb that uses it in a metaphorical description of a triumph of sorts; "You can have no more of a cat than its skin" (cf. G. L. Apperson, *English Proverbs and Proverbial Expressions,* London, Toronto, New York, 1929, 89, which records its use in 1570). Its meaning is somewhat clarified by its use in a fifteenth century manuscript in the Walters Art Gallery (cf. Frank and Miner, *Proverbes en Rimes* [see note 25], 55 [LXIX]), where, after verses that allude to the necessity of taking risks in order to make gains, it concludes: "Il a du chat bon gage, Cil qui en tient la peau." In other words, if I understand this idiom correctly, the cat-skin (or partial success) is about all one can expect to gain in this rather difficult world. Finally, Huguet, *op. cit.* (Vol. 2, Paris, 1932, 241–244), among other idoms, notes that "emporter le chat" means to leave without paying one's reckoning, which could have been suggested by the idiom "to escape with one's skin." This may suggest that our weary traveler will still have to pay for his transgressions on the Day of Judgment.

[74] Tolnay, *Bosch,* 1966 (see note 4), 338 f., notes that now there is a general agreement with his assumption that the *Seven Deadly Sins* in the Prado is an early work by Bosch; and he points out that the four corner paintings, including *The Dying Man,* appear to be in an earlier style than the representations of the Vices in the center of the table-top.

[75] Bax, *Ontcijfering,* 223, seems to be justified in assuming that a caged bird hung in the doorway of a tavern, as it is in the Rotterdam painting, was meant to advertise a brothel; but in *The Dying Man* it is shown in the interior of a home where its significance must be different.

[76] Herbert Friedmann, *The Symbolic Goldfinch,* Washington, D.C., n.d. (*Bollingen Series,* 7), 186–187, interprets the cat and bird motif as I do, but unfortunately gives no sources. Black cats were often used in witchcraft and seen as one of the possible metamorphoses of the Devil according to Joseph

on the traveler's pack then could signify victory over such forces, or act as a talisman to exorcise them.

In any case, our harried traveler in the Rotterdam painting, just as his counterpart on the *Hay-Wagon* triptych, is burdened by his possessions, his weapons, superstitions, and appetites. Surely this generic Everyman could move faster and better without his impediments, but, as Bosch seems to imply, it is not in the nature of man to be perfect.

Two birds can be found on the tree behind the traveler. They have ambiguous symbolic connotations that seem to reflect upon the man's chances. Owls sometimes symbolize Acedia, as well as a number of other vices, but they also can mean Sapientia.[77] The other bird, whose inverted position and coloration suggests that he is a nuthatch, a bird often mistaken for a woodpecker even today,[78] is also ambiguous in this context. According to *Physiologus* the woodpecker abides in hollow, decayed trees as the Devil does in a man who is faint-hearted on the path of virtue:[79] however, the woodpecker's ability to distinguish decay behind seemingly healthy bark can be seen as a sign of good judgment, and his action to eliminate rottenness can mean that there is a chance for the man's salvation.

In the Rotterdam painting the road of life leads to a gate instead of a bridge, and when our Everyman turns to follow the road through it, he will be facing the gallows that loom over an otherwise idyllic scene to remind him of punishment. It has been suggested that the gate is an allusion to death[80] which would make

Ennemoser, *The History of Magic,* transl. William Howitt, London, 1854, Vol. 2, 102, 104, 105 f., 153, and 178. Inasmuch as the traveler carries a striped cat's skin it is unlikely that it represents a victory over the Devil, but it is still possible that it could have been carried as a protective talisman against the forces of evil.

[77] The owl symbolizes Superbia in the *Dyalogus creaturarum moralizatus* (see note 55), 178 f.; Invidia, Avaritia, Acedia, and Gula (cf. Bloomfield, *Seven Deadly Sins,* 246–248); Night, Death, and Sapientia (cf. Guy de Tervarent, *Attributs et symboles dans l'art profane (1450–1600)*, Geneva, 1959, 96–99); and it is often interpreted as a symbol of heresy, or an irreverent attitude towards religion.

[78] Bax, *Ontcijfering,* 226, erroneously identifies it as a titmouse.

[79] *Physiologus,* ed. James Carlill, in *The Epic of the Beast,* ed. William Rose, London, n.d., 208 f.

[80] Philip, *Nederlands kunsthistorisch jaarboek,* 9 (1958), 71–73.

it an apt parallel to the "bridge of sighs" in the *Hay-Wagon* version. Aymès points out, however, that similar gates appear prominently in several Netherlandish paintings of the Adoration,[81] in which the motif could be a reference to death, or possibly, to everlasting life in the spirit of Christ.[82] It is not without significance that in Bosch's Rotterdam painting the freestanding gate can be by-passed, but only if the traveler strays from the path on which he is treading. With this in mind, and considering the traveler's effort to defend himself, we have to assume that Bosch equates the traveler's road with the path to salvation and shows that at least he is trying to keep on the right path.

In the long run the evidence of Bosch's later works bears out the impression of optimism that we feel is expressed in this painting. It is no accident that Bosch was so often concerned with hermit saints, the exemplary heroes who struggled to overcome their baser natures, and who went into the wilderness to withdraw from the distractions of human contact and the comforts of civilization.[83] Over and over again he repeats this traditional theme of redemption, but he underscores it more heavily than most artists, making the temptations appear vivid and frightening in order to heighten our awareness of the difficulties that have to be borne if we are to maintain the purity of our souls. Bosch is a realist rather than a pessimist; he recognizes man's weaknesses, but he urges him on emphatically, telling him to try to rise above them, because, as he reveals horrendous glimpses of hell's torments, the price of slothful neglect is too terrible to contemplate. Finally, in his choice of a means of communication—so different from the type of classicistic personification that Bellini exploited to please his humanistic patrons—Bosch tries to make his message available to all, evoking genre scenes that speak to the experience of every man. Symbolic

[81] Aymès, *Bildersprache* (see note 1), 11.
[82] Pemán, *op. cit.* (see note 26), 131, and note 34, sees the gate as a reference to *John* 10:9 ("I am the door: by me if any man enter in, he shall be saved, and shall go in and out, and find pasture"). *Luke* 13:24 is almost equally relevant ("Strive to enter in at the strait gate: for many, I say unto you, will seek to enter in, and shall not be able").
[83] For example, in his Lisbon triptych to Saint Anthony, the retable of the Hermits in the Ducal Palace in Venice, the *Saint John the Baptist* in Madrid's Museo Lazaro-Galdiano, Ghent Museum's *Saint Jerome in the Wilderness,* and Berlin's *Saint John on Patmos.*

elements are no longer central or essential in the Rotterdam painting; they are used only when all else fails. The morality drama is enacted in terms of life itself, and the viewer's experience is enough to help him to interpret the behavior of man. With remarkable inventiveness, Bosch combined and refurbished artistic and literary traditions to create a new kind of moralistic genre painting that pointed the way for the artists in Quentin Massys's circle and Pieter Bruegel.

HIERONYMUS BOSCH IN SOME LITERARY CONTEXTS

Helmut Heidenreich

QUEVEDO, A CRITIC OF BOSCH?

In his survey, Xavier de Salas very aptly allots a key role to Quevedo [Francisco de Quevedo y Villegas, 1580–1645] whose close connexions with the fine arts are comparatively well documented. He was on friendly terms with some of the eminent artists who had swarmed to the court of Philip IV, and his portrait was painted by several of them, including Velázquez, as an uncorroborated tradition has it.[1] In his defence of the noble art of painting Butrón quotes him as one of his authorities, and the influential court painter Vincencio Carducho includes him in his list of aristocratic patrons and art collectors[2] (which provokes speculation as to whether Quevedo bought pictures from him or even sat for him). Quevedo fervently admired art collecting in others, and shortly before his death in

"Hieronymus Bosch in Some Literary Contexts" (excerpted), by Helmut Heidenreich. From *Journal of the Warburg and Courtauld Institutes*, Vol. 33 (1970), pp. 176–87. Reprinted by permission of the author and the publisher.

[1] A. Palomino, *Museo pictórico*, Vol. 3, p. 333; cf. A. Papell, *Quevedo: Su tiempo, su vida, su obra*, 1947, pp. 120 and 217 ff., and L. Astrana Marín's article on Quevedo in the literary history by Díaz-Plaja, *Historia general de las literaturas hispánicas*, Barcelona, 1953, Vo. 3, pp. 510, 513, 556.

[2] Juan de Butrón, *Discursos apologéticos en que se defiende la ingenuidad del arte de la pintura*, Madrid, 1626, discurso IV, fol. 13; Vincencio Carducho, *Dialogos de la pintura*, Madrid, 1633, diálogo VIII, fol. 159v. Palomino does not mention Quevedo in connexion with Carducho (*op. cit.*, Vol. 3, pp. 293–5).

1645 he made several bequests of paintings to the local priests and to his steward out of what was left of his own gallery. Without substantiating his claim, Astrana Marín takes it for granted that Quevedo had tried his own hand at painting,[3] as so many artistically-minded contemporaries had done. Another biographer spins out a romantic tale of Quevedo's frustrated endeavours to become a painter of Goya's stature.[4] Such conjectures are apparently due to a sonnet attributed to Góngora in which he satirizes his rival as a poetaster and a dauber who on account of his "low verse and sorry colours" fails in both arts.[5]

The conspicuous number of allusions to Bosch in Quevedo's works led his contemporaries to believe that he was directly inspired by the painter—a story revived in 1852 by his editor Fernández-Guerra[6] and repeated by later biographers. The notable exception among recent Quevedo scholars is Emilio Carilla, who goes to some length to critically analyse the pictorial technique of the two men and to point out their differences.[7] Nevertheless, in Quevedo's own century the similarity of the two artists was so strongly felt that some satirical works were circulated under the pseudonym of Bosch and—following Quevedo's practice—dubbed "dreams" (e.g., the two copies of a pamphlet called *Sueño de Vosco* and *Sueño de el Bosco* respectively,[8] referring to a political incident at the court of

[3] *Francisco de Quevedo y Villegas: Obras en prosa,* ed. L. Astrana Marín, 1932, p. 498a, and *Obras en verso,* 1943, p. 486a, note. Quevedo's testament (*ibid.,* pp. 870a–871a) only states the subject of three pictures, not their painters: *Saint Jerome* (silver-framed), *Magdalene* "with a Juan Andrés de Oria," and *Christ at the Column.*

[4] R. Gómez de la Serna, *Quevedo,* Buenos Aires, 1953, p. 172.

[5] "Don Luis de Góngora a Don Francisco de Quevedo saviendo se ejercitava en el arte de la pintura. Soneto," MS ed. by M. Artigas, *Don Luis de Góngora y Argote,* 1925, app. iv, pp. 378–9. Palomino does not, however, include Quevedo in his long catalogue of amateur painters (*op. cit.,* Vol. 1, pp. 161–3).

[6] Arnaldo Franco-Furt, *El tribunal de la justa venganza,* Valencia, 1635, pp. 133–4; Jusepe Martínez, *Discursos practicables del nobilísimo arte de la pintura* (written about 1675), ed. V. Carderera, Vol. 2, Madrid, 1866, p. 185; A. Fernández-Guerra, "Discurso preliminar," *Obras de Don Francisco de Quevedo Villegas,* tom. i, Biblioteca de Autores Españoles, Vol. 23, Madrid, 1852, p. xvii.

[7] E. Carilla, *Quevedo: entre dos centenarios,* Tucumán, 1949, pp. 114–18. In his first paper de Salas too refutes the insinuation that Bosch had been copied by Quevedo and points out their artistic dissimilarities (*op. cit.,* p. 34).

[8] British Museum, MS Egerton 327, *Papeles tocantes a D. Juan de Austria y P.*

Madrid in 1668/69). The idea of Quevedo's close relationship to the graphic arts seems to have lingered on. A faint echo of it may be seen in an eighteenth-century imitation of his *Visions* by Torres Villaroel where the author shows his idol around the Madrid of the Bourbons; he makes Quevedo shudder at the depraved taste of the Frenchified upper-classes, who had replaced the saints on their walls by prints of erotic subjects and carousals and of other diverting rococo themes.[9]

Unfortunately, neither of his seventeenth-century biographers reveals to what extent and on what grounds Quevedo was qualified as an *arbiter picturae*. As the son of a court official and of a lady-in-waiting to the queen, and later as a diplomat under Philip III and as a member of the entourage of Philip IV, he certainly had more chances than most of those who wrote about the Flemish eccentric to see, at various stages of his life, Bosch's apocalyptic visions displayed in the royal collection. Besides, his reputed bookishness and his long poem on painting, *El Pincel*, make it likely that he knew the work of aesthetic theorists and art historians, especially since he had been to Italy, where he visited the chief art centres. But he quotes neither Vasari nor even Sigüenza, and art tracts have not been found among his recognizable sources.[10] This proves very little, of course, and we need not go all the way with Carilla who,

Everardo Nithardo (1667–1672), fols. 81–83, and MS Egerton 354, fols. 214–16 (not in de Salas, but mentioned by Mérimée, *Essai*, 1886, p. 213, n. 1). The first of these manuscript collections contains also an anti-monarchical *Sueño político* after Boccalini (fols. 40–48), the second a *Memorial* by Quevedo (fols. 240–5). The name of a Dutch translator of Quevedo, too, looks fictitious, but may be real: Hieronymus van Bosch, *De Wieg en het Graaf* [*La cuna y la sepultura*], Holland, 1665?, Amsterdam, 1718, cited by Zedler, *Universal Lexicon*, Vol. 4, pp. 794–5; this is probably the same as Jeronimus de Bosch, *Eenige Stichtelyke Traktaatjes van Don Francisco de Quevedo*, The Hague, 1667, Amsterdam, 1718 and 1730; cf. M. Buisman, *Populaire Prozaschrijvers van 1600 tot 1815*, Amsterdam, s.a. [1960], nos. 1881–83, and J. A. van Praag, "Ensayo de una bibliografía neerlandesa de las obras de Don Francisco de Quevedo," *Hispanic Review*, Vol. 7, 1939, pp. 151–66.

[9] Diego Torres de Villaroel, *Visiones y visitas de Torres con Don Francisco de Quevedo por la corte*, Madrid [1728?], vision XII, p. 43.

[10] Quevedo does include Argote de Molina and Ambrosio de Morales [see pp. 31–33 of this book] in his catalogue of recent Spanish scholars and poets in his *España defendida* (1609), ed. by R. Selden Rose, Madrid, 1916, cap. IV, p. 68.

in a chapter on Quevedo's literary culture, raises some doubts about the profundity of his erudition. Neglect of the moderns when quoting authorities, especially by those imbued with humanism, is by no means exceptional in the Spanish Golden Age, one of the most notorious cases being Gracián's silence on Cervantes. Perhaps we should not altogether see Quevedo as a juggler with received notions drawn from books, but more as a man subject to strong creative urges responding violently to any given situation.

Quevedo's overt response to Bosch is extraordinary for both the number and the context of his allusions. They spread over his entire literary career, and it is difficult to establish a chronological order for them. Most appear to belong to his earlier period (before 1620). The best-known example we find in his picaresque novel *Historia de la vida del Buscón* (Saragossa 1626, but likely to have been written before 1610) embedded in a description of daybreak at a doss-house. In their ridiculous efforts to make themselves look respectable by patching up their tatters, the picaresque inmates are frozen into crooked and crouched attitudes that surpass in strangeness the unusual postures of some of the figures in Bosch's paintings:

> Qual para culcusirse debaxo del braço, estirandole, hazia L. Uno hincado de rodillas, remedava un cinco de guarismo, socorria a los cañones. Otro por plegar las entrepiernas, metiendo la cabeça entre ellas, se hazia un ovillo. No pintò tan estrañas posturas Bosco como yo vi.[11]

Of course, none of Bosch's known paintings deals with a similar subject; nor does the author trouble to explain—inadvertently, or tongue-in-cheek—how his non-hero, who is also the observer of this scene, came by such artistic knowledge, descending as he does from the last dregs of society. Unless Quevedo had in mind one of

[11] "One of them, botching himself under his stretched-out arm, resembled the letter L; another one, on his knees and darning his long hose, looked like the number 5; yet another one tried to mend the crotch of his trousers and clapped his head between his legs coiling himself up into a ball of yarn. Never did Bosch paint such odd postures as I saw." Cf. *ed. cit.*, lib. ii, cap. 2, fol. 49. In other editions the numbering is lib. iii, cap. 2, or simply cap. 15, and some texts have *pinturas* instead of *posturas* (see the critical edition of the *Buscón* by F. Lázaro Carreter, Salamanca, 1965, p. 171). A. Castro takes this passage for a later amplification because it is missing in his own text (see his edition in the Clásicos Castellanos, 1927, p. 174).

the spurious Bosch pictures about which Felipe de Guevara complains, or his disputed drawings of cripples that were circulating as prints,[12] he subconsciously or deliberately picked from Bosch's moralistic paintings one striking detail to reshape and reset it in totally different surroundings. This is perfectly in line with the general style of this novel, where he displays his virtuosity in devising far-fetched descriptive analogies. In this case the comparison with Bosch is less incongruous than it seems at first. By portraying his *pícaros* as letters of the alphabet, as digits, and as coils of yarn, he achieves a grotesque effect of men turning into inanimate objects, which is not unlike some of Bosch's allegorical pantomimes, with their knotted bodies and acrobatic performers. Moreover, Quevedo's simile reminds us of the grotesque letters composed of people which were frequent in graphic art of that period.[13] Although I am not aware of a direct model, it is possible that he recalled ornamental designs of this kind when creating his Bosch-like literary fantasia. Whichever may have been the source of Quevedo's inspiration, no writer before or after him has seen the Flemish painter in a comparable connexion with the picaresque world. Most translators have bungled this passage, not understanding the analogy, and the nineteenth-century illustration of the scene, which cries out for the imagination of a Daumier, falls completely flat because of its humdrum realism.[14]

The next examples not merely suggest but point directly to one major subject of Bosch's, *The Temptations of Saint Anthony,* which our poet adopts as one of his stock motifs. In more than a dozen passages he exploits the popular saint and his attributes (Saint Anthony's fire, his piglet, the ravens, etc.) for his verbal ingeniosities, the temptation theme with its obvious opportunities

[12] F. de Guevara, *Comentarios,* 1788, pp. 41–42; E. Sudeck, *Bettlerdarstellungen vom Ende des 15. Jh. bis zu Rembrandt,* Strassburg, 1931, pp. 12–20.

[13] Cf. D. Guilmard, *Les maîtres ornemanistes,* Vol. 2, 1881, Pl. 142; P. Jessen, *Meister des Ornamentstichs: Bd. 1, Gotik und Renaissance im Ornamentstich* [1924], Pls. 128, 129a. I am indebted to Professor Gombrich for pointing out to me this parallel.

[14] See the illustration by Daniel Urrabieta Vierge in the French editions by A. Germond de Lavigne, *Oeuvres choisies de F. de Quevedo,* 1882, p. 145, and by J. H. Rosny, *Pablo de Ségovie el gran Tacaño,* 1902, p. 134, and in the English edition by H. E. Watts, *Pablo de Segovia the Spanish Sharper,* 1892, p. 150.

for antifeminist witticisms being his absolute favourite. In the satirical portrait of an old hag, *Pintura de la mujer de un abogado, abogada ella del demonio* (dated 1608 by Astrana Marín), Quevedo begins by identifying her with the devil, her ugly face being suited both to the nightmares and the pig of Saint Anthony:

> Viejecita, arredro vayas,
> donde sirva por lo lindo
> a San Antón esa cara
> de tentación y cochino.

After accumulating endless images of ghastliness, decrepitude, and death, and after an elaborate pun on face, mask, and Anthony (*carantoña*)[15] he describes her head:

> barba que con la nariz
> se junta a dar un pellizco;
> sueño de Bosco con tocas,
> rostro de impresión del grifo;[16]

and he rambles on, calling her a fishy vision, crocodile, scarecrow, mandrake-root, witch, and so on.

Rather than a full-scale portrait, this poem is a jumble of superlatives wrought into an inverted encomium. Nevertheless, it contains one definite iconic reference. Female seducers or ugly witches certainly occur in sundry paintings of that particular theme. In its treatment by Bosch, however, they are mostly diminutive figures or they are blotted out by more conspicuous phantoms. There is one exception, though, that fits the words "Bosch's night-

[15] One wonders if the name Antonio and the popular subject of the saint's female tempters have played some part in the semantic development of this puzzling word. Originally it means "ugly mask" and adopts the secondary significance of "ugliness of a heavily made-up woman" (Covarrubias, *Tesoro de la lengua castellana*, 1611, fol. 197).

[16] "Little old one, *vade retro!* where, for its beauty, your face of a tempter and of a hog were fit for Saint Anthony's tribulation and for his pig . . . your chin joining your nose to form a pair of pincers; you nightmare of Bosch with a head-dress, your face giving the impression of a griffin." Cf. *F. de Quevedo: Obras completas I*, ed. J. M. Blecua, Barcelona, 1963, no. 762, pp. 977–80, ll. 69–73. Quevedo uses nearly identical formulae in describing his Dueña Quiñantona in his *Sueño de la muerte* without, however, referring to Bosch.

mare with a head-dress." It is a work of uncertain authenticity in the Prado Museum,[17] showing a wrinkled face larger than life, wrapped in a white head-scarf, crowned by a dove-cot, and placed in the gable of an open barn. With some exaggeration its robust features may even suggest the "impression of a griffin," implying the rapacity of Celestina the bawd. Through its disproportionate size and unsual position this unforgettable face dominates the whole scene. It is apparently the point of departure for Quevedo's carica-ture. We have here another example of highlighting one subordinate but captivating pictorial element; placed into a context alien to the religious subject it produces a witty misinterpretation of the saintly theme: the painter's praise of the holy man's constancy is turned into a denunciation of the unholy female sex. In this allusion Que-vedo probably counted on some popular ideas on the *Temptations* in general and could perhaps rely on some current name given to this particular version by Bosch by a public who loved to identify pictures by one striking detail (witness the nicknaming of Bosch's *Garden of Delight* as *Fresas*, "strawberries," and Velázquez's *Sur-render of Breda* as *Las Lanzas*, "the spears").

Possibly with such proverbial notions in mind, Quevedo forges metaphoric variants of Saint Anthony's tribulations without pin-pointing one particular picture and without explicitly naming Bosch: in a burlesque ballad on an unsavoury erotic adventure (a distorted paraphrase of Don Quixote's grotesque encounter with the kitchen-maid Maritornes), in a satirical epitaph, and in the caricatures of his literary enemies Alarcón and Morovelli.[18] He even uses it in ironic self-portraits where he refers to his dreaded cen-soriousness and sarcasm, *Concertáme esas medidas*[19] and *Refiere él mismo sus defectos*. In this last-named poem (dated 1636 by Astrana Marín) he alludes to his own deformity, calling himself a nightmare that does not tempt Saint Anthony but grunts at him:

[17] Entered 1524 in one of the royal inventories; cf. E. Larsen, "Les tentations de Saint Antoine de Jérôme Bosch," *Revue Belge d'Archéologie et d'Histoire de l'Art*, Vol. 19, 1950, pp. 3–41, no. 10; Ch. Tolnay, *Kritischer Katalog der Werke des Hieronymus Bosch*, Baden-Baden, 1965, no. 42, pp. 380 and 436.

[18] Blecua, *ed. cit.*, no. 803 (pp. 1129–33), no. 819 (p. 1169), no. 856 (pp. 1211–15), no. 858 (pp. 1216–18).

[19] *Ibid.*, no. 651 (pp. 702–3).

Danles nombres de visiones
a los trastos de mi bulto,
y dicen que a San Antón,
si no le tiento, le gruño.[20]

In a satirical sonnet on crinolines, *Mujer puntiaguda con enaguas*,[21] Quevedo sees women as bells without a clapper, walking pyramids, upturned whipping-tops, sugar loaves, paper hats, kitchen utensils, and other conical shapes, and he ends with the recommendation to such a "sharp-pointed vision of St. Anthony" to call herself Lady Funnel and to throw her dress to the devil. Even without mentioning the painter's name, he invokes by this odd assembly of objects the memory of images we would swear to have seen in Bosch. How much stronger must the impression that Quevedo had "copied" from him have been to the contemporary public who had probably heard about the Flemish painter rather than seen him and who were ignorant of Arcimboldi and other mannerist virtuosi.

It is hard to say whether Quevedo initiated this fashion of using Saint Anthony as a metaphor or whether his admirers and the frequent imitators of his jokes drew from a common popular source.[22] By his obsessive reiteration, Quevedo certainly helped to spread this Bosch cliché, of which Gallardo availed himself as late as 1815 in a fragment called *La fantasmagoría*.[23] In this cliché seventeenth-century Spanish satirists had at their disposal a unique iconic reference that was at once familiar to the *vulgo* and appealing to the learned, whereas their French contemporaries, for example, had to have recourse to antiquity for their erudite literary illustrations.[24]

[20] "People mock at the useless junk of my body giving it names of phantoms and saying that if I don't tempt Saint Anthony, I grunt at him." *Ibid.*, no. 790 (pp. 1095–97).

[21] *Ibid.*, no. 525 (p. 564).

[22] For the iconic tradition connected with this theme, cf. W. R. Juynboll, *Het komische genre in de italiaansche schilderkunst gedurende de zeventiende en de achttiende eeuw: Bijdrage tot de geschiedenis van de caricatuur*, Leiden, 1934, pp. 44–54.

[23] See the examples in Salas, *El Bosco en la literatura española*, 1943, pp. 26, 35, 38, and "Más sobre el Bosco en España," 1956, p. 111, and F. Sánchez-Cantón, "Goya y D. Bartolomé José Gallardo," *Archivo Español de Arte*, Vol. 21, 1956, pp. 243–5 (not in de Salas).

[24] Compare the caricatures of female ugliness by Maynard, Sigognes and other contributors to *Le cabinet satyrique*, Paris, 1618. Cf. A. Blanchard, "Aspects

The third Bosch quotation we find in a long poem beginning: *"Alguacil del Parnaso . . ."* (dated 1621 by Astrana Marín). It forms part of the literary war sparked off by Góngora's *Polifemo* (1612) and *Soledad primera* (1613) which developed into a slanging-match between the two poets. Although better organized than Quevedo's former verse satires, this onslaught is similar in its annihilating intent and in its intense method of vilification: a sequence of outright insults and hidden insinuations, often with the barest logical connexion. In order to denounce Góngora's sacrilege against the hallowed laws of neo-Aristotelian poetics and his deliberate deviation from the poetical practice of the Italianate Renaissance classics, Quevedo distorts the name of Góngora, that "Jack Catch of Parnassus," into "gongorilla," pours scorn on his old age, confutes his invidious carping at Lope de Vega and at himself, and asks him to give up writing offensive nonsense:

> Trata de extrema unción y no de musas,
> que escribes moharraches,
> Bosco de los poetas,
> todo diablos y culos y braguetas.[25]

Quevedo thunders on for about one hundred lines full of unflattering epithets, calling his rival, among other things, Satan, Jew, and homosexual. This savage portrait of physical decay and moral baseness is shot through with quotations from Góngora's poems, which are held up to derision, and it closes with the anecdote that Góngora's house had to be fumigated with "Garcilaso lozenges" in order to "degongorise" its stench.

For Xavier de Salas that passage referring to Bosch is the climax of a series of calumnies hurled at Góngora's non-conformism—not just of style, but of religious faith: by equating the poet with the painter, Quevedo condemns the irreverence and scepticism of both. While we must always be wary of some *double-entendre* in Quevedo's writings, it is hard to agree with de Salas here. From the opening allusion to Parnassus to the closing line

de la poésie réaliste," *Le Préclassicisme français,* ed. J. Torel, 1952, pp. 183 ff.
[25] "Mind your extreme unction rather than bother about the Muses, for what you write is absurd rubbish, you Bosch among the poets: nothing but devils, buttocks, and cod-pieces." Cf. Blecua, *ed. cit.,* no. 853 (pp. 1205–9).

borrowed from the *Soledades*, this satire is clearly aimed at Góngora's *cultismo*, every other idea in the poem being ancillary to that object. If from the first stanza to the final image of the exorcism this attack is worded in religious terms, this was the most obvious and most forcible way of exposing Góngora's literary heresy. It is true that Quevedo excessively exploits the fact that Góngora had difficulties in proving his Christian ancestry. But in branding him as an Israelite convert Quevedo does no more than avail himself of the strongest standard defamations commonly known as *las cinco palabras de Castilla*[26] of which Quevedo was not the only user nor Góngora his only victim. Nor, placed as it is fairly near the beginning of the poem, is this passage its culminating point, but rather forms the basis for broadening out into stronger and more explicit denigrations. Obviously it is the reference to Góngora's literary absurdities (*moharraches* being more powerful and more deprecatory than *disparates,* the synonymous term usually applied to Bosch's paintings) that conjures up the nickname "Bosch of the poets." This is explained as "nothing but devils and buttocks" —a feature of some of Bosch's works but not of Góngora's verse; with the malicious coupling "buttocks" with "cod-piece" (*braguetas* being a handy rhyme for *poetas*). Quevedo can now pillory Góngora both as a religious and a sexual pervert in order to make his literary crime look more monstrous.

A later reference to Merlin Cocayo (line 89) reminds us of Sigüenza's interpretation of Bosch's eccentric manner. This strengthens the view that it was solely to illustrate his artistic principles that Quevedo used the painter's name in this context. The same intention becomes abundantly clear when Lope de Vega adopts this Bosch image to wield it against the Gongorists and their enigmatic anti-classical style. Having cited Quevedo as one of his authorities, Lope mocks at the unintelligible, rule-breaking "handful of verses of a Hieronymus Bosch, however excellent and inimitable a painter he may be," confronts them with Ovid's

[26] The five capital insults entitling an injured Spaniard to revenge himself with impunity: cuckold, traitor, heretic, leper, and sodomite, "à quoy la prattique ordinaire adjouste *judio*"; cf. Barthélemy Joly, *Voyage en Espagne* (1603–4), ed. L. Barrau Dihigo, *Revue Hispanique,* Vol. 20, 1909, p. 572. See also A. Collard, "La herejía de Góngora," *Hispanic Review,* Vol. 36, 1968, pp. 328–37.

poetry and compares them to the obscurity of the *carmina Salio-rum*.[27] On the whole, the lines quoted reveal something about Quevedo's associative use of imagery and his creative art of twisting the meaning of words, but they hardly embody a serious verdict on Bosch's religion.

In support of his opinion that Quevedo disapproved of Bosch on theological grounds, de Salas points to the significant prose passage on the painting of devils in the satiric tale *El alguacil endemoniado* (written 1607, first printed 1627). There, in the course of an interview about life in hell, the Devil shows himself offended at the way men represent him and his crew with animal attributes, although in fact they look dignified enough to be hermits and magistrates. Wanting an end to this abuse, they had already taken Hieronymus Bosch to account for the caricature he had made of them in his painted "dreams":

> Remediad esto, que poco ha que fue Geronymo Bosco allà, y preguntandole, porque avia hecho tantos guisados de nosotros en sus sueños? dixo: porque no avia creydo nunca, que avia demonios de veras.[28]

Without any comment on the painter's excuse that he had never before believed in their existence, the Devil goes on to complain about the disrespectful use of his name in proverbial sayings; in the end he is disposed of as a liar.

In spite of its obvious interest, this passage has provoked few comments, and those chiefly from art critics. Justi, slightly lacking his usual lucidity, supposes it might be out of *Künstlerneid* that a jealous Quevedo placed Bosch in Hell. De Salas infers from Bosch's

[27] Lope de Vega, "A un señor destos reynos. Epistola septima," *La Circe*, Madrid, 1624, fols. 191ʳ–193ʳ. It is not true, though, that he calls Góngora's verse *Sueños del Bosco*, as Menéndez Pelayo and others have maintained. The related accusation of following the macaronic poet Folengo was a commonplace of criticism brought against any innovators of style; cf. X. de Salas, "Un lugar común de la crítica," *Archivo Español de Arte*, Vol. 16, 1943, pp. 418–21.

[28] "Remedy this state of affairs. For a little while ago Hieronymus Bosch was here and when asked why he had made such a hotch-potch of us in his dreams, he replied: 'Because I had never believed that devils were real.'" Cf. F. de Quevedo, *Sueños y discursos*, Valencia, 1628, fol. 15ᵛ. The later expurgated versions merely eliminate the word for hermit, leaving the passage otherwise untouched.

doubts about the reality of demons that Quevedo thereby wanted to indict the essential irreligiosity of the painter; he believes that in this negative interpretation of the *diableries* Quevedo was venting the opinion of the Madrid intellectuals of his time, that they vaguely knew about the "heterodoxy" of the first Spanish Bosch collectors, and that these had understood the recondite meaning of his symbols. This de Salas takes for an indirect confirmation of Fränger's well-known assumption that Bosch used the cryptography of an heretic sect—a thesis with which many Bosch scholars do not agree. In her detailed analysis of the artistic parallels between Bosch and Quevedo, Margarita Levisi dissociates herself from these reflections on the orthodoxy of Bosch. Nevertheless she accepts the reasoning of de Salas, adding that Sigüenza was an "isolated voice" in defence of Bosch (in fact, he was the only one to raise the issue of his heresy!). Isabel Mateo Gómez, too, follows de Salas with a misleading quotation, saying that in the *Alguacil endemoniado* Bosch is called an "unbeliever who wraps his lack of faith in the disguise of jests"; (Quevedo, of course, makes no such statement).[29] In opposition to de Salas, Margherita Morreale stresses the common Christian concern of the painter and the writer, underlines Quevedo's love of contradiction, and reminds us of the jocular context of this passage, quoting a similar confession of disbelief from another of Quevedo's Hell fantasies.[30] The other commentators are not very helpful, which is to be regretted particularly in the studies of Fernández and of Miss Nolting-Hauff.[31]

It is always tricky to determine on which side of the fence a

[29] C. Justi, "Die Werke des Hieronymus Bosch in Spanien," *Jahrbuch der kgl. preußischen Kunstsammlungen,* Vol. 10, 1889, p. 137 [see pp. 44–56 in this book]; X. de Salas, *El Bosco en la literatura española,* 1943, pp. 32–35, 55–56, and "Más sobre el Bosco en España," 1956, pp. 112 ff.; the connexion of the Spanish *alumbrados* with Bosch had been expounded before by A. M. Salazar, "El Bosco y Ambrosio Morales," 1955, pp. 121–134 [see pp. 31–33 in this book]; M. Levisi, "Hieronymus Bosch y los *Sueños* de Francisco de Quevedo," *Filologia,* Vol. 9, 1963, pp. 165, 176 f., and 182; I. Mateo Gómez, *El Bosco en España,* 1965, p. 13.

[30] M. Morreale, "Quevedo y el Bosco: Una apostilla a los *Sueños,*" *Clavileño,* Vol. 7, no. 40, 1956, pp. 40–44; F. de Quevedo, "Discurso de todos los diablos" (1627), *Obras en prosa,* ed. Astrana Marín, p. 219b.

[31] Cf. S. E. Fernández, *Ideas sociales y políticas en el "Infierno" de Dante y en los "Sueños" de Quevedo,* México, 1950, pp. 68, 173; Ilse Nolting-Hauff, *Vision, Satire und Pointe in Quevedos "Sueños,"* Munich, 1968, p. 179, n. 106.

satirist is really sitting. In our passage the artistic precepts concerning infernal subjects laid down by the Counter-Reformation are openly challenged by the Devil. Is it unthinkable that Quevedo had made Bosch the mouthpiece of his own scepticism? After all, it was not much of an outrage to controvert popular devil-lore and to poke fun at its cruder forms at a time when on the Spanish stage exorcism and similar horse-play had become stock jokes in the comic interludes.[32] Besides, in Quevedo's sophisticated handling of point-of-view (a fictitious narrator reports his interview of an obsessed person who talks through his imaginary spirit by whom he is tormented, who in turn relates a statement supposed to be made by an historic personage dead for a century!), Bosch's words acquire the sober ring of an objective and neutral testimony. The final denouncement of the report from Hell as a fictitious story heightens this ironic juggling with authenticity, but it also upsets our speculations on the author's true opinion. Perhaps Morreale is right in suspecting that Quevedo cared little one way or the other about this question—a kind of aloofness or indifference the Spanish poet may have had in common with the Flemish painter.[33]

In order to arrive at the correct image of Bosch, it is essential to note that there is no hint of reprimand for him in this text. Bosch's person is in no way disparaged (quite unlike the heavily caricatured figures in the tale), his reply—ingenuous or pert—goes uncommented upon, and above all, there is no mention of his punishment (as there is for the other inmates of Hell). All commentators on this passage have tacitly assumed that Bosch was one of Quevedo's condemned; but the text says no more than "he was there a little while ago." Apart from this serious oversight, no critic has pointed to one widely available work that shows that Quevedo was not the first to send Bosch on a visit to Hell. I am referring to Dominicus Lampson who compiled a gallery of Flemish artists, *Pictorum aliquot celebrium Germaniae Inferioris effigies*

[32] J. Deleito y Piñuela, *La vida religiosa española bajo el cuarto Felipe*, 1952, pp. 319–22.

[33] "Wer den Teufel ernstlich fürchtet, malt ihn nicht an die Wand. Und so dürfte der dem Maler geistig verwandte Quevedo gedacht haben." ["Who truly fears the devil does not paint him, and in this sense Quevedo, spiritual descendant of Bosch, apparently agreed."] M. Friedländer in *Jheronimus Bosch*, ed. K. G. Boon *et al.* [Catalogue of the Bosch Exhibition, 's-Hertogenbosch 1967], p. 26.

(Antwerp, 1572). In the Latin caption under Bosch's self-portrait (pl. 3) Lampson confirms what we also know from Van Vaernewyck that as a *faiseur de diables* Bosch was in his own time considered the unrivalled master; to achieve such perfection, Lampson says, the secret abysses of Tartarus must have been open to the painter, which also explains his terrified expression:

> Quid sibi vult, Hieronyme Boschi,
> Ille oculus tuus attonitus? quid
> Pallor in ore? velut lemures si
> Spectra Erebi volitantia coràm
> Aspiceres? Tibi Ditis avari
> Crediderim patuisse recessus
> Tartareasque domos tua quando
> Quiquid habet sinus imus Averni
> Tam potuit bene pingere dextra.[34]

In his eulogy on Pieter Breughel in the same work (pl. 19) Lampson echoes Guicciardini in hailing him as a second Bosch who seems even to surpass his master in painting *ingeniosa somnia*. Lampson had supplied Vasari with biographical information about the painters from the Low Countries; his *Effigies* were re-issued several times in the sixteenth and seventeenth centuries and incorporated into similar Dutch, French, and English compilations; they were also available in the principal centres of the European book-trade.[35] This cannot but have helped to spread the notions attached to Bosch's name, i.e., the notion of his being an authority on devils, a visitor to the underworld, and—due to this insight—a painter of ingenious dreams. Lampson's *Effigies* eventually reached

[34] ["What is the meaning, Hiernonymus Bosch, of that frightened eye of yours? Why that pallor of your face? It seems as if you were seeing spectres and apparitions of Hell flying face to face. I should think that you had listened to the roaring depth of Pluto's domain and that the gates of hell were opened to you. You were such an excellent artist that you could paint all that has been enclosed in deepest hell."]

[35] S. Sulzberger, "Dominique Lampsonius et l'Italie," *Miscellanea Gessleriana,* Antwerp, 1948, pp. 1187–9; for the later editions of Lampson's *Effigies* see the preface to the reissue by J. Puraye, Liège, 1956. The editions by Hondius of 1610 and 1618 are recorded in the bookseller's catalogue of Georg Draud, *Bibliotheca classica, sive catalogus officinalis,* Frankfurt, 1611, p. 821, and 1625, p. 1139. See also the chapter "Le commerce d'estampes" in A. J. J. Delen, *Histoire de la gravure dans les anciens Pays-Bas: 2ᵉ partie: Le XVIᵉ siècle. Les graveurs d'estampes,* Paris, 1935, pp. 149–70.

the Peninsula (1585) in a consignment of various illustrated works for Benito Arias Montano,[36] the Biblical scholar who initiated Father Sigüenza in the art of librarianship and who made bequests of books to the Escorial library. Whereas Arias Montano turns up in Quevedo's life and works, his biographers have not traced Lampson there. Another source, however, makes it seem likely that he had come across the Flemish humanist. Lampson's letters were published in the same edition of Lipsius's correspondence that contained Lipsius's first reply to Quevedo (10 October 1604).[37] Quevedo was always proud of this epistolary honour, and if we know next to nothing about his library we may be certain that he owned, or was at least familiar with, this work where his name is printed beside that of his learned idol.

This is far from being proof that Quevedo's source of information actually was Lampson. Nevertheless, the raw material was assembled there. Without indulging in wild speculation we may therefore doubt whether it is pure coincidence that no other authority and no other painter but Bosch appears in that vision of Quevedo, descends to Hell, and gives evidence of his nightmares. Since the whole order of things is inverted in Quevedo's tale, Bosch does not bring hellish visions up from Pluto's realm to paint them for earthly beings (as he does in Lampson), but he steps down to the inferno to report to the devils about the incongruities he had produced on earth. Other motifs integrated into this passage (the devil complaining of his ugliness, the witty repartee of the painter, the suspicion of blasphemy in grotesque paintings) were

[36] Delen, *ibid.,* pp. 166 f. This shipment also contained several copies of anonymous *Grotesques,* and on an earlier occasion Arias had bought different engravings by J. Cock [in A. J. J. Delen, *Histoire de la gravure dans les anciens Pays-Bas: 2ᵉ partie: Le XVIᵉ siècle. Les graveurs d'estampes,* Paris, 1935], p. 153, n. 2). See also J. de Sigüenza, "History of the Order of St. Jerome" [pp. 34–41 in this book], lib. iv, discurso 11, and M. Bataillon, "Philippe Galle et Arias Montano," *Bibliothèque d'Humanisme et Renaissance,* Vol. 2, 1942, pp. 132–60.

[37] Justus Lipsius, *Epistolarum selectarum tomi XI,* Antwerp, 1605–7. Lampson's letters are in the first and second *Centuria miscellanea* and in the *Centuria secunda ad Belgas;* the letter to Quevedo is in the *Centuria quinta miscellanea postuma* (1607), p. 54. The complete correspondence between Lipsius and Quevedo (together with Lipsius's letters to Arias Montano and other Spaniards) is reproduced with a Spanish translation by A. Ramírez, *Epistolario de Justo Lipsio y los españoles, 1577–1606,* Madrid, 1966, nos. 92, 93, 95, 97.

traditional, too.[38] Whoever or whatever suggested these ideas to Quevedo, he transformed them in an original way into a device of narrative irony providing, as it were, a second level to his *sueño* by matching it with Bosch's *somnium*. For the painter's confession is not just a whimsical anecdote to raise a chuckle but points to the very subject of the whole story: Bosch had mistakenly painted devils as fantastic beasts because he did not know there were genuine ones. But there are real demons; they are shaped like humans, and they form the pandemonium of society. That is precisely what the author sets out to show in his *Alguacil endemoniado*.[39]

In my view none of the Bosch passages quoted confirms the contention of de Salas that Quevedo was "the first to criticize the Flemish painter as an atheist." If that was in his mind, our virtuoso in the art of diatribe and fault-finding failed dismally in this case— quite unbelievably so, judging by the standard of his satiric performance and his output of invective. It is true that Quevedo nowhere explicitly comes down on the side of Bosch for reasons open to conjecture (his wariness of theological pitfalls? his predominantly classical background and tastes? the prevailing Italianate fashion in painting?). But it is also true that Bosch is one of the few modern authorities and one of the still fewer artists whom Quevedo mentions by name in his literary works, that as an illustration of unique achievement he calls him in not once, but repeatedly, and that he does so more often than any of his contemporaries. Twice he introduces Bosch as the unsurpassed example of oddity and ugliness in nature being outstripped by its representation in art, once to illustrate extreme boldness in literature by audacity in painting, and once as a witness to give his expert opinion on an artistic question. Judging by this record it would be easier to read into those passages some veiled admiration for the painter rather than disapproval, open or implied. But in view of the author's love for paradox, ambiguity, and witty innuendo we must not in turn become dogmatic about this predilection.

[38] Cf. A. Ilg, *Zeitstimmen über Kunst und Künstler der Vergangenheit,* Vienna, 1881, pp. 37–39, 58–62; E. Kris and O. Kurz, *Die Legende vom Künstler,* Vienna, 1934, pp. 61–64. I am obliged to Professor Gombrich for drawing my attention to these sources.

[39] I disagree here with Miss Nolting-Hauff who seems to deny a didactic idea which gives unity to the anecdotal structure of the story (*op. cit.,* p. 58).

Biographical Data

Hieronymus Bosch was born ca. 1450 in 's-Hertogenbosch (Bois-le-Duc) in North Brabant, where he lived for his entire career and where he died in 1516. A number of documents, mostly preserved in the records of the Brotherhood of Our Lady (*Rekeningen van Onze Lieve Vrouwe Broederschap*) and the acts of the city (*Protocollen van de stad 's-Hertogenbosch*), permit us to reconstruct much of the painter's life and background (see especially Gerlach, 1967, 1968). He was born into a long line of painters, of a family who apparently moved from Nijmegen or Aachen to 's-Hertogenbosch sometime early in the fifteenth century. His grandfather Jan van Aachen (died 1454) is recorded as receiving commissions from the Brotherhood of Our Lady in 's-Hertogenbosch, and his father, Anthonis van Aken (died 1478/9), was also active there. Several documents refer to works by Anthonis, including wings for an altarpiece for the Chapel of Our Lady in the church of Saint John, which were apparently left unfinished at his death and purchased back from the Brotherhood by Bosch (*Jeroen die maelre*) in 1480/81. Bosch was one of five children. An older brother, Goossen, was also a painter and inherited the father's workshop.

There is some confusion regarding Bosch's name. Listed in the documents sometimes as Joen or Jeroen van Aken, his first name was usually Latinized as Jheronymus, Jeronimus, or Hieronymus, a fact that has led some scholars to believe that there were probably two artists with similar names active in 's-Hertogenbosch, but this is not likely. The problem is further complicated by the fact that he signed his paintings *Jheronymus Bosch* (and not *van Aken*), identifying himself with the town of his birth rather than with his family, perhaps to distinguish himself from other painters in his family.

In 1481 Bosch is mentioned as the husband of Aleyt van der Meervenne, a patrician lady whose mother came from a family of pharmacists (thus accounting for Bosch's knowledge of the tools and craft of al-

161

chemy) and whose father was a nobleman. Through this marriage Bosch came into considerable wealth, inheriting properties from Aleyt's family that included an estate called *ten Roedeken* in Oorschot, a village near 's-Hertogenbosch.

Bosch was enrolled in the Brotherhood of Our Lady by 1486/7, and numerous documents record his activity for this organization until his death. Between 1488 and 1492 Bosch painted the shutters for an altar-piece of Our Lady, the center of which was a carved panel (*Schnitzal-tar*) executed earlier, in 1476/7, by the famed sculptor from Utrecht, Adriaen van Wesel. In 1493/4 Bosch prepared designs on "a pair of old bedsheets" for the stained glass windows in the Brotherhood's chapel in the church of Saint John.

His most notable documented commission—in 1504—is preserved in the archives in Lille (Département du Nord). In that year the em-peror Philip the Fair commissioned Bosch to execute a huge painting of the Last Judgment, with representations of heaven and hell. No trace of this work has been discovered, although some have linked the document to *The Last Judgment* triptych in Vienna attributed to Bosch or to *The Last Judgment* fragment in Munich. These associations are not con-vincing, however. Other documents testify to his activity in 's-Hertogen-bosch from 1507 to 1513. Bosch's death in 1516 is recorded in the *Obitus fratrum* of the Brotherhood of Our Lady: "*Jheronimus Aquen alias Bosch insignis pictor*" ("Jheronimus Aken, called Bosch, illustrious painter").

ATTRIBUTIONS AND CHRONOLOGY

Considering the complex nature of the subject matter of Bosch's paintings, it is not surprising that few studies have been devoted to the problems of the style, attribution, and chronology of his works. De Tol-nay's pioneering monograph (1937) is perhaps the best study to consult for these aspects of his art (also the 1966 English edition) since most authorities, including Baldass and Combe, have followed him closely in matters of attribution and dating of both paintings and drawings. Re-cently some scholars (K. G. Boon and K. Arndt) have questioned the authenticity of a number of drawings included in De Tolnay's catalogue, and it is very likely that more paintings will come under more careful scrutiny in future studies.

Much work remains to be done, too, with regard to the roots of his style. While many scholars argue that Bosch must have received his training somewhere other than his hometown, which they consider to be a provincial center (cf., however, L. Pirenne, 1967), De Tolnay writes that his style actually developed there: "By gradually setting free pro-vincial Dutch painting from the techniques and stylistic elements of the Flemish tradition embodied by the van Eycks, and being the first to draw inspiration from the indigenous spirit of his country, Hieronymus

Bosch created an art that heralded the great national Dutch school of the seventeenth century" (p. 11). De Tolnay suggests that the sculptures and frescoes in the great Gothic church of Saint John in 's-Hertogenbosch had a significant influence on the formation of his early style. It is possible, in fact, that Bosch's grandfather Jan van Aachen painted the large fresco in the cathedral of Christ on the Cross with donors.

Van Mander emphasized the fact that Bosch generally employed a technique usually called *alla prima*, that is, applying the paint directly on a prepared surface with little or none of the customary detailed underdrawing or underpainting. Since the 1967 Bosch exhibition in 's-Hertogenbosch, a number of infrared photographs and reflectographs[1] of many of his major works have been made that should provide important new materials for further studies of his style and technique (see R. van Schoute, 1967). But until a more definitive analysis of his technique is made, serious problems of attribution and chronology will remain, and De Tolnay's selection of authentic works and his dating of them will remain the most convincing analysis.

In his 1937 monograph, De Tolnay cautiously accepted some twenty-seven works as authentic paintings by Bosch. Among the better known attributions that he questioned or rejected were *The Adoration of the Magi* (New York, Metropolitan Museum), *The Temptation of Saint Anthony* (Madrid, Prado), and the two triptychs of *The Last Judgment* (Bruges and Vienna). In his recent English edition (1966), De Tolnay accepted some additional works, including the Bruges *Last Judgment*, which he identified as an authentic piece on the basis of the newly cleaned grisaille panels on the exterior of the altarpiece.

CHRONOLOGY OF PAINTINGS, ACCORDING TO DE TOLNAY

EARLY PERIOD (1475–1485)

The Cure of Folly (Museo del Prado, Madrid)

The Seven Deadly Sins (Museo del Prado, Madrid)

The Adoration of the Magi (the Epiphany Altar) (Philadelphia Museum of Art)

The Conjuror (Musée Municipal, Saint Germain-en-Laye)

The Marriage at Cana (Boymans-van Beuningen Museum, Rotterdam)

The Ecce Homo (Städel Institute, Frankfurt)

[1] A new process developed by J. R. S. van Asperen de Boer of the Centraal Laboratorium in Amsterdam. Cf. Jetske Sybesma Ironside, *Hieronymus Bosch: an Investigation of His Underdrawings* (Ph.D. dissertation, Bryn Mawr College, 1973).

MIDDLE PERIOD (1485–1505)

The Ship of Fools (The Louvre, Paris)

The Death of a Miser (The National Gallery of Art, Washington)

Allegory of Guttony and Lust (Yale University)

The Road to Calvary (Kunsthistorisches Museum, Vienna)

Four panels of *The Vision of Heaven and Hell* (Palazzo Ducale, Venice)

The Haywain (Museo del Prado, Madrid)

The Temptation of Saint Anthony (Museu Nacional de Arte Antiga, Lisbon)

The Garden of Earthly Delights (Museo del Prado, Madrid)

Saint John on Patmos (Staatliche Museen, Berlin-Dahlem)

Saint Jerome in the Desert (Musée des Beaux-Arts, Ghent)

Saint Julia Triptych (Palazzo Ducale, Venice)

Altarpiece of the Hermits (Palazzo Ducale, Venice)

Saint Christopher (Boymans-van Beuningen Museum, Rotterdam)

LATE PERIOD (1505–1516)

The Crucifixion (Musées Royaux des Beaux-Arts, Brussels)

The Landloper (Boymans-van Beuningen Museum, Rotterdam)

Christ Crowned with Thorns (The National Gallery, London)

Christ Crowned with Thorns (El Escorial, Madrid)

Christ before Pilate (Princeton University)

The Road to Calvary (Musée des Beaux-Arts, Ghent)

Notes on the Contributors

Don Felipe de Guevara. Guevara, a Spanish critic and connoisseur of the sixteenth century, wrote his *Commentarios de la Pintura* about 1560. He was the first to point out that many of the paintings accepted as being by Bosch were, in fact, the works of imitators. His comments are particularly interesting with regard to the Prado Table Top, which he attributes to a close follower of Bosch of special merit.

Ambrosio de Morales. Morales was a learned historian who studied at Alcalá and Salamanca in the early sixteenth century. In 1586 he collected and published the works of his uncle, Fernán Pérez de Oliva, including in the volume some of his own writings. Among these was his "Panel of Cebes, a disciple of Socrates in Thebes, translated from Greek into Castilian," which he probably wrote while still a student in Salamanca (before 1533). At the end of his translation he added a description of Bosch's *Haywain* that is the earliest known reference in Spanish literature to the Netherlandish saying that the Hay Wagon represents Vanity and Nothingness.

Fra José de Sigüenza. In 1605 Sigüenza wrote his voluminous *History of the Order of Saint Jerome,* in which appear some of the finest observations on Bosch's paintings. Sigüenza had unquestionably studied the paintings by Bosch in the Escorial, collected by Philip II, with much care, concern, and admiration, and his categories of subject matter for the artist's works remain to this day models for interpretation.

Karel van Mander. Van Mander, the Vasari of Northern painting, first published his *Book of Painters* in 1604. His biography of Bosch is mostly important for its discussion of Bosch's technique, which has been interpreted by some as *alla prima;* since, however, this term does not

really apply to his manner of painting, van Mander was very likely referring to Bosch's method of painting directly over summary underdrawings. None of the paintings mentioned by van Mander has been traced.

Carl Justi. Justi, born in 1832, was one of the pioneers in art history in Germany. He was Professor of Philosophy at Marburg and Kiel before he took a chair in art history at the University of Bonn (1872). His publications include the definitive biography of Winckelmann and various monographs and studies of Spanish artists, those of Murillo and Velázquez being especially notable. His essay on Bosch is one of the earliest scholarly assessments of the painter's art.

Charles de Tolnay. De Tolnay, Director of the Museo della Casa Buonarotti, Florence, has published major monographs on the van Eycks and Robert Campin, Bruegel, and Michelangelo. His pioneering work on Bosch has become a model of scholarship on the artist; reprinted in this volume is his sensitive analysis of *The Garden of Earthly Delights*.

Ludwig von Baldass. Baldass, one of the leading authorities on Netherlandish painting, has published numerous studies on Hieronymus Bosch. His essays on Bosch's "Image of the World" and his "Place in the History of Art" are among the most succinct summations of Bosch's position in sixteenth-century art.

Andrew Pigler. Pigler, a leading Hungarian scholar in the field of Netherlandish art, is best known in this country for his book on subject matter in Baroque painting. His essay on "Astrology and Jerome Bosch" has been one of the most influential studies on Bosch in recent years.

Lotte Brand Philip. Lotte Brand Philip, Professor of Art History at the City University of New York, Queens College, has published a number of essays on Netherlandish painting. Her article on the Peddler, by Hieronymus Bosch, in Netherlands Year-Book for History of Art 1958 is the starting point of her comprehensive study on Bosch's monumental triptychs. She has contributed most recently a revolutionary book on the Ghent altarpiece and the art of Jan van Eyck.

Charles D. Cuttler. Cuttler is Professor of Art History at the University of Iowa and a specialist in the art of the Northern Renaissance. One of his earliest articles on Bosch, "The Lisbon *Temptation of Saint Anthony*" (*The Art Bulletin*, 1957), remains the basic study on that work today. In 1968 he published his monumental *Northern Painting from Pucelle to Bruegel*.

Jakob Rosenberg. Rosenberg, Professor Emeritus of Art History at Harvard University, has written widely in the field of Netherlandish and German painting and drawing. His many publications include monographs on Lucas Cranach and Rembrandt. Well-known as a connoisseur, one of his most recent books is *On Quality in Art* (Princeton, 1967).

Irving L. Zupnick. Zupnick is Professor of Art History at the State University of New York at Binghamton. A specialist in the art of the sixteenth century in Italy and the North, Professor Zupnick has published studies on Pontormo, Bruegel, and Bosch.

Helmut Heidenreich. Heidenreich is Professor of English and Comparative Literature at the Free University in Berlin. Among his publications are studies of Spanish literature of the Golden Age.

Selected Bibliography

Angulo Iñiguez, Diego. "Saint Christopher by Hieronymus Bosch." In *The Burlington Magazine,* Vol. 82 (1940), pp. 1–3.

Baldass, Ludwig von. "Die Chronologie der Gemälde des Hieronymus Bosch." In *Jahrbuch der preussischen Kunstsammlungen,* Vol. 38 (1917), pp. 177–85.

————. *Hieronymus Bosch.* Vienna, 1943; English edition, 1960.

————. "La tendenza moralizzante in Bosch e Bruegel." In *Atti del II Congresso Internazionale di Studi Umanistici.* Rome, 1952.

Baltrusaitis, J. *Le moyen-âge fantastique.* Paris, 1955.

Bax, Dirk. *Ontcijfering van Jeroen Bosch.* The Hague, 1949.

————. "Bosschiana." In *Oud-Holland,* Vol. 68 (1953), pp. 200–208.

————. "Beschrijving en poging tot verklaring van het Tuin der Onkuisheid-drieluik van Jeroen Bosch, gevolgd door kritiek op Fraenger." In *Verhandelingen der Kon. Nederlandse Academie van Wetenschappen, Afd. Letterkunde,* Amsterdam, Vol. 63, no. 2 (1956), pp. 1–208.

————. "Jeroen Bosch' Drieluik met de gekruisigde martelaars." In *Verhandelingen der Kon. Nederlandse Academie van Wetenschappen, Afd. Letterkunde,* Vol. 68, no. 5 (1961), pp. 1–68.

————. "Bezwaren tegen L. Brand Philip's Interpretatie van Jeroen Bosch' marskamer, goochelaar, keisnijder en voorgrond van hooiwagenpaneel." In *Nederlands Kunsthistorisch Jaarboek,* Vol. 13 (1962), pp. 1–54.

————. "Jeroen Bosch en de Nederlandse Taal." In *Bijdragen bij gelegenheid van de herdenkingstentoonstelling te 's-Hertogenbosch,* pp. 61–71. 's-Hertogenbosch, 1967.

Benesch, Otto. "Der Wald der sieht und hört." In *Jahrbuch der preussischen Kunstsammlungen,* Vol. 63 (1937), pp. 258–66.

————. "Hieronymus Bosch and the Thinking of the Late Middle Ages." In *Konsthistorisk Tidskrift,* Vol. 26 (1957), pp. 21–42, 103–27.

BIEDRZYNSKI, R. *Der Garten der Lüste. Die Bildwelt des Hieronymus Bosch.* Feldafing, 1966.

BOON, K. G. "Hieronymus Bosch." In *The Burlington Magazine,* Vol. 102 (1960), pp. 457–58.

BOSCHERE, J. DE. *Jérôme Bosch et le fantastique.* Paris, 1962.

BOSMAN, A. *Hieronymus Bosch.* London, 1963.

BRANS, J. V. L. *Hieronymus Bosch en el Prado y en el Escorial.* Barcelona, 1948.

————. "Los eremitanos de Jeronimo Bosco: San Juan Bautista en el desierto." In *Goya,* no. 4 (1955), pp. 196–201.

BRINKMAN, A. "Alchemistische symboliek in het werk van Jeroen Bosch." In *Chemie en Techniek Revue,* Vol. 22 (1967), pp. 645–47.

CALAS, ELENA. "D for Deus and Diabolus. The Iconography of Hieronymus Bosch." In *The Journal of Aesthetics and Art Criticism,* Vol. 27 (1969), pp. 445–54.

————. "Bosch's *Garden of Delights*: A Theological Rebus." In *Art News,* 1970, pp. 184–99.

CALAS, NICOLAS. "Hieronymus Bosch and the Prodigal Son." In *The Harvard Art Review,* Vol. 2 (1967), pp. 15–20.

CAMP, G. VAN. "Autonomie de Jérôme Bosch, et récentes interprétations de ses oeuvres." In *Bulletin des Musées Royaux des Beaux-Arts,* Vol. 3 (1954), pp. 131–48.

CHASTEL, ANORS. "*La tentation de St. Antoine,* ou le songe du mélancolique." In *Gazette des Beaux-Arts,* Vol. 15 (1936), pp. 218–29.

CINOTTI, M. *L'Opera completa di Bosch* (Classici dell 'Arte 2). Milan, 1966.

CLAVEL, B. "Le mystère de Jérôme Bosch." In *Jardin des Arts,* no. 121 (1964), pp. 29–43.

COHEN, W. "Hieronymus Bosch." In Thieme-Becker, *Künstlerlexikon,* Vol. 4 (1910), pp. 386 ff.

COMBE, JACQUES. *Jérôme Bosch.* Paris, 1946; English edition, London, 1947.

CUTTLER, CHARLES D. "The Lisbon *Temptation of St. Anthony.*" In *Art Bulletin,* Vol. 39 (1957), pp. 109–26.

————. "Witchcraft in a Work by Bosch." In *The Art Quarterly,* Vol. 20 (1957), pp. 129–40.

————. "Bosch and the *Narrenschiff.*" In *The Art Bulletin,* Vol. 51 (1969), pp. 272–76.

DELEVOY, ROBERT L. *Bosch.* Cleveland, 1960.

DOLLMAYR, H. "Hieronymus Bosch und die Darstellung der vier Letzten

Dinge in der niederländischen Malerei des XV. und XVI. Jahrhunderts." In *Jahrbuch der kunsthistorischen Sammlungen des Allerhöchsten Kaiserhauses,* Vol. 19 (1898), pp. 284–310.

DORFLES, G. *Bosch.* Milan, 1954.

EBELING, M. J. M. "Jheronimus van Aken." In *Miscellanea Gessleriana,* pp. 444–57. Antwerp, 1948.

FRAENGER, WILHELM. *Hieronymus Bosch: das tausendjährige Reich.* Coburg, 1947; English edition, London, 1952.

———. "Johannes der Täufer, eine Meditationstafel des Freien Geistes." In *Zeitschrift für Kunst,* Vol. 2 (1948), pp. 163–75.

———. "Johannes auf Patmos, eine Umwendetafel für den Meditationsgebrauch." In *Zeitschrift für Religions—und Geistesgeschichte,* Vol. 2 (1949/50), pp. 327–45.

———. *Die Hochzeit zu Kana. Ein Dokument semitischer Gnosis bei Hiernonymus Bosch.* Berlin, 1950.

———. "Der verlorene Sohn." In *Castrum peregrini,* Vol. 1 (1951), pp. 27–39. Amsterdam. (Also in *Atti del II Congresso internazionale di studi humanistici,* pp. 187–94 Rome, 1952.)

———. "Die Versuchung des hl. Antonius von Hieronymus Bosch." In *Archivo di Filosofia,* Vol. 3 (1957), pp. 155–63.

———. "Drei Interpretationen zu Bildern von Hieronymus Bosch." In *Castrum peregrini,* Vol. 32 (1957/8), pp. 5–69.

FRIEDLÄNDER, MAX J. *Die altniederländische Malerei: Geertgen und Bosch,* Vol. 5. Berlin, 1927; English edition, New York and Washington, 1969.

GAUFFRETEAU-SÉVY, M. *Jérôme Bosch.* Paris, 1965.

GELDER, JAN GERRIT VAN. "Teekeningen van Jeroen Bosch." In *Beeldende Kunst,* Vol. 27, no. 8 (1941), pp. 57–64.

GERLACH, P. "Jeronimus van Aken alias Bosch." In *Bijdragen bij gelegenheid van de herdenkingstentoonstelling te 's-Hertogenbosch,* pp. 48–60. 's-Hertogenbosch, 1967.

———. "Studies over Jeronimus van Aken alias Bosch." In *Spiegel der Historie,* 1967, pp. 587–98, 623–70.

———. "Les sources pour l'étude de la vie de Jérôme Bosch." In *Gazette des Beaux-Arts,* Vol. 71 (1968), pp. 109–16.

GOMBRICH, ERNST H. "The Earliest Description of Bosch's *Garden of Delights*." In *The Journal of the Warburg and Courtauld Institutes,* Vol. 30 (1967), pp. 403–6.

———. "Bosch's *Garden of Delights*: a Progress Report." In *The Journal of the Warburg and Courtauld Institutes,* Vol. 32 (1969), pp. 162–70.

———. "The Evidence of Images." In *Theory and Practice,* Charles Singleton, pp. 35–104. Baltimore, 1969.

GRAULS, J. "Taalkundige toelichting bij het Hooi en den Hooiwagen." In *Gentsche Bijdragen tot de Kunstgeschiedenis,* Vol. 5 (1938), pp. 156–75.

————. "Ter verklaring van Bosch en Bruegel." In *Gentsche Bijdragen tot de Kunstgeschiedenis,* Vol. 6 (1939–40), pp. 139–46.

HEMPHILL, R. E. "The Personality and Problem of Hieronymus Bosch." In *Proceedings of the Royal Society of Medicine,* Vol. 58, no. 2 (1965), pp. 137–44.

HEIDENREICH, HELMUT. "Hieronymus Bosch in Some Literary Contexts." In *Journal of the Warburg and Courtauld Institutes,* Vol. 33 (1970), pp. 171–99.

HIRSCH, W. *Hieronymus Bosch. The Garden of Delights.* London, 1955.

HOLTEN, R. VON. "Hieronymus Bosch und die Vision des Tondalus." In *Konsthistorisk Tidskrift,* Vol. 28 (1959), pp. 99–109.

HUEBNER, F. M. *Le mystère Jérôme Bosch.* Brussels, 1965.

Jheronimus Bosch (catalogue of the exhibition in the Noordbrabants Museum, 's-Hertogenbosch), G. Lemmens, E. Taverne, J. Bruyn, and K. G. Boon. 's-Hertogenbosch, 1967.

JUSTI, CARL. "Die Werke des Hieronymus Bosch in Spanien." In *Jahrbuch der preussischen Kunstsammlungen,* Vol. 10 (1889), pp. 120–44. (Reprinted in *Miscellaneen aus drei Jahrhunderten spanischen Kunstlebens,* Vol. 2, pp. 61–93. Berlin, 1908.)

KURZ, OTTO. "Four Tapestries after Hieronymus Bosch." In *The Journal of the Warburg and Courtauld Institutes,* Vol. 30 (1967), pp. 150–62.

LAFOND, PAUL. *Hieronymus Bosch.* Brussels and Paris, 1914.

LARSON, ERIK. "*Les tentations de Saint Antoine de Jérôme Bosch.*" In *Revue belge,* Vol. 19 (1950), pp. 3–41.

LEMMENS, G., and TAVERNE, E. "Hieronymus Bosch. Naar aanleiding van de expositie in 's-Hertogenbosch." In *Simiolus,* Vol. 2 (1967/8), pp. 71–89.

LENNEBERG, H. "Bosch's *Garden of Earthly Delights,* some Musicological Considerations." In *Gazette des Beaux-Arts,* Vol. 53 (1961), pp. 135–44.

LENNEP, JAN VAN. "A propos de Jérôme Bosch: polémique, tarot et sang-dragon." In *Gazette des Beaux-Arts,* Vol. 71 (1968), pp. 189–90.

————. "Feu saint Antoine et Mandragore. A propos de la *Tentation de saint Antoine* par Jérôme Bosch." In *Bulletin des Musées Royaux des Beaux-Arts de Belgique,* 1968, pp. 115–36.

LINFERT, C. *Hieronymus Bosch, the Paintings.* London, 1959.

LURKER, M. *Der Baum in Glauben und Kunst unter besonderer Berücksichtigung der Werke des Hieronymus Bosch* (Studien zur deutschen Kunstgeschichte—328). Baden-Baden, 1960.

――――. "Das Tier in der Bildwelt des Hieronymus Bosch." In *Studium generale,* Vol. 20 (1967), 212–20.

――――. "Die Pflanze in der Bildwelt des Hieronymus Bosch." In *Studium generale,* Vol. 20 (1967), pp. 342–51.

MATEO-GOMEZ, I. "El grupo de los jugadores en *el Jardin de las Delicias.*" In *Archivo Español de Arte,* Vol. 32 (1959), pp. 253–56; Vol. 33 (1960), pp. 427–30.

――――. "El grupo de la cueva en el panel central del *Jardin de las Delicias* del Bosco." In *Archivo Español de Arte,* Vol. 36 (1963), pp. 253–57.

――――. *El Bosco en España.* Madrid, 1965.

――――. "*El Jardin de las Delicias.* A propósito de una copia temprana y un tapiz." In *Archivo Español de Arte,* Vol. 40 (1967), pp. 47–54.

McGRATH, R. L. "Satan and Bosch. The Visio Tundali and the Monastic Vices." In *Gazette des Beaux-Arts,* 1968, pp. 45–50.

MEERTENS, P. G. "Over volkskundige elementen in het werk van Jeroen Bosch." In *Volkskunde,* no. 54 (1953), pp. 172–80; no. 63 (1962), pp. 1–16; no. 65 (1964), pp. 49–60.

MIRIMONDE, A. P. DE. "La Musique dans les oeuvres des anciens Pays-Bas au Louvre." In *Revue du Louvre et des Musées de France,* Vol. 1 (1963), pp. 23–24.

――――. "Language secret des vieux tableaux." In *Mémoires de l'Académie de Stanislas,* Nancy, 1963/4, pp. 76–77.

MORAY, G. "Miró, Bosch and Fantasy Painting." In *The Burlington Magazine,* Vol. 113 (1971), pp. 387–91.

MOSMANS, J. *Jheronimus Anthoniszoon van Aken alias Hieronymus Bosch.* 's-Hertogenbosch, 1950.

PEMÁN, C. "Sobre la interpretacion del viadante al reservo del *Carro de heno* de el Bosco." In *Archivo Español de Arte,* Vol. 34 (1961), pp. 125–39.

PHILIP, LOTTE BRAND. "The Prado *Epiphany* by Jerome Bosch." In *The Art Bulletin,* Vol. 35 (1953), pp. 267–93. (Reprinted in part on pp. 88–107.)

――――. *Hieronymus Bosch.* New York, 1956.

――――. "*The Peddler* by Hieronymus Bosch, a Study in Detection." In *Nederlands Kunsthistorisch Jaarboek,* Vol. 9 (1958), pp. 1–81.

PIGLER, ANDREW. "Astrology and Jerome Bosch." In *The Burlington Magazine,* Vol. 92 (1950), pp. 132–36.

PINCHART, A. "Notes sur Jérôme van Aeken, dit Hieronymus Bosch, peintre et graveur, et sur Alard du Hameel, graveur et architecte, à Bois-le-Duc." In *Bulletins de l'Académie Royale de Belgique,* 2nd series, Vol. 4 (1858), pp. 497–505.

————. "Documents inédits." In *Archives des Arts, Sciences et Lettres,* Vol. 1 (1860), pp. 267–78. Ghent.

PIRENNE, L. "'s-Hertogenbosch ten tijde van Jheronimus Bosch." In *Bijdragen bij gelegenheid van de herdenkingstentoonstelling te 's-Hertogenbosch,* pp. 42–47. 's-Hertogenbosch, 1967.

POCH-KALOUS, MARGARETHE. *Hieronymus Bosch in der Gemäldegalerie der Akademie der bildende Künste.* Vienna, 1967.

PRAZ, MARIO. "The Canticles of Hieronymus Bosch." In *The Grand Eccentrics,* Art News Annual, Vol. 32 (1966), pp. 54–69.

PUYVELDE, LOUIS VAN. "De bedoeling van Bosch." In *Mededelingen der Kon. Akademie van Wetenschappen, afd. Letterkunde,* N.R., Vol. 19, no. 2 (1956), pp. 89–118.

————. *Die Welt von Bosch und Bruegel.* Munich, 1963.

————. "De geest van Hieronymus Bosch." In *Revue belge d'archéologie et d'histoire de l'art,* Vol. 23 (1954), pp. 238 ff.

READ, HEBERT. "Hieronymus Bosch: Symbolic Integration." In *Art and Alienation, the Role of the Artist in Society,* pp. 77–86. London, 1967.

RENGER, K. "Versuch einer neuen Deutung von Hieronymus Boschs Rotterdamer Tondo." In *Oud-Holland,* Vol. 84 (1969), pp. 67–76.

REUTERSWÄRD, PATRIK. "What Color is Divine Light?" *Art News Annual,* Vol. 35 (1969), pp. 108–27.

————. *Hieronymus Bosch* (Uppsala Studies in the History of Art, 7). Uppsala, 1970.

RINGBOM, SIXTEN. "Hieronymus Bosch's Passion Images." In *Icon to Narrative,* 1965, pp. 155–70. Åbo.

ROGGEN, D. "J. Bosch: Literatuur en Folklore." In *Gentsche Bijdragen tot de Kunstgeschiedenis,* Vol. 6 (1939/40), pp. 107–26.

ROSENBERG, JAKOB. "On the Meaning of a Bosch Drawing." In *De artibus opuscula XL—Essays in Honor of Erwin Panofsky,* pp. 422–26. New York, 1961.

SALAS, X. DE. *El Bosco en la literatura española.* Barcelona, 1943.

SALAZAR, A. M. "El Bosco y Ambrosio de Morales." In *Archivo Español de Arte,* Vol. 28 (1955), pp. 117–38.

SCHENCK, V. W. D. *Tussen duivelgeloof en beeldenstorm. Een studie over Jeroen Bosch en Erasmus van Rotterdam.* Amsterdam, 1946.

SCHMIDT-DEGENER, F. "Un tableau de Jérôme Bosch au Musée municipal de Saint-Germain-en-Laye." In *Gazette des Beaux-Arts,* Vol. 35 (1906), pp. 147–54.

SCHOUTE, R. VAN. "Le portement de croix de Jérôme Bosch au Musée de Gand. Considérations sur l'exécution picturale." In *Bulletin de l'Institut Royal du Patrimonie artistique,* Vol. 2 (1959), pp. 47–58.

————. "Jerome Bosch, *The Adoration of the Magi*." In *Bulletin of the Philadelphia Museum of Art*, Vol. 55 (1959/60), pp. 1–2.

————. "Over de techniek van Jeroen Bosch." In *Bijdragen bij gelegenheid van de herdenkingstentoonstelling te 's-Hertogenbosch*, pp. 72–79. 's-Hertogenbosch, 1967.

SELIGMAN, KURT. "Hieronymus Bosch: *The Peddler*." In *Gazette des Beaux-Arts*, Vol. 47 (1953), pp. 97–104.

SPYCHALSKA-BOCZKOWSKA, ANNA. "Material for the Iconography of Hieronymus Bosch's Triptych the Garden of Delights." In *Studia Muzealne*, Vol. 5 (1966), pp. 49–95. Poznan.

STEPPE, J. "Problemen betreffende het werk van Hieronymus Bosch." In *Jaarboek Koninklijke Academie voor Wetenschappen, Letteren en Schone Kunsten van België*, Vol. 24 (1962), pp. 156–67.

————. "Jheronimus Bosch. Bijdragen tot de historische en de ikonografische studie van zijn werk." In *Bijdragen bij gelegenheid van de herdenkingstentoonstelling te 's-Hertogenbosch 1967*, pp. 5–41. 's-Hertogenbosch, 1967.

SULZBERGER, SUSAN. "Jérôme Bosch et les maîtres de l'enluminure." In *Scriptorium*, Vol. 16 (1962), pp. 46–49.

TOLNAY, CHARLES DE. *Hieronymus Bosch* (dissertation for the University of Vienna). Vienna, 1925.

————. *Hieronymus Bosch*. Basel, 1937, revised English edition, London, 1966.

————. "Remarques sur quelques dessins de Bruegel l'Ancien et sur un dessin de Bosch récemment réapparus." In *Bulletin des Musées Royaux des Beaux-Arts*, Vol. 9 (1960), pp. 3–28.

————. "The Paintings of Hieronymus Bosch in the Philadelphia Museum of Art." In *Art International*, Vol. 7, no. 4 (1963), pp. 20–28.

VOGELSANG, W. *Hieronymus Bosch*. Amsterdam, 1951.

WERTHEIM-AYMÈS, C. A. *Hieronymus Bosch, eine Einführung in seine geheime Symbolik*. Amsterdam, 1957.

————. *Die Bildersprache des Hieronymus Bosch, dargestellt an Der verlorene Sohn, an Die Versuchung des heiligen Antonius und an Motiven aus anderen Werken*. The Hague, 1961.

WILENSKI, R. H. *Hieronymus Bosch*. London, 1953.

ZUPNICK, IRVING L. "Bosch's Representation of Acedia and the Pilgrimage of Everyman." In *Nederlands Kunsthistorisch Jaarboek*, Vol. 19 (1968), pp. 115–32.

Lists of Illustrations

177